0059760

DATE DUE

JLL 7-20-92	
SEP 2 5 1992	
FEB. 1 6 1994	
APR 09 1996	
ILL 2-14-99	

FRAUDS, MYTHS, AND MYSTERIES

FRAUDS, MYTHS, AND MYSTERIES:

Science and Pseudoscience in Archaeology

KENNETH L. FEDER
Central Connecticut State University

Mayfield Publishing Company
Mountain View, California
London • Toronto

Library of Congress Cataloging-in-Publication Data

Feder, Kenneth L.
 Frauds, myths, and mysteries: science and pseudo-
science in archaeology / Kenneth L. Feder.
 p. cm.
 Includes bibliographical references.
 ISBN 0-87484-971-3
 1. Forgery of antiquities. 2. Archaeology. I. Title.
CC140.F43 1990
930. 1--dc20 89–13599
 CIP

Manufactured in the United States of America
10 9 8 7 6 5 4 3

Mayfield Publishing Company
1240 Villa Street
Mountain View, California 94041

Sponsoring editor, Janet M. Beatty; managing editor, Linda Toy; production editor,
Carol Zafiropoulos; manuscript editor, Joan Pendleton; text and cover designer,
Jeanne M. Schreiber; cover art/photo, © Michael Friedel/Woodfin Camp and Asso-
ciates; production artist, Jean Mailander; illustrators, Joan Carol and Alan Noyes.
The text was set in 10/12.5 Palatino and printed on 50# Finch Opaque by Banta
Company.

Preface

"Say, what do you think about the guy who says that spacemen helped the Egyptians build the Pyramids?"
"Were Adam and Eve Australopithecus?*"*
"I heard that the Vikings were here before the Indians."
"The Maya were heavy into crystals — they had the power!"

All of us who teach archaeology hear comments such as these from our students, who often bring with them into the classroom notions of ancient astronauts, Noah's ark, psychic archaeology, pyramid power, lost continents, harmonically converging ancestors, and more.

Wishing to understand the extent of the problem, I initiated a student questionnaire survey at my institution in 1983 (Feder 1984, 1985/6). What I found, and what has been replicated in a subsequent study involving nearly one thousand students from Connecticut, Texas, and California (Feder 1987; Harrold and Eve 1987), was that a high proportion of undergraduate students are uninformed, or, worse, misinformed about human antiquity. Consistently high percentages of students in the sample believed, for instance, that Atlantis was the home of a great civilization (about 30 percent), that the Shroud of Turin was genuine (about 30 percent), that Europeans settled in America before the Vikings (about 40 percent), and that extraterrestrial aliens constructed ancient monuments like the pyramids (about 15 percent) (Hudson 1987).

Also distressing, but, perhaps not surprising, was the conclusion I was able to draw from my 1983 study that merely having completed a course in introductory archaeology had little statistical impact on student belief levels

v

in unsubstantiated claims relating to the human past. In fact, only when specific topics had been addressed within a general, scientific framework in various courses were students significantly less likely to accept unverified, unsupported propositions about the human past.

It is my strong feeling that we, as a discipline, need to respond to this problem. After all, if our students understand archaeological dating methods but still feel that ancient astronauts built the pyramids, we cannot claim reasonably to be producing an archaeologically literate citizenry.

My intent in writing this book is not simply to debunk individual claims. Such a book might be useful, but of short-lived value. The aim here is to put the analysis of such claims firmly within the perspective of the scientific method as it relates to archaeology. I devote an entire chapter to scientific epistemology. Further, each chapter that deals with a specific archaeological topic includes a "Current Perspectives" section in which I present a scientific approach to the chapter issue. The book is meant to serve both as a supplemental text for introductory courses in archaeology and as a stand-alone text for those courses that focus on popular topics in archaeology or on science versus pseudoscience in archaeology (of which, according to my survey of the discipline [Feder 1984], there is a gratifyingly growing number).

There is an ebb and flow to the particular kinds of nonsense that are all too often associated with archaeology. Von Däniken's books, for example, are no longer on the best-seller list although a compendium of three of his books has recently been published (von Däniken 1989). And it has been more than ten years since *America B.C.* by Barry Fell was selected by the American Booksellers Association to be presented to the White House library as one of the 250 best books of 1973-77. But while the fortunes of these writers may be waning, many of the ideas they promulgated and the movements they spawned are still with us. For example, archaeological pseudoscience in the guise of "New Age" proclamations about the ancient Maya, Egyptians, and others is alive and well.

Our discipline exists, by and large, as a result of public interest in the human past. As a result, archaeology is threatened by misperceptions and misunderstandings of how we work, what we know about the human past, and why we study it. I hope that in writing this book, I have helped students understand how archaeology works, what we know about the past, and why the veritable past is as exciting and intriguing as the fantasies concocted by the purveyors of pseudoscience.

Acknowledgments

I owe a debt of gratitude to a number of friends and colleagues for their help in researching, editing, and producing this book. Among my colleagues who directly commented on the manuscript, I must thank Sarah Campbell, Western Washington University; John W. Olsen, University of Arizona; Glenn Davis Stone, Columbia University; and Stephen Williams, Harvard University. Though we were not always in agreement, their extraordinarily thoughtful comments have induced me to write the very best book I possibly could. Thanks go, as always, to my very good friend and true colleague, Michael Alan Park, whose help in my growth as an anthropologist and writer has been inestimable.

I would also like to thank colleagues who, though not contributing directly to this book, have inspired me by their dedication to the science of archaeology and their commitment to respond to the pseudoscience that afflicts our discipline: John R. Cole, Marshall McKusick, and Dean Snow deserve special mention. I should also thank those colleagues in other disciplines who I do not know but who, by their dedication to communicating the excitement of genuine science to a public too enamored of nonsense, have served to inspire me. Among these I would like to mention Roy Chapman Andrews, Isaac Asimov, Stephen Jay Gould, and Carl Sagan.

Of course, I must thank the people at Mayfield. It is absolutely remarkable that at a single publishing house there is such a constellation of stars— the very best sponsoring editor, Jan Beatty; the very best managing editor, Linda Toy; the very best production editor, Carol Zafiropoulos; and the very best permissions editor, Pamela Trainer—anywhere in the universe. I am not sure writing a book is supposed to be as much fun as it is working with this group of enormously talented and dedicated people. I also thank Joan Pendleton, my copyeditor, for her fine work.

Finally, I cannot end this acknowledgment section without thanking my wife Melissa and son Joshua. To them I apologize for disappearing into my office for days at a time. I also thank them for their patience with my single-mindedness. Without their love, support, and understanding I could not have written this book—and I am not sure there would have been any reason to. And finally, to Joshua especially, I apologize for the fact that one of your first intelligible utterances was "Dada work, book."

Contents

For Lissa

Science and Pseudoscience

If all of the claims were true, this world would be an extraordinarily strange place, far different from what orthodox science would suppose.

Cats would be psychic and children could bend spoons with the power of their minds. Aliens from outer space would regularly fly over the earth, kidnap people, and perform medical examinations on them.

People could read minds, and by shuffling and dealing a special deck of playing cards (called Tarot), your future could be predicted. Sleeping under a pyramid-shaped bedframe would be conducive to good health, and wearing a quartz crystal suspended on a chain around your neck would make you more energetic.

Furthermore, the precise locations of enormously distant celestial bodies at the instant of your birth would determine your personality as well as your future. People could find water, treasure, and even archaeological sites with forked sticks or bent coat hangers. You could learn to levitate by taking a course.

Beyond this, if all of the claims were true, people living today would actually have lived many times in the past and could remember when they were kings or artists (few would remember being ordinary). And hundreds of boats and planes and thousands of people would have disappeared under mysterious circumstances in the dreaded "Bermuda Triangle."

Also, plants would think and have feelings, dolphins would write poetry, and cockroaches and even fertilized chicken eggs would be clairvoyant. Some people would spontaneously burst into flames for no apparent reason; and tiny ridges on your hands, bumps on your head, and even the shape of your behind could be used to understand your personality. People

could have sex with ghosts or the devil. Finally, human prehistory could best be understood as the result of supernatural occurrences, enormous cataclysms, and the interference of extraterrestrial space aliens.

It would be a strange world indeed, and the list of extreme, mysterious, and occult claims goes on and on (Figure 1.1). For many of you, some of the claims listed above (all of which have actually been published—even the clairvoyant chicken eggs!) might seem to be interesting to think about. Some of you might think that at least a few are reasonable, logical, and believable.

After all, science has scoffed at things in the past that eventually turned out to be true (meteors, for example). Maybe there is more to some of these claims than close-minded scientists are willing to admit. There must be something to UFOs, ESP, astrology, reincarnation, palmistry, biorhythms, fortune telling, dowsing, ancient astronauts, and so on; magazines, television, and movies flaunt these topics frequently. They can't all be fake, can they?

I have a confession to make. I used to read books on flying saucers and psychic power. I owned a Ouija board and a pendulum, and I analyzed handwriting and conducted ESP tests. I felt that there had to be something to some of these interesting ideas.

But it bothered me that the results of my ESP tests never really deviated from chance expectations and my Ouija board didn't work at all. I owned a small telescope and spent a lot of time looking at the nighttime sky, but I never saw anything that did not have some natural or ordinary explanation (an airplane, helicopter, blimp, bird, satellite, star, planet, or whatever). Yet I kept searching. Like most people, I wanted to believe in these fascinating possibilities rejected by orthodox science.

In the late 1960s, lured by the promise of four books for a dollar in the introductory offer, I signed up for a book club catering to occult tastes. In return, I received *The Complete, Illustrated Book of the Psychic Sciences; Yoga, Youth, and Reincarnation; The Black Arts;* and *The Morning of the Magicians.* The first three contained interesting little tidbits that seemed perfectly reasonable to me at the time: evidence of "real" hauntings and prophetic dreams, the usefulness of astrology, testimony about people's subconscious memories of past lives, and so on. The yoga book, along with some strange claims about reincarnation, actually taught some healthy exercises.

It was the fourth book, though, that really opened my eyes. Without their knowing it, the authors of this marvelous collection of outrageous claims, Louis Pauwels and Jacques Bergier (1960), played an important role in converting me from a completely credulous individual, open to all sorts of absolutely absurd ideas, to a scientific rationalist, still open to the possibility of all sorts of absolutely absurd ideas, but demanding rigorous proof that, unfortunately, these all seem to lack.

UFO ALIEN BURNED OUT MY CANCER
WITH LASER BEAMS

Bizarre Mole People Tribe Stole My Bride

NOAH'S ARK FOUND IN GOBI DESERT —
REMAINS OF INTELLIGENT, 2–LEGGED
LIZARD PEOPLE DISCOVERED
ON BOARD SAY SOVIET
SCIENTISTS

PSYCHIC DOCTOR
HEALS DYING KIDS
WITH HIS EYES

Liberace's Ghost Visits Me Every Friday Night

Figure 1.1 Actual headlines as they appeared in issues of various tabloid or "supermarket" newspapers.

The Morning of the Magicians

Remarkable claims about things that scientists were trying to hide from the public filled *The Morning of the Magicians*—evidence for reincarnation, levitation, ghosts, and so on. As always when I read most of these books, the first claim left me excited and fascinated. The second claim provided almost the same sense of intellectual exhilaration. But the third, fourth, fifth, and sixth were just more of the same. I slowly began to lose the ability to be surprised by the authors' claims of effective magical incantations, telepathy, the mystically engineered transformation of lead to gold, and the like. As exciting as any one of these claims might have been, the cumulative effect was simply a buildup of an intellectual resistance to surprise. I became immune to the claims. I was bored.

In skimming through the book, I found a section on remarkable discoveries in prehistoric archaeology related to the occult. It surprised me that there was any archaeology in the book at all; I had never considered connections between the occult and archaeology. Fascinated by the possibilities, I immediately began to read that section.

And I was absolutely appalled by what I read. I knew quite a bit about the archaeological topics they discussed, and what they said was incredible. Their claims about Egyptian pyramids; the massive, carved stone heads of Easter Island; the ancient culture of Peru; and other archaeological artifacts,

sites, and cultures were based on misinformation, the twisting of facts, and the misrepresentation of archaeological data and the study of the past.

At their very best, the authors' claims showed extreme ignorance. For example, their assertions about the supersophistication of prehistoric metallurgy in South America were misleading. Their insistence that this industry was somehow mysterious showed a gross ignorance of very well documented, sixteenth-century eyewitness accounts by Spanish explorers of the native metal-making process.

Their claims about advanced information exhibited in the dimensions of the Egyptian pyramids—the distance from the earth to the sun, for example, and the precise value of pi—had been made years before. Such claims were invariably based on incorrect measurements, miscalculation, and not just a little wishful thinking.

The authors' extraordinarily strange view of the past is best summed up in their own words:

> It is possible that our civilization is the result of a long struggle to obtain from machines the powers that primitive man possessed, enabling him to communicate from a distance, to rise into the air, to liberate the energy of matter, abolish gravitation, etc. (Pauwels and Bergier 1960:109)

In other words, according to the authors of *The Morning of the Magicians*, today we are simply rediscovering abilities that prehistoric people had—the ability to fly, to harness the energy of the atom, and to communicate electronically, for example. Although today we do so with machines, prehistoric people apparently could do it with their minds. Pauwels and Bergier were honest enough; they had entirely, openly, and unabashedly abandoned a skeptical approach: "No hypothesis is excluded: an atomic civilization long before what we call the prehistoric era; enlightenment received from the inhabitants of Another World, etc." (p. 105).

On simple facts, they were consistently wrong. These were things that might not be noticed by a nonarchaeologist. For example, they stated that the Toltecs built the Pyramid of the Sun at the Mexican site of Teotihuacán (p. 115). That's like saying the seventeenth-century Dutch settlers of New York City built Yankee Stadium; the Toltecs culture did not come onto the scene until at least two hundred years after Teotihuacán was abandoned.

In South America, the authors noted with amazement, archaeologists have found statues of camels, "which are unknown in South America" (p. 114), implying some sort of ancient mystery. Yet camels originated in South America, where four separate, camel-like species still exist (llama, alpaca, vicuña, and guanaco). The authors of *The Morning of the Magicians* also stated that there were prehistoric statues of dinosaurs in South America, though science tells us that the last of the dinosaurs became extinct some sixty million years ago (see Chapter 11).

They stated that the Mayan civilization of Mesoamerica is "far older than that of Greece" (p. 115). Yet classical Greece dates to well over twenty-five hundred years ago, while the Mayan civilization was at its peak more than one thousand years later, barely fifteen hundred years ago.

How, I wondered, could authors who seemed so well informed about physics, psychology, chemistry, biology, and history, be so confused when it came to my own field of archaeology? How could they so eloquently "prove" the existence of all sorts of occult things related to these other fields of science and be so lacking in their knowledge of the human past?

And then it struck me. Of all of the disciplines discussed in *The Morning of the Magicians*, archaeology was the only one with which I had more than just a passing familiarity. The more I thought about it, the clearer it became. The often-bizarre claims in *The Morning of the Magicians* that were related to physics, chemistry, biology, psychology, and history seemed reasonable to me primarily because I did not have the knowledge necessary to assess them intelligently.

It was a valuable lesson indeed. The authors had not mysteriously abandoned scholarly research and the scientific method (see Chapter 2 of this book) only in the one field in which I was well versed. As I looked further into their claims it became obvious that they had ignored the truth in just about every phenomenon they had described.

I began to read a number of books written by scientists in various fields who had been similarly appalled by the extreme claims made by occultists like Pauwels and Bergier. Again and again, I saw reactions and arguments that mirrored mine after reading the prehistory section of *The Morning of the Magicians*. When astronomers analyzed claims about extraterrestrial life, astrology, and UFOs; when psychologists examined telepathy and clairvoyance; when physicists and chemists investigated alleged evidence for perpetual motion machines or alchemy, they were nearly unanimous in their skepticism. In other words, claims that may have sounded good to me could easily be discounted, disproven, and disposed of by people who knew more than just a little bit about them. All those interesting occult claims that had fascinated me could be shown to be, at best, highly speculative and unproven or, at worst, complete nonsense.

Pseudoscience and Archaeology

I then began to search out more of the unsubstantiated, occult, and speculative claims that were being made about the prehistoric past by people who, it seemed, were wholly ignorant of modern archaeology. I have been doing this ever since, and it has been a surprisingly fruitful, if depressing, search. Little did I realize when I began to read *The Morning of the Magicians* how popular archaeological occultism and fraud is.

No one can deny that archaeology generates a great deal of public interest. People are fascinated by subjects like pyramids, Stonehenge, and the Aztecs. Archaeology survives because people are interested enough in it to take courses, go to museums, visit sites, and buy books about it.

Sadly, unscrupulous people try to take advantage of this interest by making unsupported claims about the discoveries made in this fascinating field. *The Morning of the Magicians* was not the first, and it certainly has not been the last, of the published, printed, spoken, filmed, or televised attempts to twist and pervert the discoveries made in archaeology.

With professional archaeologists spending the bulk of their time writing and talking to each other about their discoveries, the public often learns about archaeology from mass market paperbacks written by people whose major motivation is not to educate the public, but rather to prove some pet theory and/or make a lot of money. The result is a public interested in the human past, but often grossly misinformed about it. Recent studies of college students have shown their acceptance of a variety of unsubstantiated claims made about the human past (for example, the existence of the Lost Continent of Atlantis and the ancient astronaut hypothesis; see Figure 1.2) that virtually all archaeologists reject (Bainbridge 1978; Feder 1984; Harrold and Eve 1987). This situation presents a real danger to archaeology.

Archaeology, therefore, is a fascinating field that has, ironically, suffered because of its popularity. There are lots of interesting, sometimes hilarious, examples of the misuse of archaeology. Book publishers, movie makers, magazines, newspapers, and the *National Enquirer* have fed us a steady diet of ancient astronauts, psychic archaeology, Bigfoot, Atlantisology, and so on. And there is nothing new about it.

An important question to ask is "Why?" From the tales related in this book, six basic motives or explanations come forth:

1. Money, undeniably, can be a major motivating factor. The public's interest in archaeology is so great that many people willingly fork over their hard-earned cash to see artifacts or read about sites. The opportunities for charlatans to take advantage of an interested audience are virtually limitless.

2. Fame is another consideration. The desire to find the oldest site or the one that shows everybody else to be wrong has motivated many, including some professional archaeologists. This desire for fame and notoriety has unfortunately led not just a few to alter or exaggerate their data.

3. Nationalism is a broader sort of fame that has also served as a motive for extreme or unsubstantiated archaeological claims. The desire to prove some sort of nationalistic or racial claim through archaeology has been common. Wanting to show

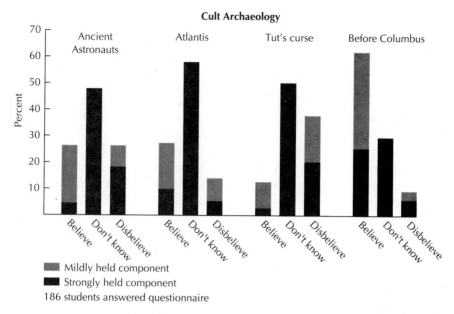

Figure 1.2 Student responses (strongly believe, mildly believe, don't know, mildly disbelieve, strongly disbelieve) to the following statements: "Aliens from other worlds visited the earth in the prehistoric past." "There is good evidence for the existence of the Lost Continent of Atlantis." "An ancient curse placed on the tomb of the Egyptian Pharaoh, King Tut, actually killed people." "America was discovered by Europeans many years before Columbus." From a survey conducted by the author at Central Connecticut State University (Feder 1984).

that "we" were here first or that "we" were civilized before "you" has again led some to play fast and loose with the archaeological facts.

4. Unfortunately, religion has also played a role in archaeological fraud. Many religions have their roots in remote antiquity. Some of their adherents dabble in archaeology, trying to prove the validity of their religious beliefs or claims through the discovery of archaeological evidence.

5. The desire for a more "romantic" past also plays a role. For some, lost continents, ancient astronauts, and psychic archaeologists seem more interesting than the discoveries of genuine archaeology. The quest for a more romantic past is the cause of at least some of the public's desire and willingness to believe claims that, if given some thought, could be easily disposed of.

6. Finally, and put bluntly, some of the extreme, unproven, bizarre, silly, and crazy claims made about the human past can be traced to the mental instability of their proponents. In other words, crazy claims often originate in crazy minds.

My purpose in writing this book is to give you the perspective of a professional archaeologist on unsubstantiated claims made about the prehistoric past, as well as on extreme claims made concerning how we can learn about that past.

The nonarchaeological topics that I mentioned at the beginning of this chapter (UFOs, ESP, etc.) have been discussed at length by experts in the relevant scientific fields. They will not be the focus here. However, I hope that through reading this book you will come to understand that ancient astronauts, psychic archaeology, extreme diffusionism, and the other claims to be discussed are the archaeological equivalents of these. If you are interested, some very good publications point out the lack of evidence for such things as ESP (*The Psychology of the Psychic*, by David Marks and Richard Kammann 1980, and *ESP and Parapsychology: A Critical Re-Evaluation*, by C.E.M. Hansel 1980), UFOs (Klass 1986, 1989), the efficacy of astrology (Bastedo 1981), and so on. There even is an excellent journal that presents articles where paranormal or extreme claims made in the name of science are skeptically assessed (*The Skeptical Inquirer*).

Here I will present a discussion of the scientific method (Chapter 2) and then go on to detail popular frauds in the field of prehistoric archaeology—the Cardiff Giant (Chapter 3) and Piltdown Man (Chapter 4). Next, we explore the controversy concerning the origin of the American Indians (Chapter 5), the debate over who discovered the Americas after the Indians (Chapter 6), and the historical argument over the source of the so-called Moundbuilder culture of North America (Chapter 7). Next, we delve into some unsubstantiated claims about the prehistoric archaeological record—the Lost Continent of Atlantis (Chapter 8), the ancient astronaut hypothesis (Chapter 9), psychic archaeology (Chapter 10), and alleged archaeological evidence for particular religious beliefs (Chapter 11). Finally, some genuine archaeological mysteries will be assessed in Chapter 12. Throughout, the theme will be how the methodology of science allows us to assess claims made in the name of the science of archaeology.

There is a reason for focusing on the history of the misuse and misinterpretation of the archaeological record as well as on individual misadventures. Only, for example, by seeing the contemporary claims of the Swiss' author Erich von Däniken (see Chapter 9) as what amounts to our modern version of the Cardiff Giant (Chapter 3), only by realizing that the claims of the "scientific" Creationists (Chapter 11) have been around for close to two hundred years and discredited for almost that long, and only by seeing that the public has been gullible about archaeology almost from its inception, can we hope to understand the entire phenomenon in its proper context. And only by understanding it, can those of us committed to the study of the human past hope to deal with it.

2

Epistemology: How You Know What You Know

Knowing Things

The word *epistemology* means the study of knowledge—how you know what you know. Think about it. How does anybody know anything to be actual, truthful, or real? How do we differentiate the reasonable from the unreasonable, the meaningful from the meaningless—in archaeology or in any other field of knowledge? Everybody knows things, but how do we really know these things?

I know that there is a mountain in a place called Tibet. I know that the mountain is called Everest, and I know that it is the tallest land mountain in the world (there are some a bit taller under the ocean). I even know that it is precisely 29,028 feet high. But I have never measured it; I've never even been to Tibet. Beyond this, I have not measured all of the other mountains in the world to compare them to Everest. Yet I am quite confident that Everest is the world's tallest peak. But how do I know that?

On the subject of mountains, there is a run-down stone monument on the top of Bear Mountain in the northwestern corner of Connecticut. The monument was built toward the end of the nineteenth century and marks the "highest ground" in Connecticut (Figure 2.1). When the monument was built to memorialize this most lofty and auspicious of peaks—the mountain is all of 2,316 feet high—people knew that it was the highest point in the state and wanted to recognize this fact with the monument.

There is only one problem. In recent times, with more accurate, sophisticated measuring equipment, it has been determined that Bear Mountain is not the highest point in Connecticut. The slope of Frissell

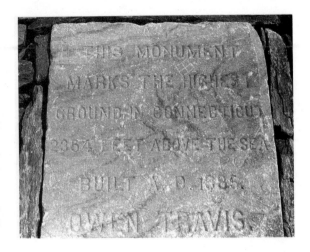

Figure 2.1 Plaque adorning a stone monument perched atop Bear Mountain in the northwest corner of Connecticut. Note that the height of the mountain is given as 2,354 feet (it actually is only 2,316 feet) and, in either case, though memorialized as "the highest ground" in the state, it is not.

Mountain, which actually peaks in Massachusetts, reaches a height of 2,380 feet on the Connecticut side of the border, eclipsing Bear Mountain by about 64 feet.

So, people in the late 1800s and early 1900s "knew" that Bear Mountain was the highest point in Connecticut. Today we *know* that they really did not "know" that, because it really was not true—even though they thought it was and built a monument saying so.

Now, suppose that I read in a newspaper, hear on the radio, or see on television a claim that another mountain has been found that is actually ten (or fifty, or ten thousand) feet higher than Mount Everest. Indeed, recently, new satellite data convinced a few, just for a while, that a peak neighboring Everest was, in actuality, slightly higher. You and I have never been to Tibet. How do we know if these reports are true? What criteria can we use to decide if the information is correct or not? It all comes back to epistemology. How indeed do we know what we think we "know"?

Collecting Information: Seeing Isn't Necessarily Believing

In general, people collect information in two ways:

1. Directly through their own experiences
2. Indirectly through specific information sources like friends, teachers, parents, books, TV, etc.

People tend to think that number 1—obtaining firsthand information, the stuff they see or experience themselves—is always the best way. This is unfortunately a false assumption because most people are poor observers.

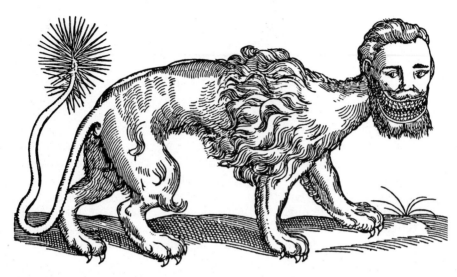

Figure 2.2 A seventeenth-century rendition of a clearly mythological beast—a *Mantichora*. The creature was considered to be real, described as being the size of a wild ass, as having quills on its tail that it could hurl at adversaries, and as having a fondness for human flesh.

For example, the list of animals alleged to have been observed by people that turn out to be figments of their imaginations is staggering. It is fascinating to read Pliny, a first-century thinker, or Topsell, who wrote in the seventeenth century, and see detailed accounts of the nature and habits of dragons, griffins, unicorns, mermaids, and so on (Byrne 1979). People claimed to have seen these animals, gave detailed descriptions, and even drew pictures of them (Figure 2.2). Many folks read their books and believed them.

Some of the first European explorers of Africa, Asia, and the New World could not decide if some of the native people they encountered were human beings or animals. They sometimes depicted them with hair all over their bodies and even as having tails (see Chapter 5).

Neither are untrained observers very good at identifying known, living animals. A red or "lesser" panda escaped from the zoo in Rotterdam, Holland, in December 1978. Red pandas are very rare animals and are indigenous to India, not Holland. They are distinctive in appearance and cannot be readily mistaken for any other sort of animal. The zoo informed the press that the panda was missing, hoping the publicity would alert people in the area of the zoo and aid in its return. Just when the newspapers came out with the panda story, it was found, quite dead, along some railroad tracks adjacent to the zoo. Nevertheless, over one hundred sightings of the panda *alive* were reported to the zoo from all over the Netherlands *after* the animal was obviously already dead. These reports did not stop until several

days after the newspapers announced the discovery of the dead panda (van Kampen 1979). So much for the absolute reliability of firsthand observation.

Collecting Information:
Relying on Others

When we explore the problems of secondhand information, we run into even more complications. Now we are not in place to observe something firsthand; we are forced to rely on the quality of someone else's observations, interpretations, and reports—as with the question of the height of Mount Everest. How do we know what to believe? This is a crucial question that all rational people must ask themselves, whether talking about medicine, religion, archaeology, or anything else. Again, it comes back around to epistemology; how do we know what we think we know, and how do we know what or whom to believe?

Science: Playing by the Rules

There are ways to knowledge that are both dependable and reliable. We might not be able to get to absolute truths about the meaning of existence, but we can figure out quite a bit about our world—about chemistry and biology, psychology and sociology, physics and history, and even prehistory. The techniques we are talking about to get at knowledge that we can feel confident in—knowledge that is reliable, truthful, and factual—are referred to as *science*.

In large part, science is a series of techniques used to maximize the probability that what we think we know really reflects the way things are, were, or will be. Science makes no claim to have all the answers or even to be right all of the time. On the contrary, during the process of the growth of knowledge and understanding, science is often wrong. The only claim that we do make in science is that if we honestly, consistently, and vigorously pursue knowledge using some basic techniques and principles, the truth will eventually surface and we can truly know things about the nature of the world in which we find ourselves.

The question then is, What exactly is science? If you believe Hollywood, science is a mysterious enterprise wherein old, white-haired, rather eccentric bearded gentlemen labor feverishly in white lab coats, mix assorted chemicals, invent mysterious compounds, and attempt to reanimate dead tissue. So much for Hollywood. Scientists don't have to look like anything in particular. We are just people trying to arrive at some truths about how the world and universe work. While the application of science can be a slow, frustrating, all-consuming enterprise, the basic assumptions we scientists hold are really very simple. Whether we are physicists, biolo-

gists, or archaeologists, we all work under four underlying principles. These principles are quite straightforward, but equally quite crucial.

1. There is a real and knowable universe.

2. The universe (which includes stars, planets, animals, and rocks, as well as people, their cultures, and their histories) operates according to certain understandable rules or laws.

3. These laws are immutable—that means they do not, in general, change depending on where you are or "when" you are.

4. These laws can be discerned, studied, and understood by people through careful observation, experimentation, and research.

Let's look at these assumptions one at a time.

There Is a Real and Knowable Universe

In science we have to agree that there is a real universe out there for us to study—a universe full of stars, animals, human history, and prehistory that exists whether we are happy with that reality or not.

The Universe Operates According to Understandable Laws

In essence, what this means is that there are rules by which the universe works: stars produce heat and light according to the laws of nuclear physics; nothing can go faster than the speed of light; all matter in the universe is attracted to all other matter (the law of gravity).

Even human history is not random but can be seen as following certain patterns of human cultural evolution. For example, the development of complex civilizations in Egypt, China, India/Pakistan, Mesopotamia, Mexico, and Peru was not based on random processes (Lamberg-Karlovsky and Sabloff 1979; Haas 1982). Their evolution seems to reflect similar general patterns. This is not to say that all of these civilizations were identical, any more than we would say that all stars are identical. On the contrary, they existed in different physical and cultural environments, and so we should expect that they be different. However, in each case the rise to civilization was preceded by the development of an agricultural economy. In each case, civilization was also preceded by some degree of overall population increase as well as increased population density in some areas (in other words, the development of cities). Again, in each case we find monumental works (pyramids, temples), evidence of long-distance trade, and the development

of mathematics, astronomy, and methods of record keeping (usually, but not always, in the form of writing). The cultures in which civilization developed, though some were unrelated and independent, shared these factors because of the nonrandom patterns of cultural evolution.

The point is that everything operates according to rules. In science we believe that, by understanding these rules or laws, we can understand stars, organisms, and even ourselves.

The Laws Are Immutable

That the laws do not change under ordinary conditions is a crucial concept in science. A law that works here, works there. A law that worked in the past will work today and will work in the future.

For example, if I go to the top of the Leaning Tower of Pisa today and simultaneously drop two balls of unequal mass, they will fall at the same rate and reach the ground at the same time, just as they did when Galileo performed a similar experiment in the seventeenth century. If I do it today, they will. Tomorrow, the same. If I perform the same experiment countless times, the same thing will occur because the laws of the universe (in this case, the law of gravity) do not change through time. They also do not change depending on where you are. Go anywhere on the earth and perform the same experiment—you will get the same results (try not to hit any pedestrians or you will see some other "laws" in operation). This experiment was even performed by U.S. astronauts on the moon. A hammer and a feather were dropped from the same height, and they hit the surface at precisely the same instant (the only reason this will not work on earth is because the feather is caught by the air and the hammer, obviously, is not). We have no reason to believe that the results would be different anywhere, or "anywhen" else.

If this assumption of science, that the laws do not change through time, were false, many of the so-called historical sciences, including prehistoric archaeology, could not exist.

For example, a major principle in the field of historical geology is that of *uniformitarianism*. It can be summarized in the phrase, "the present is the key to the past." Historical geologists are interested in knowing how the various landforms we see today came into being. They recognize that they cannot go back in time to see how the Grand Canyon was formed. However, since the laws of geology that governed the development of the Grand Canyon have not changed through time, and since these laws are still in operation, they do not need to. Historical geologists can study the formation of geological features today and apply what they learn to the past. The same laws they can directly study operating in the present were operating in the past when geological features that interest them first formed.

The present that we can observe is indeed the "key" to the past that we

cannot. This is true because the laws or rules that govern the universe are constant—those that operate today operated in the past. This is why science does not limit itself to the present, but makes inferences about the past and even predictions about the future (just listen to the weather report for an example of this). We can do so because we can study modern, ongoing phenomena that work under the same laws that existed in the past and will exist in the future.

This is where science and theology are often forced to part company and respectfully disagree. Remember, science depends on the constancy of the laws that we can discern. On the other hand, advocates of many religions, though they might believe that there are laws that govern things (and which, according to them, were established by a Creator), usually (but not always) believe that these laws can be changed at any time by their God. In other words, if God does not want the apple to fall to the ground, but instead, to hover, violating the law of gravity, that is precisely what will happen. As a more concrete example, scientists know that the heat and light given off by a fire results from the transformation of mass (of the wood) to energy. Physical laws control this process. A theologian, however, might agree with this ordinarily, but feel that if God wants to create a fire that does not consume any mass (like the "burning bush" of the Old Testament), then this is exactly what will occur. Most scientists simply do not accept this assertion. The rules are the rules. They do not change, even though we might sometimes wish that they would.

The Laws Can Be Understood

This may be the single most important principle in science. The universe is knowable. It may be complicated, and it may take years and years to understand even apparently simple phenomena. However, little by little, bit by bit, we expand our knowledge. Through careful observation and objective research and experimentation, we can indeed know things.

So, our assumptions are simple enough. We accept the existence of a reality independent of our own minds, and we accept that this reality works according to a series of unchanging laws or rules. We also claim that we can recognize and understand these laws or at least recognize the patterns that result from these universal rules. The question remains then: how do we do science—how do we explore the nature of the universe, whether our interest is planets, stars, atoms, or human prehistory?

The Workings of Science

We can know things by employing the rules of logic and rational thought. Scientists—archaeologists or otherwise—usually work through a combination of the logical processes known as *induction* and *deduction*. The

dictionary definition of induction is "arguing from specifics to generalities," while deduction is defined as the reverse, arguing from generalities to specifics.

What is essential to good science is objective, unbiased observations—of planets, molecules, rock formations, archaeological sites, and so on. Often, on the basis of these specific observations, we induce explanations called *hypotheses* for how these things work.

For example, we may study the planets Mercury, Venus, Earth, and Mars (each one presents specific bits of information). We then induce general rules about how we think these inner planets in our solar system were formed. Or, we might study a whole series of different kinds of molecules and then induce general rules about how all molecules interact chemically. We may study different rock formations and make general conclusions about their origin. We can study a number of specific prehistoric sites and make generalizations about how cultures evolved.

Notice that we cannot directly observe planets forming, the rules of molecular interaction, rocks being made, or prehistoric cultures evolving. Instead, we are inducing general conclusions and principles concerning our data that seem to follow logically from what we have been able to observe.

This process of induction, though crucial to science, is not enough. We need to go beyond our induced hypotheses by testing them. If our induced hypotheses are indeed valid—that is, if they really represent the actual rules according to which some aspect of the universe (planets, molecules, rocks, ancient societies) works—they should be able to hold up under the rigors of scientific hypothesis testing.

Observation and suggestion of hypotheses, therefore, are only the first steps in a scientific investigation. In science we always need to go beyond observation and hypothesizing. We need to set up a series of "if . . . then" statements; "if" our hypothesis is true "then" the following deduced "facts" will also be true. Our results are not always precise and clear-cut, especially in a science like archaeology, but this much should be clear—scientists are not just out there collecting a bunch of interesting facts. Facts are always collected within the context of trying to explain something or in trying to test a hypothesis.

As an example of this logical process, consider the health effects of smoking. How can scientists be sure that smoking is bad for you? After all, it's pretty rare that someone takes a puff on a cigarette and immediately drops dead. The certainty comes from a combination of induction and deduction. Observers have noticed for about three hundred years that people who smoked seemed to be more likely than people who did not to get certain diseases. As long ago as the seventeenth century, people noticed that habitual pipe smokers were subject to tumor growths on their lips and in their mouths. From such observations we can reasonably, though tentatively, induce a hypothesis of the unhealthfulness of smoking, but we still

need to test such a hypothesis. We need to set up "if . . . then" statements. If, in fact, smoking is a hazard to your health (the hypothesis we have induced based on our observations), then we should be able to deduce some predictions that must also be true. Sure enough, when we test specific, deduced predictions like

1. Smokers will have a higher incidence than nonsmokers of lung cancer
2. Smokers will have a higher incidence of emphysema
3. Smokers will take more sick days from work
4. Smokers will get more upper respiratory infections
5. Smokers will have diminished lung capacity
6. Smokers will have a shorter life expectancy

we see that our original, induced hypothesis—cigarette smoking is hazardous to your health—is upheld.

That was easy, but also obvious. How about an example with more mystery to it, one in which scientists acting in the way of detectives had to solve a puzzle in order to save lives? Carl Hempel (1966), a philosopher of science, provided the following example in his book *The Philosophy of Natural Science.*

The Case of Childbed Fever

In the 1840s things were not going well at the Vienna General Hospital, particularly in Ward 1 of the Maternity Division. In Ward 1 more than one in ten of the women brought in to give birth died soon after of a terrible disease called "childbed fever." This was a high death rate even for the 1840s. In one year 11.4 percent of the women who gave birth in Ward 1 died of this disease. It was a horrible situation and truly mystifying when you consider the fact that in Ward 2, another maternity division in the *same* hospital at the *same* time, only about one in fifty of the women (2 percent) died from this disease.

Plenty of people had tried their hand at inducing some possible explanations or hypotheses to explain these facts. It was suggested that more women were dying in Ward 1 due to "atmospheric disturbances," or perhaps it was "cosmic forces." However, no one had really sat down and considered the deductive implications of the various hypotheses—those things that would necessarily have been true if the proposed, induced explanation were in fact true. No one, that is, until a Hungarian doctor, Ignaz Semmelweis, attacked the problem in 1848.

Semmelweis made some observations in the maternity wards at the hospital. He noted some differences between Wards 1 and 2 and induced

a series of possible explanations for the drastic difference in the mortality rates. Semmelweis suggested:

1. Ward 1 tended to be more crowded than Ward 2. The overcrowding in Ward 1 was the cause of the higher mortality rate there.

2. Women in Ward 1 were from a lower socioeconomic class and tended to give birth lying on their backs, while in Ward 2 the predominate position was on the side. Birth position was the cause of the higher mortality rate.

3. There was a psychological factor involved; the hospital priest had to walk through Ward 1 to administer the last rites to dying patients in other wards. This sight so upset some women already weakened by the ordeal of childbirth that it contributed to their deaths.

4. There were more student doctors in Ward 1. Students were rougher than experienced physicians in their treatment of the women, unintentionally harming them and contributing to their deaths.

These induced hypotheses all sounded good. Each marked a genuine difference between Wards 1 and 2 that might have caused the difference in the death rate. Semmelweis was doing what most scientists do in such a situation; he was relying on creativity and imagination in seeking out an explanation.

Creativity and imagination are just as important to science as good observation. But being creative and imaginative was not enough. It did not help the women who were still dying at an alarming rate. Semmelweis had to go beyond producing possible explanations; he had to test each one of them. So, he deduced the necessary implications of each:

1. If hypothesis 1 were correct, then cutting down the crowding in Ward 1 should cut down the mortality rate. Semmelweis tried precisely that. The result: no change. So the first hypothesis was rejected. It had failed the scientific test; it simply could not be correct.

2. Semmelweis went on to test hypothesis 2 by changing the birth positions of the women in Ward 1 to match those of the women in Ward 2. Again, there was no change, and another hypothesis was rejected.

3. Next, to test hypothesis 3, Semmelweis rerouted the priest. Again, women in Ward 1 continued to die of childbed fever at about five times the rate of those in Ward 2.

4. Finally, to test hypothesis 4 Semmelweis made a special effort to get the student doctors to be more gentle in their birth assistance to the women in Ward 1. The result was the same; 10 or 11 percent of the women in Ward 1 died compared to about 2 percent in Ward 2.

Then, as so often happens in science, Semmelweis had a stroke of luck. A doctor friend of his died, and the way he died provided Semmelweis with another possible explanation for the problem in Ward 1. Though Semmelweis's friend was not a woman who had recently given birth, he did have precisely the same symptoms as did the women who were dying of childbed fever. Most importantly, this doctor had died of a disease just like childbed fever soon after accidentally cutting himself during an autopsy.

Viruses and bacteria were unknown in the 1840s. Surgical instruments were not sterilized, no special effort was made to clean the hands, and doctors did not wear gloves during operations and autopsies. Semmelweis had another hypothesis; perhaps the greater number of medical students in Ward 1 was at the root of the mystery, but not because of their inexperience. Instead, these students, as part of their training, were much more likely than experienced doctors to be performing autopsies. Supposing that there was something bad in dead bodies and this something had entered Semmelweis's friend's system through his wound—could the same bad "stuff" (Semmelweis called it "cadaveric material") get onto the hands of the student doctors, who then might, without washing, go on to help a woman give birth? Then, if this "cadaveric material" were transmitted into the woman's body during the birth of her baby, this material might lead to her death. It was a simple enough hypothesis to test. Semmelweis simply had the student doctors carefully wash their hands after performing autopsies. The women stopped dying in Ward 1. Semmelweis had solved the mystery.

Science and Nonscience:
The Essential Differences

Through objective observation and analysis, a scientist, whether a physicist, chemist, biologist, psychologist, or archaeologist, sees things that need explaining. Through creativity and imagination, the scientist suggests possible hypotheses to explain these "mysteries." The scientist then sets up a rigorous method through experimentation or subsequent research to deductively test the validity of a given hypothesis. If the implications of a hypothesis are shown not to be true, the hypothesis must be rejected and then it's back to the drawing board. If the implications are found to be true, we can uphold or support our hypothesis.

A number of other points should be made here. The first is that in order for a hypothesis, whether it turns out to be upheld or not, to be scientific in the first place, it must be testable. In other words, there must be clear, deduced implications that can be drawn from the hypothesis and then tested. Remember the hypotheses of "cosmic influences" and "atmospheric disturbances"? How can you test these? What are the necessary implications that can be deduced from the hypothesis, "More women died in Ward 1 due to atmospheric disturbances"? There really aren't any, and therefore such a hypothesis is not scientific—it cannot be tested. Remember, in the methodology of science, we ordinarily need to:

1. Observe
2. Induce general hypotheses or possible explanations for what we have observed
3. Deduce specific things that must also be true if our hypothesis is true
4. Test the hypothesis by checking out the deduced implications

If there are no specific implications of a hypothesis that can then be analyzed as a test of the validity or usefulness of that hypothesis, then you simply are not doing and cannot do "science."

For example, suppose you observe a person who appears to be able to "guess" the value of a playing card picked from a deck. Next, assume that someone hypothesizes that "psychic" ability is involved. Finally, suppose the claim is made that the "psychic" ability goes away as soon as you try to test it (actually named the "shyness effect" by some researchers of the paranormal). Such a claim is not itself testable and therefore not scientific.

Beyond the issue of testability, another lesson is involved in determining whether an approach to a problem is scientific. Semmelweis induced four different hypotheses to explain the difference in mortality rates between Wards 1 and 2. These "competing" explanations are called *multiple working hypotheses*. Notice that Semmelweis did not simply proceed by a process of elimination. He did not, for example, test the first three hypotheses and—after finding them invalid—declare that the fourth was necessarily correct since it was the only one left that he had thought of.

Some people try to work that way. A light is seen in the sky. Someone hypothesizes it was a meteor. We find out that it was not. Someone else hypothesizes that it was a military rocket. Again this turns out to be incorrect. Someone else suggests that it was the Goodyear Blimp, but that turns out to have been somewhere else. Finally, someone suggests that it was the spacecraft of people from another planet. Some will say that this must be correct, since none of the other explanations panned out. This is nonsense. There are plenty of other possible explanations. Eliminating all of the explanations *we* have been able to think of except one (which, perhaps,

has no testable implications) in no way allows us to uphold that final hypothesis. We will see just such an error in logic when we discuss the Shroud of Turin artifact in Chapter 11.

It's like seeing a card trick. You are mystified by it. You have a few possible explanations: the magician did it with mirrors, there was a helper in the audience, the cards were marked. But when you approach the magician and ask which it was, he assures you that none of your hypotheses is correct. Do you then decide that what you saw was an example of genuine, supernatural magic? Of course not! Simply because you or I cannot come up with the right explanation does not mean that the trick has a supernatural explanation. We simply admit that we do not have the expertise to suggest a more reasonable hypothesis.

Finally, there is another rule to hypothesis making and testing. It is called *Occam's Razor* or *Occam's Rule*. In essence it says that when a number of hypotheses are proposed through induction to explain a given set of observations, the simplest hypothesis is probably the best.

Take this actual example. During the eighteenth and nineteenth centuries, huge, buried, fossilized bones were found throughout North America and Europe (Figure 2.3). One hypothesis, the simplest, was that the

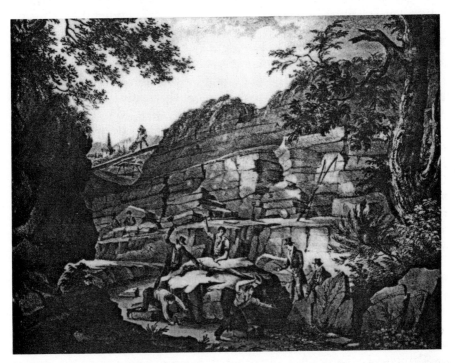

Figure 2.3 An 1827 lithograph of a fossil quarry in the Tilgate Forest, Sussex, England. Workers are extracting a dinosaur bone from a large rock fragment. From Mantell's *Geology of Sussex.*

bones were the remains of animals that no longer existed. This hypothesis simply relied on the assumption that bones do not come into existence by themselves, but always serve as the skeletons of animals. Therefore, when you find bones, there must have been animals who used those bones. However, another hypothesis was suggested: the bones were deposited by the Devil to fool us into thinking that such animals existed (Howard 1975). This hypothesis demanded many more assumptions about the universe than did the first: there is a Devil, that Devil is interested in human affairs, he wants to fool us, he has the ability to make bones of animals that never existed, and he has the ability to hide them under the ground and inside solid rock. That is quite a number of unproven (and largely untestable) claims to swallow. Thus, Occam's Razor says the simpler hypothesis, that these great bones are evidence of the existence of animals that no longer exist—in other words, dinosaurs—is better. The other one simply raises more questions than it answers.

The Art of Science

Don't get the impression that science is a mechanical enterprise. Science is at least partially an art. It is much more than just observing the results of experiments.

It takes great creativity to recognize a "mystery" in the first place. In the apocryphal story, countless apples had fallen from countless trees and undoubtedly conked the noggins of multitudes of stunned individuals who never thought much about it. It took a fabulously creative individual, Isaac Newton, to even recognize that herein lay a mystery. Why did the apple fall? No one had ever articulated the possibility that the apple could have hovered in midair. It could have moved off in any of the cardinal directions. It could have gone straight up and out of sight. But it did not. It fell to the ground as it always had, in all places, and as it always would. It took great imagination to recognize that in this simple observation (and in a bump on the head) rested the eloquence of a fundamental law of the universe.

Further, it takes great skill and imagination to invent a hypothesis in this attempt to understand why things seem to work the way they do. Remember, Ward 1 at the Vienna General Hospital did not have written over its doors, OVERCROWDED WARD or WARD WITH STUDENT DOCTORS WHO DON'T WASH THEIR HANDS AFTER AUTOPSIES. It took imagination first to recognize that there were differences between the wards and, quite importantly, that some of the differences might logically be at the root of the mystery. After all, there were in all likelihood many, many differences between the wards: their compass orientations, the names of the nurses, the precise alignment of the windows, the astrological signs of the doctors who worked in the wards, and so on. If a scientist were to

attempt to test all of these differences as hypothetical causes of a mystery, nothing would ever be solved. Occam's Razor must be applied. We need to focus our intellectual energies on those possible explanations that require few other assumptions. Only after all of these have been eliminated, can we legitimately consider others. As summarized by that great fictional detective, Sherlock Holmes:

> It is of the highest importance in the art of detection to be able to recognize, out of a number of facts, which are incidental and which are vital. Otherwise, your energy and attention must be dissipated instead of being concentrated.

Semmelweis concentrated his attention on first four, then a fifth possible explanation. Like all good scientists he had to use some amount of what we can call "intuition" to sort out the potentially vital from the probably incidental. Even in the initial sorting we may be wrong. Overcrowding seemed a very plausible explanation to Semmelweis, but it was wrong nonetheless.

Finally, it takes skill and inventiveness to suggest ways for testing the hypothesis in question. We must, out of our own heads, be able to invent the "then" part of our "if . . . then" statements. We need to be able to suggest those things that must be true if our hypothesis is to be supported. There really is an art to that. Anyone can claim there was a Lost Continent of Atlantis (Chapter 8), but often it takes a truly inventive mind to suggest precisely what archaeologists must find if the hypothesis of its existence were indeed to be valid.

Semmelweis tested his hypotheses and solved the mystery of childbed fever by changing conditions in Ward 1 to see if the death rate would change. In essence, the testing of each hypothesis was an experiment. In archaeology, the testing of hypotheses often must be done in a different manner. There is a branch of archaeology called, appropriately enough, "experimental archaeology" that involves the experimental replication and utilization of prehistoric artifacts in an attempt to figure out how they were made and used. In general, however, archaeology is largely not an experimental science. Archaeologists more often need to create "models" of some aspect of cultural adaptation and change. These models are simplified, manipulable versions of cultural phenomena.

For example, James Mosimann and Paul Martin (1975) created a computer program that simulated or modeled the first human migration into America some 12,000 years ago. By varying the size of the initial human population and their rate of growth and expansion, as well as the size of the big-game animal herds in the New World, Mosimann and Martin were able to test their hypothesis that these human settlers caused the extinction of many species of game animals. The implications of their

mathematical modeling can be tested against actual archaeological and paleontological data.

Ultimately, whether a science is experimentally based or not makes little logical difference in the testing of hypotheses. Instead of predicting what the results of a given experiment must be if our induced hypothesis is useful or valid, we predict what new data we must be able to find if a given hypothesis is correct.

For instance, we may hypothesize that long-distance trade is a key element in the development of civilization based upon our analysis of the ancient Maya. We deduce that if this is correct—if this is, in fact, a general rule of cultural evolution—we must find large quantities of trade items in other parts of the world where civilization also developed. We might further deduce that these items should be found in contexts that denote their value and importance to the society (for example, in the burials of leaders). We must then determine the validity of our predictions and, indirectly, our hypothesis by going out and conducting more research. We need to excavate sites belonging to other ancient civilizations and see if they followed the same pattern as seen for the Maya relative to the importance of trade.

Testing a hypothesis certainly is not easy. Sometimes errors in testing can lead to incorrectly validating or rejecting a hypothesis. Some of you may have already caught a potential problem in Semmelweis's application of the scientific method. Remember hypothesis 4? It was initially suggested that the student doctors were at the root of the higher death rate in Ward 1, because they were not as gentle in assisting in birthing as were the more experienced doctors. This hypothesis was not borne out by testing. Retraining the students had no effect on the mortality rate in Ward 1. But suppose that Semmelweis had tested this hypothesis instead by removing the students altogether prior to their retraining. From what we now know, the death rate would have indeed declined, and Semmelweis would have concluded incorrectly that the hypothesis was correct. We can assume that once the retrained students were returned to the ward (gentler, perhaps, but with their hands still dirty) the death rate would have jumped up again since the students were indeed at the heart of the matter, but not because of their presumed rough handling of the maternity patients.

This should point out that our testing of hypotheses takes a great deal of thought and that we can be wrong. We must remember: we have a hypothesis, we have the deduced implications, and we have the test. We can make errors at any place within this process—the hypothesis may be incorrect, the implications may be wrong, or the way we test them may be incorrect. Certainty in science is a scarce commodity. There are always new hypotheses, alternative explanations, and more deductive implications to test. Nothing is ever finished, nothing is set in concrete, nothing is ever defined or raised to the level of religious truth.

Beyond this, it must be admitted that scientists are, after all, ordinary human beings. They are not isolated from the cultures and times in which they live. They share many of the same prejudices and biases of other members of their societies. Scientists learn from mentors at universities and often inherit their perspectives. It often is quite difficult to go against the scientific grain, to question accumulated wisdom, and to suggest a new approach or perspective.

For example, when German meteorologist Alfred Wegener hypothesized in 1912 that the present configuration of the continents resulted from the breakup of a single inclusive landmass and that the separate continents had "drifted" into their current positions (a process called *continental drift*), most rejected the suggestion outright. Yet today, Wegener's general perspective is accepted and incorporated into the general theory of *plate tectonics*.

Philosopher of science Thomas Kuhn (1970) has suggested that the growth of scientific knowledge is not neatly linear, with knowledge simply building on knowledge. He maintains that science remains relatively static for periods and that most thinkers work under the same set of assumptions—the same *paradigm*. New ideas or perspectives, like those of Wegener or Einstein, that challenge the existing orthodoxy, are usually initially rejected. Only once scientists get over the shock of the new ideas and start testing the new frameworks suggested by these new paradigms are great jumps in knowledge made.

That is why in science we propose, test, tentatively accept, but never prove a hypothesis. We keep only those hypotheses that cannot be disproved. As long as an hypothesis holds up under the scrutiny of additional testing through experiment and/or is not contradicted by new data, we accept it as the best explanation so far. Some hypotheses sound good, pass the rigors of initial testing, but are later shown to be inadequate or invalid. Others—for example, the hypothesis of biological evolution—have held up so well (all new data either were or could have been deduced from it) that they will probably always be upheld. We usually call these very well supported hypotheses *theories*. However, it is in the nature of science that no matter how well an explanation of some aspect of reality has held up, we must always be prepared to consider new tests and better explanations.

We are interested in knowledge and explanations of the universe that work. As long as these explanations work, we keep them. As soon as they cease being effective because new data and tests show them to be incomplete or misguided, we discard them and seek new ones. In one sense, Semmelweis was wrong after all, though his explanation worked at the time—he did save lives through its application. We now know that there is nothing inherently bad in "cadaveric material." Dead bodies are not the cause of childbed fever. Today we realize that it is a bacteria that can grow in the flesh of a dead body that can get on a doctor's hands, infect a pregnant

woman, and cause her death. Semmelweis worked in a time before the existence of such things was known. Science in this way always grows, expands, and evolves.

Science and Archaeology

The study of the human past is a science and relies on the same general logical processes that all sciences do. Unfortunately, perhaps as a result of its popularity, the data of archaeology have often been used by people to attempt to prove some idea or claim. Too often, these attempts have been bereft of science.

Archaeology has attracted frauds and fakes. Myths about the human past have been created and popularized. Misunderstandings of how archaeologists go about their tasks and what we have discovered about the human story have too often been promulgated. As I stated in the first chapter of this book, my purpose is to describe the misuse of archaeology and the nonscientific application of the data from this field. In the chapters that follow, the perspective of science will be applied to frauds, myths, and mysteries concerning the human past.

𝔖𝔏𝔖𝔏𝔖𝔏𝔖𝔏𝔖𝔏 3 𝔖𝔏𝔖𝔏𝔖𝔏𝔖𝔏𝔖𝔏

The Goliath of New York: The Cardiff Giant

Myths and fairy tales are filled with stories of giant human beings. From the rough customer whom Jack and the Beanstalk ran into, to Paul Bunyan, giants have been used by legend makers to teach lessons to children or simply to entertain. Sometimes legends, myths, or fairy tales have some basis in reality, but we all know that there are no such things as giants. Nevertheless, not everyone has always been so sure of that.

In fact, before the twentieth century, many people probably did believe in giants. They believed because the Bible said that giant men did indeed inhabit the earth before "Noah's Flood." The Book of Genesis in the Old Testament makes no bones about it when it says, "There were giants in the earth in those days" (Genesis 6:4).

There is an even more explicit description of one of these "giants" later on in the Old Testament, in the Book of Samuel. In relating the famous story of David and Goliath, the writers provide this very detailed description of Goliath's truly mammoth proportions:

> And there went out a champion out of the camp of the Philistines named Goliath of Gotha whose height was six cubits and a span. And he had a helmet of brass upon his head, and he was armed with a coat of mail, and the weight of the coat was five thousand shekels of brass ... his spear's head weighed six hundred shekels of iron. ... (1 Samuel 17:4–7)

We do not measure things in *cubits*, *spans*, or *shekels*, so you'll need some help here. A cubit has had a number of slightly varying definitions in

different cultures and times. The range has essentially been between 17 and about 21 inches. The nearest guess for biblical times is taken from ancient Egypt of the same period, where a cubit was a bit more than 20 inches. Let's settle on 20. A span is defined as the distance between your thumb and pinky with your palm spread, or about 9 inches. A shekel, an ancient Hebrew measurement of weight, was about one-half of one of our ounces.

Now, if we translate Goliath's measurements into our modern system, we can calculate that, according to the authors of the Old Testament, Goliath stood 10' 9" in height, his armor weighed over 150 pounds, and his spear head alone tipped the scales at close to 19 pounds.

Remember, in the nineteenth century the literal truth of everything in the Bible was believed not by just a small minority of zealous fundamentalists. For many, claims made in the Bible were not viewed as hypotheses to be tested against data. They were not seen as legends, myths, or allegorical tales. They were instead viewed as revelations simply to accept and believe as historical truths. For many there was no question about it; Adam and Eve really were the first human beings, Jonah really was swallowed by a whale, and a ten-foot-tall giant by the name of Goliath actually had existed.

Therefore, we may all know that giants do not really exist and never have, but most God-fearing people in Europe and North America before this century probably did believe in giants.

Not surprisingly, during this time rumors were circulated concerning the discovery of evidence of ancient giant men (along with tales of the discovery of Noah's Ark, pieces of the true cross, and so on). No one believed that the Bible needed validation, but the discovery of things that seemed to uphold the truth of any of the Bible's stories was considered helpful in assisting people to better understand the Holy Word (see Chapter 11).

There were stories spread of giant fossil bones found in burial mounds in midwestern North America (see Chapter 7). In New York State, there was a rumor that the skeletons of five enormous human beings had been found during the building of a railroad grade (Silverberg 1970). In the early 1700s Cotton Mather, who previously had helped inspire the Salem witch trials, claimed that some huge bones sent to him by the governor of Massachusetts were the remains of "sinful giants" drowned in Noah's Flood (Howard 1975).

So, it was clear. The Bible said there were giants in the old days, and there could be no question about it—there really had been giants. Any artifacts or finds that would help support such a biblical claim were, of course, greatly appreciated and accepted unquestioningly by many.

The Cardiff Giant

Thus was the public's imagination sparked when the story began to spread in October 1869 of the discovery of the fossilized remains of a giant man in

the little farming village of Cardiff in upstate New York (see Franco 1969 for a detailed accounting of the Cardiff Giant story). Unlike other eighteenth- and nineteenth-century rumors of the archaeological discovery of prehis- toric giants, the mystery of this find was solved soon after its "discovery." We even still have the Giant himself to admire. His "petrified" remains continue to inspire wonder as they did in the late 1860s, but in a different sense—today we can wonder how in the world people accepted such a transparent fake.

The Discovery

On Saturday, October 16, 1869, a Mr. Stub Newell hired some men to dig a well behind the barn on his farm in Cardiff, New York, just outside of Syracuse. While digging, the workmen came across something very hard and large at a depth of about three feet. Though curious, Newell was said

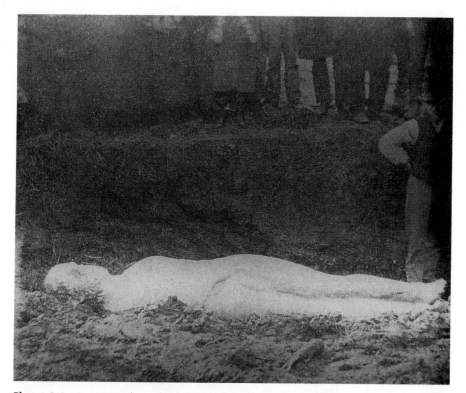

Figure 3.1 An 1869 photograph of the Cardiff Giant in its place of discovery on the Stub Newell farm. An unidentified digger stands to the right of the Giant and curious onlookers gaze down upon the remarkable discovery. (Courtesy of the New York State Historical Association, Cooperstown)

to be "annoyed and perplexed" by the discovery—it was reported in the *Syracuse Daily Journal* of Wednesday, October 20, 1869, that he had even suggested filling up the pit and keeping the whole thing quiet. Nevertheless, Newell had the workers expand their excavations. When they were done, the group of men looked down with amazement upon their thoroughly remarkable discovery. Lying at their feet in the pit was a man of enormous size and proportions whose body, it seemed, had turned to stone (Figure 3.1). He indeed appeared to be a man over ten feet in height, with twenty-one-inch-long feet, and three-foot-wide shoulders. He seemed to be "petrified" like the trees in the Petrified Forest in Arizona. There, millions of years ago, trees had fallen into a sandy, wet swamp. As the wood in the trees decayed, a hollow mold was formed, into which minerals poured. These minerals, over millions of years, became fused, forming beautiful and colorful stone casts of the trees. In some cases, even the tree rings are visible on these amazing petrified logs. If it could happen to a tree, perhaps it could happen to a man. Thus was the "discovery" of the Cardiff Giant made and the legend of a petrified giant man born.

Word quickly spread in the sleepy little town of a few hundred and soon, that very afternoon and the next day in fact, local people were gazing with astonishment at the spectacular find in the bottom of the pit behind Stub Newell's barn. As a reporter for the *Syracuse Daily Journal* put it, "Men left their work, women caught up their babies, and children in numbers all hurried to the scene where the interest of that little community centered" (October 20, 1869).

Ostensibly just a simple farmer, Newell then exhibited a remarkable degree of business acumen as well as surprising intuition concerning the marketability of the unique discovery on his property. According to the report mentioned above in the *Syracuse Daily Journal*, Newell rejected a number of offers, including an initial bid of fifty dollars and a later tender of one thousand dollars, to buy shares in the Giant. No more than two days had passed before Newell had instead obtained a license to exhibit the Giant and purchased and erected a tent over the slumbering, petrified man. He then began to charge fifty cents for a peek, and the paying public came in droves (Figure 3.2).

From all over New York State, the Northeast, and even beyond, 300–500 people daily flocked to the Newell farm. On the first few weekends after its discovery, thousands showed up, all more than ready to wait in line to pay their half-dollar to get a brief glimpse of the petrified "Goliath" of Cardiff (it was actually called that in advertisements). All thoughts of farming on the Newell homestead were abandoned as the crowd of carriages carrying the curious from the train station in Syracuse to the Newell farm increased. The entire farm was transformed virtually overnight into a highly profitable tourist enterprise, with a food tent, carriage service, cider stand, and, of course, the center of attraction—the awe-inspiring Giant

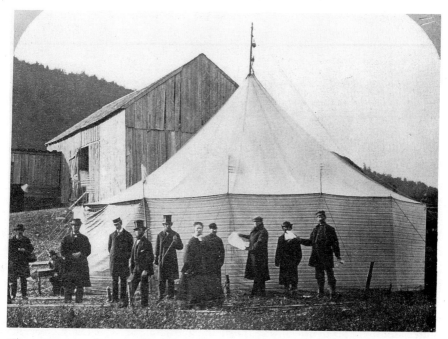

Figure 3.2 Just days after his "discovery," Stub Newell forgot about farming, erected a tent over the giant petrified man, and began charging people fifty cents to view its remains. (Courtesy of the Onondaga Historical Association, Syracuse)

himself (Figure 3.3). One of Newell's relatives, a Mr. George Hull, estimated in a later report that appeared in the *Ithaca Daily Journal* (January 4, 1898) that by not quite three weeks after the discovery, Newell had collected approximately $7,000 in admission fees—a remarkable sum even by today's standards!

But it was not just Stub Newell who was profiting from this very lucky discovery on his property. While the two small hotels in town were benefiting from a great influx of business, Cardiff was simply too small to accommodate the incredible surge of tourists who were making the trek to see the Giant. These people needed to be fed and housed, and that job fell to the businessmen of nearby Syracuse. In a very short time, the Cardiff Giant became a major factor in the economy of that city. Pilgrims streamed into town to pay homage to the Giant and, at the same time, to pay their dollars for the services such a tourist attraction demanded.

The economic impact of the Giant on Syracuse cannot be underestimated and was enough to convince a consortium of Syracuse businessmen and professional people to make Stub an offer he couldn't refuse. While a number of attempts to purchase shares in the Giant previously had been rebuffed, on October 23, just one week after its discovery, these astute people paid Newell $30,000 for a three-fourths interest in the Giant. By

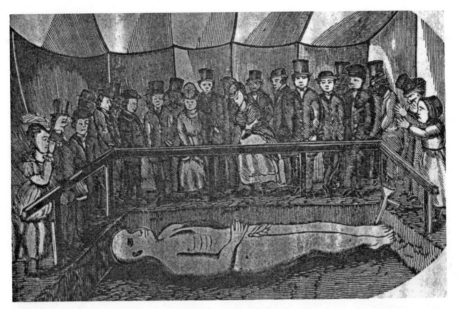

Figure 3.3 From *The Onondaga Giant*, a pamphlet published in 1869, this engraving shows a crowd of people viewing the Giant in the tent on the Newell farm. Note the strategically placed fig leaf.

today's standards that figure would almost certainly be in the millions of dollars. By purchasing a controlling share in the Giant, these businessmen were ensuring that it would stay near Syracuse, where it could continue to boost the local economy. At the same time they were assuring themselves a part of the enormous profits the Giant seemed certain to produce.

They were almost right. Between October 23 and November 5, the Syracuse investors had already made back $12,000 of their investment exhibiting the Giant at the Newell farm (Franco 1969:431). I'll save you the math—at fifty cents admission and three-fourths ownership of the Giant and its profits, in that short period about 32,000 people paid for the privilege of seeing the Cardiff Giant.

With no sign of "Giant mania" abating, and with visions of dollar signs dancing in their heads, the Syracuse businessmen decided to move the Giant to Syracuse itself, where it would be easier for even greater numbers of people to see it. With great pomp and ceremony, not to mention free publicity through local newspaper coverage, the Giant was disinterred and transported to an exhibition hall in Syracuse. Among its admirers was the circus entrepreneur P. T. Barnum, who made an attempt to buy the Giant but was turned down. According to the *Ithaca Daily Journal* article mentioned earlier, Barnum then offered the syndicate of owners $60,000 merely for the use of the Giant for three months. Again he was rebuffed. Barnum

was not to give up trying to make a circus attraction out of the Giant, however. More on his unique solution to the problem later.

The Beginning of the End

Everything seemed to be going well. Newspapers were printing feature articles about the Giant. The local railroad even made a regular, ten-minute stop across the street from where it was being exhibited in Syracuse to enable people just passing through to run in to see the giant petrified man. And people continued to come in great numbers to see the miraculously preserved, petrified giant man from before Noah's Flood.

But all was not well. Slowly at first, but then at an accelerating rate, rumors began to surface that the Giant was a fake. A local resident, Mr. Daniel Luce, provided a very detailed report, recounted in the *Syracuse Standard* of November 1, 1869, of an extremely large wagon, carrying a sizeable and obviously heavy load, that he remembered traveling toward Cardiff the previous year. Some wondered out loud whether the very large wagon had been carrying a fraudulent, giant statue of a man.

There is also some testimony, as indicated in the *Ithaca Daily Journal* article already cited, that Stub Newell had begun bragging to relatives about the very profitable fraud that he had perpetrated on the American public.

Beyond this—and this is very important—professional scientists, including geologists and paleontologists who had traveled to Cardiff or Syracuse to examine the Giant in detail, almost without exception immediately declared it to be a fake and a fraud. Dr. J. F. Boynton, a geologist at the University of Pennsylvania, stated after carefully examining the Giant:

> It is positively absurd to consider this a fossil man. It has none of the indications that would designate it as such, when examined by a practical chemist, geologist, or naturalist. (*Syracuse Daily Journal*, October 20, 1869).

Boynton further noted the presence of fresh plant material mixed in with the soil from above the Giant, indicating a probable recent burial.

Most important of the scientific skeptics probably was Othniel C. Marsh, a professor at Yale University and one of the most famous paleontologists of his time. Marsh examined the Giant and declared it to be "very remarkable." When asked by one of the Giant's owners if they could quote Marsh on that, Marsh is supposed to have said, "No. You may quote me on this though: a very remarkable fake!" (Howard 1975:208).

Marsh correctly noted that the Giant was made of gypsum, a soft stone that would not last very long in the wet soil of the Newell farm. Even worse, Marsh identified tool marks on the alleged petrified man.

The skepticism of so highly respected a scientist as Marsh had some

impact, and a number of the New York City newspapers (in particular, the *New York Herald*) that had previously praised the Giant, now changed their minds. But the statements of Marsh and other, less well known scientists could not alone dissuade the public from the notion that the Cardiff Giant was a real, petrified man whose existence supported biblical stories of human giants before Noah's Flood.

Hull's Confession

The meteoric rise to fame of the Cardiff Giant was cut short, and his fall from grace was just as quick. A previously shadowy figure involved with promoting the Giant confessed in December 1869 to perpetrating a fraud on the American public. George Hull, a distant relation of Stub Newell, unburdened his soul, and the Giant's value dropped from that of a spectacular archaeological find to that of one slightly worn chunk of gypsum.

George Hull was a cigar manufacturer in Binghamton, New York. Ironically, he also was a devout atheist. He revealed the entire story toward the end of his life in an interview he gave to the *Ithaca Daily Journal* in 1898.

A conversation with a fundamentalist minister in Iowa convinced him that there was money to be made in marketing archaeological specimens that might seem to lend validity to Bible stories. Hull hit upon the "giant" idea in 1866. In a subsequent visit to the Midwest in June 1868, he purchased a large block of gypsum in Fort Dodge, Iowa. He then had it shipped to Chicago, where he hired sculptors to produce a statue of a giant, slumbering man.

After work had gone on for a couple of months, the Giant was almost complete. However, upon viewing it, Hull was unhappy. Initially, the face of the giant statue looked just like George Hull's own! The sculptors had even given the Giant hair and a beard to match Hull's. The stoneworkers could not be blamed. After all, this rather strange, secretive man had requested that they create a statue of a giant, naked, recumbent man—not the usual kind of request.

Obviously, it would not satisfy Hull's plan to have the Giant bear any resemblance whatsoever to its creator. It would not have been very convenient if any of the Giant's investigators had noticed the rather astonishing similarity between the face of the petrified Man and that of Stub Newell's mysterious cousin.

But all was not lost. Hull first had the sculptors remove the hair on the head and face. However, he still was unsatisfied. He next got some blocks of wood into which he hammered a bunch of darning or knitting needles so that their points stuck out of the faces of the blocks. Hull proceeded to pound on the Giant with these blocks. You can imagine the expression on the faces of the sculptors, seeing this madman attack the artistic creation he had just paid them to produce. Hull liked the effect though; it gave the

surface of the statue the pore-like appearance of skin. As if this weren't enough, Hull next rubbed acid all over the sculpture, which further reinforced its ancient appearance.

After all this, Hull finally was satisfied. The Giant now looked nothing like him. Better still, it looked very old. The scene at last was set for the great archaeological fraud.

Hull had the Giant shipped in a wooden box by railroad to Union, New York. In November 1868 it was finally brought by wagon to his cousin Stub Newell's farm and secretly buried behind the barn (apparently with Newell's knowledge and cooperation). To make certain that no one would connect the shipment with the discovery of the Giant, it was left to lie in the ground for about a year. Then, according to plan, nearly twelve months later, Hull instructed Newell to hire a crew of men to dig a well where they were both very much aware that the Giant would be discovered. The rest is very embarrassing history. It should finally be pointed out that it was apparently Newell's bragging to friends and relatives about the fraud that induced Hull to come clean before the whole thing blew up in their faces.

Needless to say, the other owners of the Giant, the businessmen of Syracuse who were benefiting from the Giant's presence, and the ministers who had included reference to the Giant's discovery in their Sunday sermons were not pleased by Hull's revelations. It did not seem likely that people were going to go out of their way and pay to see a gypsum statue that was one and one-half years old. Beyond this, religious support for a fraud could certainly damage the credibility of the religious leaders involved.

The syndicate of owners initially tried to quash the confession or at least discredit it. They claimed that Hull had been put up to it by the people of the surrounding towns because they were jealous of the discovery in Cardiff and the successful exploitation of it by Syracuse. But Hull's story was too detailed and reasonable to ignore. When the sculptors in Chicago came forward to verify Hull's confession, the Giant's days as a major tourist attraction were at an end.

The End of the Giant

The Giant's demise was not without its ironies. After P. T. Barnum had been turned down in his initial attempt to purchase the Giant, he simply went out and had a plaster duplicate made. He even billed the statue as the "real" Cardiff Giant. In other words, Barnum was charging people to see the Cardiff Giant, but his Cardiff Giant was a fake; it was, put bluntly, a fake of a fake! After revenues dropped as a result of the Hull confession, the owners of the "real" fake took the Giant on the road, hoping to drum up some business and maybe even turn the whole fiasco of the confession to their advantage (Figure 3.4). Coincidentally, the real fake and Barnum's fake of

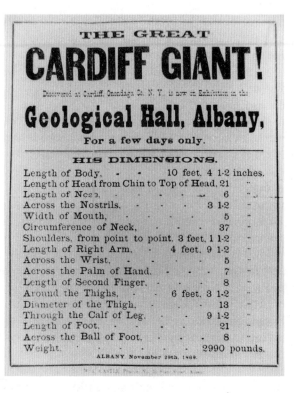

THE GREAT

CARDIFF GIANT!

Discovered at Cardiff, Onondaga Co. N. Y. is now on Exhibition in the

Geological Hall, Albany,

For a few days only.

HIS DIMENSIONS.

Length of Body, - -	10 feet. 4 1-2 inches.
Length of Head from Chin to Top of Head, 21	"
Length of Nose, - - - -	6 "
Across the Nostrils, - - -	3 1-2 "
Width of Mouth, - - -	5 "
Circumference of Neck, - - -	37 "
Shoulders, from point to point, 3 feet, 1 1-2	"
Length of Right Arm, - 4 feet, 9 1-2	"
Across the Wrist, - - -	5 "
Across the Palm of Hand, - - -	7 "
Length of Second Finger, - -	8 "
Around the Thighs, - - 6 feet, 3 1-2	"
Diameter of the Thigh, - -	13 "
Through the Calf of Leg, - -	9 1-2 "
Length of Foot, - - -	21 "
Across the Ball of Foot, - -	8 "
Weight, - - - -	2990 pounds.

ALBANY November 29th, 1869.

Figure 3.4 The Giant on tour. After serious questions were raised regarding the Giant's authenticity, the consortium of owners decided to take their show on the road. This handout advertised the Giant's appearance in Albany, New York, on November 29, 1869. (Courtesy of the New York State Historical Association, Cooperstown)

the fake, were both being displayed at the same time in New York City. And would you believe it? Barnum's copy outdrew the real Cardiff Giant.

Mark Twain was so amused by the whole mess that he wrote a short story about it. Titled "A Ghost Story," it concerns a man who takes a room at a hotel in New York City and is then terrorized by the ghost of a poor, tormented, giant man. The ghost turns out to be, in fact, the spirit of the Cardiff Giant. The Giant's soul has been condemned to wander the earth until his physical remains are once again laid to rest. He nightly wanders the halls of the hotel as his fossilized body is cruelly displayed in the exhibit hall across the street. But, as luck would have it, the poor tormented soul of the Giant has made a grievous error. As the hotel resident informed him, "Why you poor blundering old fossil, you have had all your trouble for nothing—you have been haunting a plaster cast of yourself. . . . " The ghost of the poor Giant was haunting Barnum's fake. Even he was fooled.

Why Did They Do It?

The motive for the perpetration of the Cardiff Giant fraud is obvious. Very clearly it was money. George Hull and Stub Newell made far more money displaying the Giant than they ever could have through selling cigars or

farming—their legal professions. Money continued to motivate those who benefited from the Giant but who played no part in perpetrating the fraud in the first place. The businessmen of Syracuse grew rich as a result of the Giant, and a small town in rural New York was put on the map. We do not know if any in the syndicate of owners or if any of the other benefiting businessmen of Syracuse had questions about the authenticity of the Giant. If they did, the money motive probably was sufficient to keep them quiet.

There also is an explanation for why people with no monetary investment wished to believe that the Cardiff Giant was genuine. Certainly, the religious element behind the public's desire to believe in the validity of the Giant cannot be overestimated. When publications in 1869 referred to the discovery as a "Goliath," they were not making a simple analogy; they were making a serious comparison between the Cardiff discovery and the biblical story of Goliath of Gotha.

Moreover, I would also include the romance of mystery as an explanation for why people chose to accept the Giant even though scientists who studied it declared it to be, at best, a statue and, at worst, a fraud. Whether the Giant lent proof to a biblical claim or not, perhaps it was the simple romance of such an amazing discovery that played at least a secondary role in convincing people to part with their hard-earned money to see what was pretty clearly a gypsum statue.

The lesson of the Cardiff Giant is one that you will see repeated in this book. Trained observers such as professional scientists had viewed the Giant and pronounced it to be an impossibility, a statue, a clumsy fraud, and just plain silly. Such objective, rational, logical, and scientific conclusions, however, had little impact. A chord had been struck in the hearts and minds of many otherwise levelheaded people, and little could dissuade them from believing in the truth of the Giant. Their acceptance of the validity of the Giant was based on their desire, religious or not, to believe it.

Even today, many Creationists (see Chapter 11) claim that every word in the Bible is literally true. Just as many in previous centuries believed the literal, historical accuracy of biblical stories (including those of Adam and Eve, the Flood, and even giants), so do the modern Creationists. Their belief in biblical giants has led them to claim that they have discovered enormous "manprints"—the alleged footprints of human giants from "before the Flood." Thus, belief in giants has not disappeared in the twentieth century, but has continued among this group of religious fundamentalists. As we will see in greater detail in Chapter 11, once again the desire to believe something that is clearly false has overridden rationality.

Finally, after laughing at all those silly people who in 1869 paid fifty cents to see the Giant, you can now all laugh at me; I paid $4.50 to see him (along with a very fine museum). The poor, tortured Giant has at last found a final resting place at the Farmers' Museum in Cooperstown, New York, where the admission was $4.50 a few years ago. Finally the Giant has found

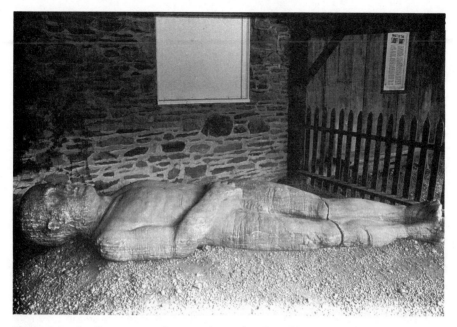

Figure 3.5 In silent repose, the Giant has at last found his eternal rest at the Farmers'
Museum in Cooperstown, New York.

his peace. Do I detect a hint of a smile on his face? I guess the Cardiff Giant
has the last laugh after all (Figure 3.5).

CURRENT PERSPECTIVES
Frauds

A clumsy fraud like the Cardiff Giant didn't fool scientists in the nineteenth
century and certainly would fool no one today. But frauds related to the
human past have greatly increased in sophistication since that time. Frauds
frequently can no longer be detected by simple, visual inspection. Today,
scientists may have to apply a broad arsenal of scientific and high-tech
weapons in their assessment of questionable artifacts to determine whether
they are authentic or fraudulent.

For example, when it was discovered in the middle of the nineteenth
century, many accepted the authenticity of the *Holly Oak pendant*. That
artifact, found in Delaware, appeared to be an incised drawing on shell of
a prehistoric woolly mammoth. It reminded many of the Paleolithic cave
paintings and carvings of Europe of 20,000 years ago, convincing some of

the existence of a similar—and similarly ancient—artistic tradition in North America.

Recently, however, the shell itself has been age-tested using the technique of *radiocarbon dating* (Griffin et al. 1988). In this procedure, the remains of once-living things (bones, wood, seeds, antlers, hide, nuts, shell) can be dated by reference to the amount of a radioactive isotope of carbon (carbon 14) left in the object. Carbon 14 decays at a regular, known rate and thus serves as a sort of atomic clock. It is quite useful to archaeologists when dating objects more than a few hundred and less than 60,000 years old.

The Holly Oak pendant, if genuine, should have dated to more than 10,000 years ago since that is about the time that woolly mammoths became extinct—obviously, people would not have been drawing mammoths long after they had disappeared. In fact, the shell turned out to be only about 1,000 years old. The artifact was a fake, carved on an old piece of shell.

In another case, the so-called Vinland Map was touted as a historical artifact that dated to about A.D. 1440, proving the pre-Columbian Viking discovery of America (see Chapter 6). Clearly shown on this map, ostensibly based on Viking explorations, were the coasts of Baffin Island, Labrador, and Newfoundland in Canada. The map was very convincing. Even a wormhole in the map matched holes in two genuine documents with which it supposedly was bound for five centuries.

Though the map appeared genuine to the naked eyes of many cartographic experts as well as to historians, to the probing eye of the microscopist, the map possessed fatal flaws. Using the powerful tools of scanning electron and transmission electron microscopy, Walter McCrone (1976) was able to detect telltale evidence of fraud in the form of ink particles of *anatase* no more than .1 micrometer across. Anatase is a titanium-based ink not known to the world until the 1920s. Using another analytical tool, the ion microprobe, McCrone determined that the liquid matrix in which the ink pigment was contained consisted of an alkyd resin, also unknown until the 1920s. The Vinland Map was drawn, not in the fifteenth century, but in the twentieth; it was a fake. With tools like the scanning electron microscope and techniques like radiocarbon dating, the hoaxers can have a very hard time indeed fooling present-day archaeologists.

Dawson's Dawn
Man: The Hoax
at Piltdown

The Piltdown Man fossil is a literal skeleton in the closet of prehistoric archaeology and human paleontology. This single specimen seemed to turn our understanding of human evolution on its head and certainly did turn the heads of not just a few of the world's most talented scientists. The story of Piltdown has been presented in detail by Ronald Millar in his 1972 book *The Piltdown Men*, by J. S. Weiner in his 1955 work *The Piltdown Forgery*, and most recently in 1986 by Charles Blinderman in *The Piltdown Inquest*. The story is useful in its telling if only to show that even scientific observers can make mistakes. This is particularly the case when trained scientists are faced with that which they are not trained to detect—intellectual criminality. But let us begin before the beginning, before the discovery of the Piltdown fossil.

The Evolutionary Context

We need to turn the clock back to Europe of the late nineteenth and early twentieth centuries. The concept of evolution—the notion that all animal and plant forms seen in the modern world had descended or evolved from earlier, ancestral forms—had been debated by scientists for quite some time (Greene 1959). It was not until Charles Darwin's *On the Origin of Species* was published in 1859, however, that a viable mechanism for evolution was proposed and supported with an enormous body of data. Darwin had meticulously studied his subject, collecting evidence from all over the world for more than thirty years in support of his evolutionary mechanism called

natural selection. Darwin's arguments were so well reasoned that most scientists soon became convinced of the explanatory power of his theory. Darwin went on to apply his general theory to humanity in *The Descent of Man*, published in 1871. This book was also enormously successful, and more thinkers came to accept the notion of human evolution.

Around the same time that Darwin was theorizing about the biological origin of humanity, discoveries were being made in Europe and Asia that seemed to support the concept of human evolution from ancestral forms. In 1856, workmen building a roadway in the Neander Valley of Germany came across some remarkable bones. The head was large but oddly shaped (Figure 4.1). The cranium (the skull minus the mandible or jaw) was much flatter than a modern human's, the bones heavier. The face jutted out, the forehead sloped back, and massive bone ridges appeared just above the eye sockets. Around the same time, other skeletons were found in Belgium and Spain that looked very similar. The postcranial bones (all the bones below the skull) of these fossils were quite similar to those of modern humans.

There was some initial confusion about how to label these specimens. Some scientists concluded that they simply represented pathological freaks. Rudolf Virchow, the world's preeminent anatomist, explained the curious bony ridges above the eyes as the result of blows to the foreheads of the creatures (Kennedy 1975). Eventually, however, scientists realized that these creatures, then and now called *Neandertals* after their most famous find-spot, represented a primitive and ancient form of humanity.

The growing acceptance of Darwin's theory of evolution and the discovery of primitive-looking, though humanlike, fossils combined to radically shift people's opinions about human origins. In fact, the initial abhorrence many felt concerning the entire notion of human evolution from lower, more primitive forms was remarkably changed in just a few decades (Greene 1959). By the turn of the twentieth century, not only were many people comfortable with the general concept of human evolution, but there actually was also a feeling of national pride concerning the discovery of a human ancestor within one's borders.

The Germans could point to their Neandertal skeletons and claim that the first primitive human being was a German. The French could counter that their own Cro-Magnon—ancient, though not as old as the German Neandertals—was a more humanlike and advanced ancestor; therefore, the first true human was a Frenchman. Fossils had also been found in Belgium and Spain, so Belgians and Spaniards could claim for themselves a place within the story of human origin and development. Even so small a nation as Holland could lay claim to a place in human evolutionary history since a Dutchman, Eugene Dubois, in 1891 had discovered the fossilized remains of a primitive human ancestor in Java, a Dutch-owned colony in the western Pacific.

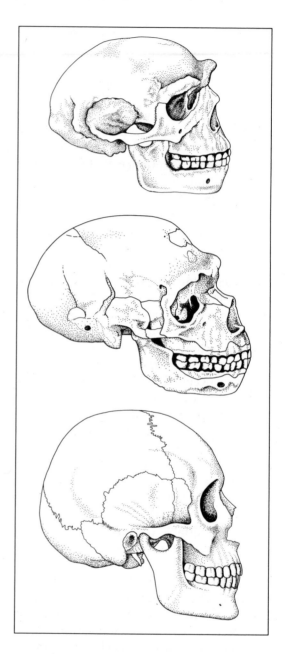

Figure 4.1 Drawings showing the general differences in skull size and form between *Homo erectus* (Peking Man—500,000 years ago [top]), Neandertal Man (100,000 years ago [center]), and a modern human being [bottom]. Note the large brow ridges and forward-thrusting faces of *Homo erectus* and Neandertal, the rounded outline of the modern skull, and the absence of a chin in earlier forms. (Carolyn Whyte)

However, one great European nation did not and could not participate fully in the debate over the ultimate origins of humanity. That nation was England. Very simply, by the beginning of the second decade of the twentieth century, no fossils of human evolutionary significance had been located in England. This lack of fossils led French scientists to label English human paleontology mere "pebble-collecting" (Blinderman 1986).

The English, justifiably proud of their cultural heritage and cultural evolution, simply could point to no evidence that humanity had initially developed within their borders. The conclusion reached by most was completely unpalatable to the proud English—no one had evolved in England. The English must have originally arrived from somewhere else.

At the same time that the English were feeling like a people with no evolutionary roots of their own, many other Europeans were still uncomfortable with the fossil record as it stood in the first decade of the twentieth century. While most were happy to have human fossils in their countries, they were generally not happy with what those fossils looked like and what their appearance implied about the course of human evolution.

Java Man (now placed in the category *Homo erectus* along with Peking Man), with its small cranium—its volume was about 900 cubic centimeters (cc), compared to a modern human average of about 1,450 cc—and large eyebrow ridges, seemed quite apelike (see Figure 4.1). Neandertal Man, with his sloping forehead and thick, heavy brow ridges appeared to many to be quite ugly, stupid, and brutish. While the skulls of these fossil types were clearly not those of apes, they were equally clearly not fully human. On the other hand, the femur (thigh bone) of Java Man seemed identical to the modern form. While some emphasized what they perceived to be primitive characteristics of the postcranial skeleton of the Neandertals, this species clearly had walked on two feet; and apes do not.

All this evidence suggested that ancient human ancestors had primitive heads and, by implication, primitive brains, seated atop rather modern-looking bodies. This further implied that it was the human body that evolved first, followed only later by the development of the brain and associated human intelligence.

Such a picture was precisely the opposite of what many people had expected and hoped for. After all, it was argued, it is intelligence that most clearly and absolutely differentiates humanity from the rest of the animal kingdom. It is in our ability to think, to communicate, and to invent that we are most distant from our animal cousins. This being the case, it was assumed that such abilities must have been evolving the longest; in other words, the human brain and the ability to think must have evolved first. Thus, the argument went, the fossil evidence for evolution should show that the brain had expanded first, followed by the modernization of the body.

Such a view is exemplified in the writings of anatomist Grafton Elliot Smith. Smith said that what most characterized human evolution must have been the "steady and uniform development of the brain along a well-defined course . . ." (as quoted in Blinderman 1986:36). Arthur Smith Woodward, ichthyologist and paleontologist at the British Museum of Natural History, later characterized the human brain as "the most complex mechanism in existence. The growth of the brain preceded the refinement of the features and of the somatic characters in general" (Dawson and Woodward 1913).

Put most simply, many researchers in evolution were looking for fossil evidence of a creature with the body of an ape and the brain of a human being. What was being discovered, however, was the reverse; both Java and Neandertal Man seemed more to represent creatures with apelike, or certainly not humanlike, brains but with humanlike bodies. Many were uncomfortable with such a picture.

A Remarkable Discovery in Sussex

Thus was the stage set for the initially rather innocuous announcement that appeared in the British science journal *Nature* on December 5, 1912, concerning a fossil find in the Piltdown section of Sussex in southern England. The notice read, in part:

> Remains of a human skull and mandible, considered to belong to the early Pleistocene period, have been discovered by Mr. Charles Dawson in a gravel-deposit in the basin of the River Ouse, north of Lewes, Sussex. Much interest has been aroused in the specimen owing to the exactitude with which its geological age is said to have been fixed. . . . (p. 390)

In the December 19 issue of *Nature*, further details were provided concerning the important find:

> The fossil human skull and mandible to be described by Mr. Charles Dawson and Dr. Arthur Smith Woodward at the Geological Society as we go to press is the most important discovery of its kind hitherto made in England. The specimen was found in circumstances which seem to leave no doubt of its geological age, and the characters it shows are themselves sufficient to denote its extreme antiquity. (p. 438)

According to the story later told by those principally involved, in February 1912 Arthur Smith Woodward at the British Museum received a letter from Charles Dawson—a Sussex lawyer and amateur scientist. Woodward had previously worked with Dawson and knew him to be an extremely intelligent man with a keen interest in natural history. Dawson informed Woodward in the letter that he had come upon several fragments of a fossil human skull. The first piece had been discovered in 1908 by workers near the Barcombe Mills manor in the Piltdown region of Sussex, England. In 1911, a number of other pieces of the skull came to light in the same pit, along with a fossil hippopotamus bone and tooth.

In the letter to Woodward, Dawson expressed some excitement over the discovery and claimed to Woodward that the find was quite important and might even surpass the significance of Heidelberg Man, an important specimen found in Germany just the previous year.

Figure 4.2 This drawing with anatomical labels of the fragmentary remains of the Piltdown cranium appeared in a book written by one of the fossil's chief supporters. (From *The Evolution of Man*, by Grafton Elliot Smith, Oxford University Press)

Due to bad weather, Woodward was not immediately able to visit Piltdown. Dawson, undaunted, continued to work in the pit, finding fossil hippo and elephant teeth. Finally, in May 1912, he brought the fossil to Woodward at the museum. What Woodward saw was a skull that matched his own expectations and those of many others concerning what a human ancestor should look like. The skull, stained a dark brown from apparent age, seemed to be quite modern in many of its characteristics. The thickness of the bones of the skull, however, argued for a certain primitiveness. The association of the skull fragments with the bones of extinct animals implied that an ancient human ancestor indeed had inhabited England. By itself this was enormous news; at long last, England had a human fossil (Figure 4.2).

Things were to get even more exciting for English paleontologists. At the end of May 1912 Dawson, Woodward, and Pierre Teilhard de Chardin—a Jesuit priest with a great interest in geology, paleontology, and evolution whom Dawson had met in 1909—began a thorough archaeological excavation at the Piltdown site (Figure 4.3). More extinct animal remains and flint tools were recovered. The apparent age of the fossils based upon comparisons to other sites indicated not only that Piltdown was the earliest human fossil in England, but also that, at an estimated age of 500,000 years, the Piltdown fossil represented potentially the oldest known human ancestor in the world.

Then, to add to the excitement, Dawson discovered one half of the mandible. Though two key areas—the chin, and the condyle where the jaw connects to the skull—were missing, the preserved part did not look anything like a human jaw. The upright portion or *ramus* was too wide, and the bone too thick. In fact, the jaw looked remarkably like that of an ape (Figure 4.4). Nonetheless, and quite significantly, the molar teeth exhibited humanlike wear. The human jaw, lacking the large canines of apes, is free to move from side to side while chewing. The molars can grind in a sideways motion

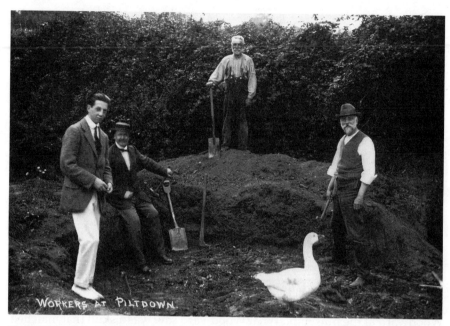

Figure 4.3 Paleontological excavations proceed at Piltdown. From left to right: Pierre Teilhard de Chardin, Charles Dawson, an unidentified workman, a goose, and Arthur Smith Woodward. (From the Archives of the British Museum [Natural History])

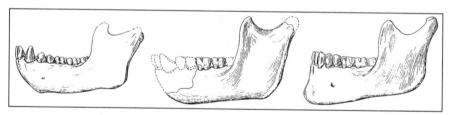

Figure 4.4 Comparison of the mandibles (lower jaws) of a young chimpanzee [left], modern human [right], and Piltdown [center]. Note how much more similar the Piltdown mandible is to that of the chimp, particularly in the absence of a chin. The presence of a chin is a uniquely human trait. (From Dawson and Woodward, 1913, The Geological Society of London)

in a manner impossible in monkeys or apes. The wear on human molars is, therefore, quite distinct from that of other primates. The Piltdown molars exhibited such humanlike wear in a jaw that was otherwise entirely apelike.

That the skull and the jaw had been found close together in the same geologically ancient deposit seemed to argue for the obvious conclusion that they belonged to the same ancient creature. But what kind of creature could it have been? There were no large brow ridges like those of Java or Neandertal Man. The face was flat as in modern humans and not snoutlike

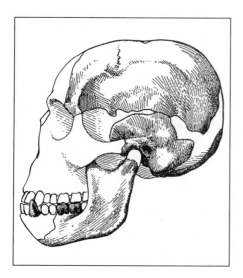

Figure 4.5 Drawn reconstruction of the Piltdown skull. The portion of the skull actually recovered is shaded. As reconstructed, the cranium shows hominid (human) traits and the mandible shows pongid (ape) traits. Compare this drawing to those in Figure 4.1. With its humanlike head and apelike jaw, the overall appearance of the Piltdown fossil is far different from *Homo erectus*, Neandertal, or modern humans. (From *The Evolution of Man*, Grafton Elliot Smith, Oxford University Press)

as in the Neandertals. The profile of the cranium was round as it is in modern humans, not flattened as it appeared to be in the Java and Neandertal specimens (Figure 4.5). According to Woodward, the size of the skull indicated a cranial capacity or brain size of at least 1,100 cc (Dawson and Woodward 1913), much larger than Java and within the range of modern humanity. Anatomist Arthur Keith (1913) suggested that the capacity of the skull was actually much larger, as much as 1,500 cc, placing it close to the modern mean. But the jaw, as described above, was entirely apelike.

The conclusion drawn first by Dawson, the discoverer, and then by Woodward, the professional scientist, was that the Piltdown fossil—called *Eoanthropus dawsoni*, meaning Dawson's Dawn Man—was the single most important fossil find yet made anywhere in the world. Concerning the Piltdown discovery, the *New York Times* headline of December 19, 1912, proclaimed "Paleolithic Skull Is a Missing Link." Three days later the *Times* headline read "Darwin Theory Is Proved True."

The implications were clear. Piltdown Man, with its modern skull, primitive jaw, and great age, was the evidence many human paleontologists had been searching for: an ancient man with a large brain, a modern-looking head, and primitive characteristics below the important brain. As anatomist G. E. Smith summarized it:

> The brain attained what may be termed the human rank when the jaws and face, and no doubt the body also, still retained much of the uncouthness of Man's simian ancestors. In other words, Man at first, so far as his general appearance and "build" are concerned, was merely an Ape with an overgrown brain. The importance of the Piltdown skull lies in the fact that it affords tangible confirmation of these inferences. (Smith 1927:105–6)

If Piltdown were the evolutionary "missing link" between apes and people, then neither Neandertal nor Java Man could be. Since Piltdown and Java Man lived at approximately the same time, Java might have been a more primitive offshoot of humanity that had become extinct. Since Neandertal was much more recent than Piltdown, yet looked more primitive where it really counted (that is, the head), Neandertal must have represented some sort of primitive throwback, an evolutionary anachronism (Figure 4.6).

By paleontological standards the implications were breathtaking. In one sweeping blow Piltdown had presented England with its first ancestral human fossil, it had shown that human fossils found elsewhere in the world were either primitive evolutionary offshoots or later throwbacks to a more primitive type, and it had forced the rewriting of the entire story of human evolution. Needless to say, many paleontologists, especially those in England, were enthralled by the discovery in Sussex.

In March 1913, Dawson and Woodward published the first detailed account of the characteristics and evolutionary implications of the Piltdown fossil. Again and again in their discussion, they pointed out the modern characteristics of the skull and the simian appearance of the mandible. Their comments regarding the modernity of the skull and the apelike characteristics of the jaw, as you will see, turned out to be accurate in a way that few suspected at the time.

Additional discoveries were made at Piltdown. In 1913 a right canine tooth apparently belonging to the jaw was discovered by Teilhard de Chardin. It matched almost exactly the canine that had previously been proposed for the Piltdown skull in the reconstruction produced at the British Museum of Natural History. Its apelike form and wear were precisely what had been expected: "If a comparative anatomist were fitting out *Eoanthropus* with a set of canines, he could not ask for anything more suitable than the tooth in question," stated Yale University professor George Grant MacCurdy (1914:159).

Additional artifacts, including a large bone implement, were found in 1914. Then, in 1915, Dawson wrote Woodward announcing spectacular evidence confirming the first discovery; fragments of another fossil human skull were found (possibly at a site just two miles from the first—Dawson never revealed the location). This skull, dubbed Piltdown II, looked just like the first with a rounded profile and thick cranial bones. Though no jaw was discovered, a molar recovered at the site bore the same pattern of wear as that seen in the first specimen.

Dawson died in 1916 and, for reasons not entirely clear, Woodward held back announcement of the second discovery until the following year. When the existence of a second specimen became known, many of those skeptical after the discovery of the first Piltdown fossil became supporters. One of those converted skeptics, Henry Fairfield Osborn, president of the American Museum of Natural History, suggested:

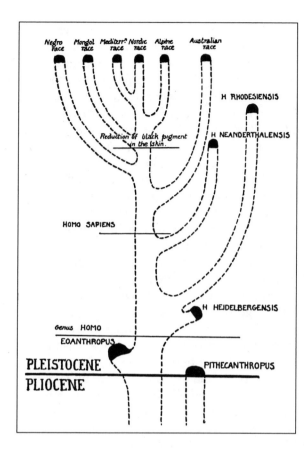

Figure 4.6 Among its supporters, *Eoanthropus* (Piltdown Man) was seen as more directly ancestral to modern humanity than either *Homo erectus*—here labeled *Pithecanthropus* and depicted as an entirely separate evolutionary pathway—or Neandertal—shown here as a short-lived diversion off the main branch of human evolution. (From *The Evolution of Man*, Grafton Elliot Smith, Oxford University Press)

If there is a Providence hanging over the affairs of prehistoric man, it certainly manifested itself in this case, because the three minute fragments of this second Piltdown man found by Dawson are exactly those which we should have selected to confirm the comparison with the original type. (1921:581)

The Piltdown Enigma

There certainly was no unanimity of opinion, however, concerning the significance of the Piltdown discoveries. The cranium was so humanlike and the jaw so apelike that some scientists maintained that they simply were the fossils of two different creatures; the skeptics suggested that the association of the human cranium and ape jaw was entirely coincidental. Gerrit S. Miller, Jr. (1915) of the Smithsonian Institution conducted a detailed analysis of casts of Piltdown I and concluded that the jaw was certainly that of an ape (see Figure 4.4). Many other scientists in the United States and Europe

agreed. Anatomy professor David Waterston (1913) at the University of London, King's College, thought the mandible was that of a chimpanzee. The very well-known German scientist Franz Weidenreich concluded that Piltdown I was " . . . the artificial combination of fragments of a modern-human braincase with an orangutan-like mandible and teeth" (1943:273).

Coincidentally or not, after Dawson's death no further discoveries were made in either the Piltdown I or II localities, though Woodward continued excavating at Piltdown through the 1920s. Elsewhere in the world, however, human paleontology became an increasingly exciting and fruitful endeavor. Beginning in the late 1920s as many as forty individuals of a species now called *Homo erectus* were unearthed at Zhoukoudian, a cave near Beijing in China (see Figure 4.1). Ironically, Davidson Black, anatomist at the Peking Union Medical College, who was instrumental in obtaining financial support for the excavation, had visited Grafton Elliot Smith's laboratory in 1914 and had become fascinated by the Piltdown find (Shapiro 1974). Further, Teilhard de Chardin participated in the excavation at the cave. The Zhoukoudian fossils were estimated to be one-half million years old. Also on Java, another large group of fossils (close to twenty) were found at Sangiran; these were similar to those from Zhoukoudian.

Also in the 1920s, in Africa, the discovery was made of a fossil given the name *Australopithecus africanus*. It was initially estimated to be more than one million years old. In the 1930s and 1940s additional finds of this and other varieties of *Australopithecus* were made. In Europe the number of Neandertal specimens kept increasing; and even in England, in 1935, a fossil human ancestor was discovered at a place called Swanscombe.

Unfortunately for *Eoanthropus*, all of these discoveries seemed to contradict its validity. The Chinese and Sangiran *Homo erectus* evidence pointed to a fossil ancestor with a humanlike body and primitive head; these specimens were quite similar to Java Man in appearance (Java Man is also now considered to belong to the species *Homo erectus*), possessing large brow ridges, a flat skull, and a thrust-forward face while being quite modern from the neck down. Even the much older australopithecines showed clear evidence of walking on two feet; their skeletons were remarkably human-like from the neck down, though their heads were quite apelike. Together, both of these species seemed to confirm the notion that human beings began their evolutionary history as upright apes, not as apelike people. *Eoanthropus* seemed more and more to be the evolutionary "odd man out."

How could Piltdown be explained in light of the new fossil evidence from China, Java, Europe, and Africa? Either Piltdown was a human ancestor, rendering all the manifold other discoveries members of extinct offshoots of the main line of human evolution, or else Piltdown was the remarkable coincidental find of the only known ape fossil in England within a few feet of a rather modern human skull that seemed to date back 500,000 years. Neither explanation sat well with many people.

Unmasking the Hoax

This sort of confusion characterized the status of Piltdown until 1949, when a new dating procedure was applied to the fossil. A measurement was made of the amount of the element fluorine in the bones. This was known to be a relative measure of the amount of time bone had been in the ground. Bones pick up fluorine in groundwater; the longer they have been buried, the more fluorine they have. Kenneth Oakley of the British Museum of Natural History conducted the test. While the fossil animal bones from the site showed varying amounts of fluorine, they exhibited as much as ten times more than did either the cranium or jaw of the fossil human. Piltdown Man, Oakley concluded, based on comparison to fluorine concentrations in bones at other sites in England, was no more than 50,000 years old (Oakley and Weiner 1955).

While this certainly cast Piltdown in a new light, the implications were just as mysterious; what was a fossil human doing with an entirely apelike jaw at a date as recent as 50,000 years ago? Then, in 1953 a more precise test was applied to larger samples of the cranium and jaw. The results were quite conclusive; the skull and jaw were of entirely different ages. The cranium possessed .10 percent fluorine, the mandible less than .03 percent (Oakley 1976). The inevitable conclusion was reached that the skull and jaw must have belonged to two different creatures.

As a result of this determination, a detailed reexamination of the fossil was conducted and the sad truth was finally revealed. The entire thing had been a hoax. The skull was that of a modern human being. Its appearance of age was due, at least in part, to its having been artificially chemically stained. The thickness of the bone may have been due to a pathological condition (Spencer 1984) or the result of a chemical treatment that had been applied, perhaps to make it appear older than it was (Montague 1960).

Those scientific supporters of *Eoanthropus* who previously had pointed out the apelike character of the jaw were more right than they could have imagined; it was, indeed, a doctored ape jaw, probably that of an orangutan. When Gerrit Miller of the Smithsonian Institution had commented on the broken condyle of the mandible by saying, "Deliberate malice could hardly have been more successful than the hazards of deposition in so breaking the fossils as to give free scope to individual judgement in fitting the parts together," (1915:1) he was using a literary device and not suggesting that anyone had purposely broken the jaw. But that is likely precisely what happened. An ape's jaw could never articulate with the base of a human skull, and so the area of connection had to be removed to give "free scope" to researchers to hypothesize how the cranium and jaw went together. Otherwise the hoax would never have succeeded. Beyond this, the molars had been filed down to artificially create the humanlike wear pattern. The canine tooth had been stained with an artist's pigment and filed down to

simulate human wear; the pulp cavity had been filled with a substance not unlike chewing gum.

It was further determined that at least one of the fragments of the Piltdown II skull was simply another piece of the first one. Oakley further concluded that all the other paleontological specimens had been planted at the site; some were probably found in England, but others had likely originated as far away as Malta and Tunisia. Some of the ostensible bone artifacts had been carved with a metal knife.

The verdict was clear; as Franz Weidenreich (1943) put it, Piltdown was like the chimera of Greek mythology—a monstrous combination of different creatures. The question of Piltdown's place in human evolution had been answered: it had no place. That left still open two important questions: who did it and why?

Whodunnit?

The most succinct answer that can be provided for the question "Whodunnit?" is "No one knows." It seems, however, that every writer on the subject has had a different opinion.

Each of the men who excavated at Piltdown has been accused at one time or another (Figure 4.7). Charles Dawson is an obvious suspect. He is the only person who was present at every discovery. He certainly gained notoriety; even the species name is *dawsoni*. Blinderman (1986) points out, however, that much of the evidence against Dawson is circumstantial and exaggerated. Dawson did indeed stain the fossil with potassium bichromate and iron ammonium sulfate. These gave the bones a more antique appearance, but such staining was fairly common. It was felt that these chemicals helped preserve fossil bone, and Dawson was quite open about having stained the Piltdown specimens. In an unrelated attack on his character, some have even accused Dawson of plagiarism in a book he wrote on Hastings Castle (Weiner 1955), but this seems to be unfair; as Blinderman points out, the book was explicitly a compilation of previous sources and Dawson did not attempt to take credit for the work of others.

Dawson's motive might have been the fame and notoriety that accrued to this amateur scientist who could command the attention of the world's most famous scholars. But there is no direct evidence concerning Dawson's guilt, and questions remain concerning his ability to fashion the fraud. And where would Dawson have obtained the orangutan jaw?

Arthur Smith Woodward certainly possessed the opportunity and expertise to pull off the fraud. His motive might have been to prove his particular view of human evolution. That makes little sense though, since he could not have expected the kind of confirming evidence he knew his colleagues would demand. Furthermore, his behavior after Dawson's death

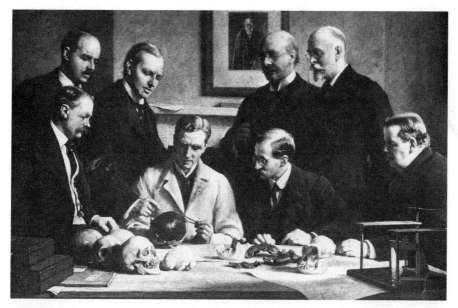

Figure 4.7 Portrait of scientists examining a number of specimens including *Eoanthropus* in 1915. From right to left, standing: A. S. Woodward, Charles Dawson, G. E. Smith, and F. O. Barlowe; from right to left, seated: E. R. Lankester, W. P. Pycraft, A. Keith, and A. S. Underwood. (From the Archives of the British Museum [Natural History])

seems to rule out Woodward as the hoaxer. His fruitlessly working the original Piltdown pit in his retirement renders this scenario nonsensical.

Even the priest Teilhard de Chardin has been accused, most recently by Harvard paleontologist and chronicler of the history of science Stephen Jay Gould (1980). The evidence marshalled against the Jesuit is entirely circumstantial, the argument strained. The mere facts that Teilhard mentioned Piltdown but little in his later writings on evolution and was confused about the precise chronology of discoveries in the pit do not add up to a convincing case.

Others have had fingers pointed at them. W. J. Sollas, a geology professor at Oxford and a strong supporter of Piltdown, has been accused from beyond the grave. In 1978, a tape-recorded statement made before his death by J. A. Douglass, who had worked in Sollas's lab for some thirty years, was made public. The only evidence provided is Douglass's testimony that on one occasion he came across a package containing the fossil-staining agent potassium bichromate in the lab—certainly not the kind of stuff to convince a jury to convict.

Even Sir Arthur Conan Doyle has come under the scrutiny of would-be Piltdown detectives. Doyle lived near Piltdown and is known to have visited the site at least once. He may have held a grudge against professional scientists who belittled his interest in and credulity concerning the

paranormal. Doyle, the creator of the most logical, rational mind in litera-
ture, Sherlock Holmes, found it quite reasonable that two young English
girls could take photographs of real fairies in their garden. But why would
Doyle strike out at paleontologists, who had nothing to do with criticizing
his acceptance of the occult? Again, there is no direct evidence to implicate
Doyle in the hoax.

The most recent name added to the roster of potential Piltdown hoax-
ers is that of Lewis Abbott, another amateur scientist and artifact collector.
Blinderman (1986) argues that Abbott is the most likely perpetrator. He had
an enormous ego and felt slighted by professional scientists. He claimed to
have been the one who directed Dawson to the pit at Piltdown and may even
have been with Dawson when Piltdown II was discovered (Dawson said
only that he had been with a friend when the bones were found). Abbott
knew how to make stone tools and so was capable of forging those found at
Piltdown. Again, however, the evidence, though tantalizing, includes no
smoking gun.

A definitive answer to the question "whodunnit" may never be forth-
coming. The lesson in Piltdown, though, is clear. Unlike the case for the
Cardiff Giant where scientists were not fooled, here many were convinced
by what appears to be, in hindsight, an inelegant fake. It shows quite clearly
that scientists, though striving to be objective observers and explainers of
the world around them, are, in the end, human. Many accepted the Pilt-
down evidence because they wished to—it supported a more comfortable
view of human evolution. Furthermore, perhaps out of naïveté, they could
not even conceive that a fellow thinker about human origins would wish to
trick them; the possibility that Piltdown was a fraud probably occurred to
few, if any, of them.

Nevertheless, the Piltdown story, rather than being a black mark
against science, instead shows how well it ultimately works. Even before its
unmasking, Piltdown had been consigned by most to a netherworld of
doubt. There was simply too much evidence supporting a different human
pedigree than that implied by Piltdown. Proving it a hoax was just the final
nail in the coffin lid for this fallacious fossil. As a result, though we may
never know the hoaxer's name, at least we know this: if the goal was to
forever confuse our understanding of the human evolutionary story, the
hoax ultimately was a failure.

CURRENT PERSPECTIVES
Human Evolution

With little more than a handful of cranial fragments, human paleonto-
logists defined an entire species, *Eoanthropus*, and recast the story of human

evolution. Later, in 1922, on the basis of a single fossil tooth found in Nebraska, an ancient species of man, *Hesperopithecus*, was defined. It was presumed to be as old as any hominid species found in the Old World and convinced some that then-current evolutionary models needed to be overhauled. The tooth turned out to belong to an ancient pig. Even in the case of Peking Man, the species was defined and initially named *Sinanthropus pekinensis* on the basis of only two teeth.

Today, the situation in human paleontology is quite different. The tapestry of our human evolutionary history is no longer woven with the filaments of a small handful of gauzy threads. We can now base our evolutionary scenarios (Figure 4.8) on enormous quantities of data supplied by several fields of science (see Feder and Park 1989 for a detailed summary of current thinking on human evolution).

Australopithecus afarensis, for example, the oldest known hominid, dating to more than 3.5 million years ago, is represented by more than a dozen fossil individuals. The most famous specimen, known as "Lucy," is more than 40 percent complete. Its pelvis is remarkably modern and provides clear evidence of its upright, and therefore humanlike, posture. Its skull, on the other hand, is quite apelike and contained a brain the size of a chimpanzee's. We even have a preserved pathway of footprints dating to the time when Lucy and her cohorts walked the earth, showing as dramatically as possible that they did so in a bipedal, humanlike fashion.

Homo erectus is known from dozens of individuals—forty from

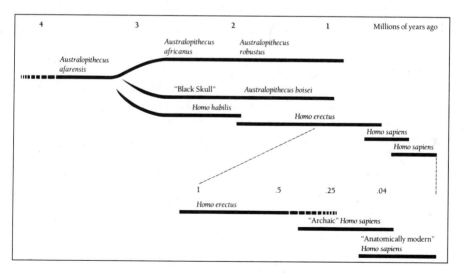

Figure 4.8 Current human evolutionary chronologies are based on a large body of paleontological, archaeological, and genetic data. There is no room for—and no need for—a precociously large-brained human ancestor like *Eoanthropus* in the human pedigree. (From *Human Antiquity*, Feder and Park, Mayfield Publishing)

Zhoukoudian alone, nearly twenty from Java, and more than a dozen from Africa. In Kenya, the 80 percent complete skeleton of a twelve-year-old *Homo erectus* boy has been dated to more than 1.5 million years ago.

Archaic forms of *Homo sapiens*, especially the famous Neandertals, number in the hundreds. The fossil human record is rich and growing. Our evolutionary scenarios are based, not on a handful of fragmentary bones, but on the remains of hundreds of individuals. Grafton Elliot Smith, Arthur Smith Woodward, and the others were quite wrong. The abundant evidence shows very clearly that human evolutionary history is characterized by the precedence of upright posture and the tardy development of the brain. It now appears that while our ancestors developed upright posture and humanlike bodies more than 3.5 million years ago, the modern human brain did not develop until as recently as 100,000 years ago.

Beyond this, human paleontologists are no longer restricted solely to the paleontological record. Exciting techniques of genetic analysis have allowed scientists to develop measures of difference between living species, including humans and our nearest extant relatives, the apes. Genetic "clocks" have been crafted from the results of such techniques.

For example, through DNA hybridization, scientists can quantify the difference between the genetic codes of people and chimpanzees. Here, an attempt is made to bond human and chimp DNA, much in the way the separate strands of the DNA double helix bond to produce the genetic code for a single organism. It turns out that the DNA of our two species is so similar that we can form a nearly complete bond. The opinion of most is that our two species could have split evolutionarily no more than five or six million years ago.

New dating techniques based on radioactive half-lives, biomechanical analysis of bones, scanning electron microscopy in bone and artifact examination, and many other new forms of analysis all make our evolutionary scenarios more concrete. It is to be expected that ideas will change as new data are collected and new analytical techniques are developed. Certainly our current views will be fine-tuned, and perhaps even drastic changes of opinion will take place. This is the nature of science. It is fair to suggest, however, that no longer could a handful of enigmatic bones that contradicted our mutually supportive paleontological, cultural, and genetic data bases cause us to unravel and reweave our evolutionary tapestry. Today, the discovery of a Piltdown Man likely would fool few.

WHO DISCOVERED AMERICA?

In 1992 we will commemorate the five hundredth anniversary of the voyage of Christopher Columbus in search of a western route to the Orient. His accidental, but certainly auspicious, discovery of a new world will be commemorated with a world exposition to be held in Seville, Spain.

As part of the preparation for the celebration, in 1982 a group of Latin-American representatives to the United Nations proposed a resolution to officially honor the great explorer for his achievement of discovering a new world and changing the course of history.

It was a simple, symbolic gesture in a body that certainly had more concrete concerns. Nevertheless, it caused quite a stir. Initially, Ireland's ambassador objected, claiming that a sixth-century Irish monk discovered America first. The representative from Iceland chimed in, asserting that the Viking Leif Eirikson had sailed to the New World five hundred years before Columbus. Next, African delegates asserted that prehistoric African navigators had also traversed the Atlantic, discovering the Americas long before Columbus. Though part of the debate was largely tongue-in-cheek, it can be said that even in the 1980s, even in the United Nations, and even in terms of a purely symbolic gesture, controversy erupts when the question posed in the title of this chapter is asked.

Ironically, the answer to this question is, at least in one sense, quite clear. Who discovered America? The American Indians did. In Chapter 6 we will be assessing various claims and arguments concerning whether Columbus was the first *non-Indian* to explore the Western Hemisphere. There is, however, little argument on this often-ignored point; even by the most conservative estimate, ancestors of modern American Indians first

entered the New World 12,000 years ago, thousands of years before any of the European, African, or Chinese contenders for the title "America's Discoverer."

So, from the perspective of native Americans, the question ultimately is moot. Whether you support the priority of Columbus's voyages of discovery or believe that Portuguese explorers made New World landfalls some decades before Columbus (Morison 1940); whether you find the evidence compelling that a Welsh nobleman, Madoc, traveled to and established colonies in North America in A.D. 1170 (Deacon 1966) or accept the Viking sagas that suggest North American exploration sometime around A.D. 1000 (Jones 1982); if you believe the claims that an Irish monk by the name of Brendan explored the North American coast in the sixth century (Ashe 1971) or that Chinese mariners visited the coast of California in A.D. 500 (Frost 1982); or even if you find reasonable the claims of a Libyan presence in the New World more than 5,000 years ago, Iberians about 3,000 years ago, and Celts 2,500 years ago (Fell 1976, 1980), it makes little difference. American Indians were already here to greet the latecomers, whether European, African, or Chinese. Whatever the evidence (or lack thereof) ostensibly supporting any of these claims, it is the Indians upon whom we must rightfully bestow the title "America's Discoverers."

The anthropological question that should concern us is not "Who discovered America?" but where did the Indians, who clearly were the first people to enter and settle America, come from? This very question was, in fact, asked by European scholars soon after they became aware of the existence of American Indians.

The Discovery of a New World

It has been said about Columbus that he was a man who, on beginning his great voyage, didn't know where he was going; upon reaching his destination, didn't know where he was; and upon returning, didn't know where he had been. For his trouble, the capital of Ohio is named for him.

This cynical view does not adequately recognize the enormity of his accomplishments nor his bravery and skills. Between 1492 and 1502–3, Columbus made four separate voyages to the New World (Figure 5.1). On the first and second of these he made landfalls on "San Salvador" (today identified as Watlings Island or, possibly, Samana Cay), Cuba, and Haiti (Marden 1986). On the third and fourth voyages, a landfall was made on the coast of South America, and a large section of the coast of Middle America (Panama, Costa Rica, and Honduras) was explored (Fernandez-Armesto 1974). His navigational skills and, just as importantly, his tenacity in the face of adverse circumstances allowed Columbus to succeed in trans-Atlantic

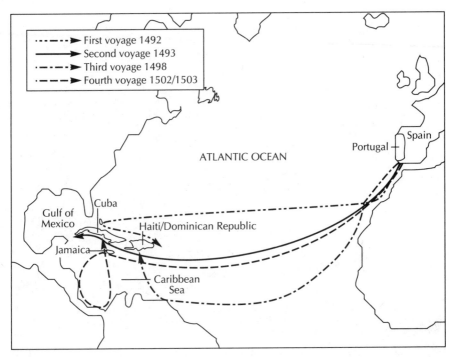

Figure 5.1 Routes taken by Columbus in his four voyages of exploration of the New World in 1492, 1493, 1498, and 1502–3. Columbus never gave up hope that he had discovered either the coast of Japan or China or lands immediately adjacent to the Orient.

crossings, where several Portuguese navigators who had attempted the trip before him had almost certainly failed (Morison 1940).

But, as great as Columbus's achievement was, he certainly was not the first discoverer of America; the Indians were. When Columbus landed on San Salvador, Cuba, Haiti, and virtually everywhere else he explored, he came into contact with large numbers of indigenous people (Figure 5.2). The source of American Indian populations, however, was not a major issue for Columbus or fifteenth-century scholars in general. As Huddleston has pointed out, "Columbus did not question the existence of men in the New World because he did not know it was a New World" (1967:5).

Remember, Columbus was seeking a route to the Orient. Despite the legend, most people in the fifteenth century did not still believe the world to be flat; there was little expectation Columbus would sail off the edge of the earth. It simply was unknown to Europeans how large the spherical earth was or if the sea to the west was navigable all the way to the Orient already described by Marco Polo, who had journeyed there from the other direction in the thirteenth century.

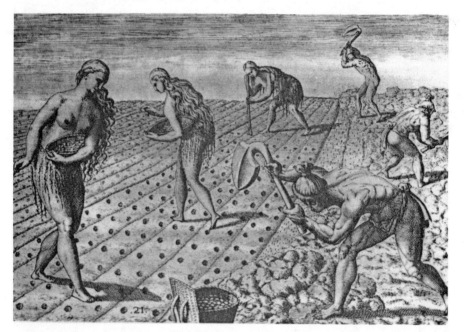

Figure 5.2 Columbus and those explorers who followed him to the New World all reported the presence of people previously unknown to Europeans—people whose existence demanded explanation within a biblical framework. Here sixteenth-century illustrator Theodore de Bry depicts natives of North America planting corn.

Though he did not understand that he had accidentally discovered the Western Hemisphere during his first voyage, Columbus did come to realize that he had not successfully reached his hoped-for destination of Cathay (China) or Cipangu (Japan). For a short time during the first voyage, he thought that Cuba was a part of mainland Asia (Fuson 1987), but he soon concluded that it was, in fact, an island. Nevertheless, he remained convinced that Cuba and the other islands he explored lay in proximity to the Asian mainland.

Unfortunately, the three subsequent voyages by Columbus resulted in no indisputable Asian landfall and seemed to deflate the notion that China and Japan were just a little further west. Columbus became so frustrated by his apparent failure to find a new route to the Orient as he had promised that, during the second voyage in 1498, he greatly overestimated (falsified?) the length of the coast of Cuba in his records. He went so far as to force his men to swear an oath stating that Cuba (called Juana in the log) was, in fact, not an island, but a continental land mass and therefore a part of Asia (Fernandez-Armesto 1974:129).

Columbus, convinced he had at least explored a number of islands off the Asian mainland, thought the people he encountered were Asians. To be

sure, in one of the published accounts of his discoveries, the *Letter to Sanchez*, Columbus does pass on a story of a tailed race of people in an area he did not visit (Major 1961:11). Nonetheless, everywhere else in his records, it is clear he believed the natives were ordinary Asians. Later, Columbus waffled on the location and nature of the lands he explored in his four voyages. In the final analysis, he simply wasn't sure what he had discovered. He spent his last days maintaining that he had, in fact, made landfalls on the coast of Asia.

Others in Europe, however, had become convinced that Columbus had discovered something far more intriguing than a western route to the Orient. There was growing sentiment that Columbus had discovered, as Amerigo Vespucci called it for the first time in print in 1503, "a *new world*, because none of these countries were known to our ancestors" (Hakluyt Society 1904). When Magellan circumnavigated the globe in 1530 it became clear that Columbus had indeed discovered a "new world."

Biblical Exegesis and American Indians

If the lands explored by Columbus were not part of Asia, then the natives were not Asians, but some heretofore unknown group of people. This idea was problematical to sixteenth-century scholars and clerics. In their world view, all people could be traced to Adam and Eve. Beyond this, all people could be more recently traced to Noah and his family (his wife, sons, and daughters-in-law), for all other descendants of the first couple had been wiped out in a great flood (see Chapter 11).

According to the Book of Genesis in the Old Testament, Noah had three sons, Shem, Ham, and Japheth. Biblical scholars had long since decided that each of the three sons represented the source for the three "races" of man recognized by Europeans: European, Oriental, and African. Japheth, apparently the best of the lot, was, naturally enough, considered to be the patriarch of the European people. Shem gave rise to the Asians, and Ham was the source for Africans. This was a neat enough arrangement for biblical literalists, but the recognition that the native people Columbus had encountered were not Chinese or Japanese created a problem. There simply was no *fourth son* of Noah to provide a source for a *fourth race* of people. Though some, like Isaac de la Peyrère in 1655, suggested that Indians were part of a separate "pre-adamite" creation that had been unaffected by the biblical flood (Greene 1959), notions of polygenesis were never particularly popular.

For most, Indians were ordinary human beings descended first from Adam and later from Noah. If any doubted that, Pope Paul III in a papal bull released in 1537 made the opinion of the Church clear when he stated that, "the Indians are truly men and that they are not only capable of understanding the catholic faith but, according to our information, desire exceedingly to receive it" (as cited in Hanke 1937:72).

That led to the only general conclusion possible: the natives of the New World must have reached its shores sometime after the Flood and could, therefore, be traced to one of Noah's sons through a historically known group of people. For some three hundred years, European thinkers speculated about who that group might be.

American Indians: From Israelites to Atlanteans

One of the first to tackle the problem of the origin of the native people of America was a Spanish writer Oviedo (Huddleston 1967). In his *General and Natural History of the Indies* published in 1535, he suggested two possible sources for indigenous American populations: lost merchants from Carthage, a Mediterranean city-state of 2,000 years before, or the followers of King Hespéro, a Spanish king who fled Europe in 1658 B.C. The latter hypothesis was quite appealing to the Spanish, who could therefore assert that Columbus had only rediscovered and reclaimed that which the Spanish had already discovered and claimed.

Speculation concerning the source of American Indians accelerated after 1550. As shown in Chapter 8, Lopez de Gomara believed they were a remnant population from the Lost Continent of Atlantis. Historian Lee Huddleston (1967:32) maintains that, in terms of numbers of references to possible geographic sources in the middle years of the sixteenth century, Atlantis was the single most popular speculation.

In 1555, the Portuguese traveler Antonio Galvão (Galvaño) cited China as the source for Indians. He was rather precocious in noticing the physical similarities between Indians and Asians in terms of "their proportions, having small eies, flat noses, with other proportions to be seene" (Galvaño 1555:19). Indeed, it has been the biological study of American Indians that has shown, perhaps most clearly, that they are Asian in origin (Steward 1973; and see the "Current Perspectives" section of this chapter).

In 1580, Diego Duran suggested that the New World natives were descendants of the so-called Lost Tribes of Israel—ten of the twelve Hebrew tribes mentioned in the Bible were historically "lost." Duran enumerated traits that he felt Indians and Jews had in common: circumcision, stories about plagues, long journeys, and the like.

It was not until Rabbi Manasseh ben Israel wrote *The Hope of Israel* in 1650, however, that the Lost Tribes hypothesis achieved widespread popularity (Huddleston 1967). *The Hope of Israel* was quite popular and spawned many similar volumes. In it, the practices, ceremonies, beliefs, stories, and even languages of individual groups of Indians were identified as being Jewish in origin. Ben Israel went so far as to claim that the Indians were still practicing Jews, but were keeping it secret from the Spanish, having heard of the Inquisition.

Joseph de Acosta and Gregoria Garcia

From our modern perspective, perhaps the most important work focusing on the origin of the Indians was *The Natural and Moral History of the Indies*, by Friar Joseph de Acosta, published in 1590. The book is a remarkably perceptive, scientific examination of the question of Indian origins.

Acosta spent seventeen years as a Jesuit missionary in Peru beginning in 1570. He recognized that however people came to the New World and wherever they came from, animals came with them since the Americas were teaming with animals. But this could have been no purposeful importation of animals , since predators like wolves and foxes were present in the New World. People clearly would not have brought such animals with them. Acosta deduced that such animals must have traveled here by themselves.

Acosta then made a simple, yet significant deduction; if animals could migrate on their own to the New World from the Old—where they must have journeyed from after the Flood, since Noah's Ark came to rest on "the mountains of Ararat," somewhere in western Asia—then "the new world we call the Indies is not completely divided and separated from the other world" (Acosta, as cited in Huddleston 1967:50).

Thus the Old and New Worlds must be connected; animals could simply walk from the Old World to the New, and people would have come to the Americas the same way. Based on geographical knowledge of his day, Acosta even proposed where such a connection might be found—northeast Asia/northwest North America. Acosta suggested this almost 140 years before the Russian explorer Bering found that the Old and New Worlds are there separated by less than 100 miles of water (Figure 5.3).

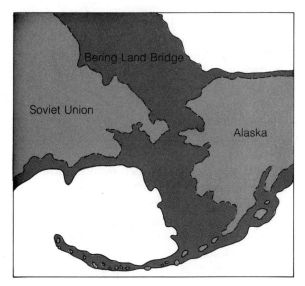

Figure 5.3 During parts of the Pleistocene Epoch, sea level dropped substantially as water evaporated from the world's oceans, fell as snow in northern latitudes and higher elevations, and did not melt but produced glaciers. This drop in sea level produced land connections like the Bering Land Bridge—a 1,500-km-wide platform of land connecting northeast Asia and northwest North America. The Bering Land Bridge provided access to the New World for animals and people in the Old World. (From *Human Antiquity*, Feder and Park, Mayfield Publishing)

Acosta's argument was remarkable for its objectivity and solid reasoning. Furthermore, it did not contradict a literal interpretation of the Bible—it was, after all, based on the assumption that all animals in the New World were descended from those saved on board the Ark.

Nevertheless, Acosta's book was not as popular as the work of a far more credulous colleague, Gregoria Garcia, who wrote his *Origins of the Indians* in 1607. Garcia listed sources for American Indians and seemed to accept them all: Lost Tribes of Israelites, ancient Spanish kings, homeless Atlanteans, not to mention globe-trotting Greeks, Norwegians, Chinese, Tartars, and Scythians. It made little apparent difference to Garcia; they *all* discovered America.

Rather than employing a deductive approach like Acosta, Garcia used a purely inductive method. He cited supposedly specific behaviors or practices of particular Asian, European, and African groups that were found in particular places in the New World and traced Indians to those Old World groups.

Tracing the Movement
of Ancient People

Tracing People By Their Culture

What Garcia, ben Israel, and most other European scholars based their tracing of American Indian cultures on were *trait list comparisons*. They hunted through descriptions of Indian cultures, seeking practices, beliefs, and even linguistic elements that were reminiscent of those in some Old World group. Where similarities were found, it was felt that a source for the American population had been identified.

Certainly, there is some logic to cultural comparison. Within the context of American society, we recognize that immigrants and their descendants often maintain traditions from their homelands. Religious practices, holiday celebrations, craftwork, clothing, and even language may persist for generations. Jews speaking Yiddish, African-Americans wearing *dashikis*, and Puerto Ricans celebrating Three Kings Day are all examples of such cultural persistence.

In these three examples and in the myriad others that could be presented, the connections between the practices of immigrants and those of their homelands are clear, specific, and detailed. Each occurs within an overall cultural context of many other persistent practices.

The evidence marshalled by European scholars in previous centuries regarding the source of American Indian populations is very different. Often, the similarities they saw were vague, generic, and biased. For example, Garcia contended that both Jews and Indians are cowardly, that neither believes in the miracles of Christ, that both are uncharitable, that

they are ungrateful, love silver, and so on (as cited in Steward 1973). These aspersions, which reflect more on Garcia's attitudes than on either native American or Jewish behavior, were taken as evidence of a connection between the two peoples.

Archaeologist David L. Clarke (1978:424) has suggested that trait list comparisons can be used to trace population movements only when certain requirements of the data are met. The traits must be specifically the same, not just vaguely similar. The traits being compared cannot be isolated behaviors. They must be part of entire complexes of traits, all of which are reflected in the supposed source and immigrant populations. The traits must co-occur repeatedly both physically and chronologically. The similarities must be so complete that the likelihood that they resulted from coincidentally parallel development or functional necessity would be minimal.

So, for example, a simple trait like circumcision, practiced by Jews as well as the Inca, does not, by itself, necessarily prove anything. The cultural/religious context and meaning of the practice in the two groups turns out to be entirely different. It is such a general trait and so many people all over the world practice it that we would quickly run out of Lost Tribes if we tried to trace them to all world cultures that circumcised their male infants.

Archaeologist John Rowe (1966) performed a wonderful exercise that shows the inadequacy of trait list comparisons. He compiled a list of sixty practices and artifacts held in common by ancient South American civilizations and the kingdoms of Europe before the Middle Ages. Some of the common traits include animal sacrifice, belief in mythically combined animals, sister marriage, cubical dice, copper tweezers, and eunuchs. Yet, there was no known contact between these cultures separated by thousands of miles of land and ocean. Rowe purposely selected traits extracted from their cultural contexts, practices dating from different time periods, and behaviors present in a few widely separated European groups and similarly few, widely separated native American groups. And this is precisely the nature of the comparisons between Old and New World cultures made by the great majority of European thinkers in earlier centuries.

Tracing People By Their Biology

Another way that archaeologists and anthropologists can trace the movement of people is by the biological analysis of the people or their skeletal remains. The human species is polymorphic; we come in different colors, shapes, and sizes. There are variations in blood type, skeletal morphology, tooth shape, and so on.

These variations are not randomly distributed across the earth, but are geographically patterned. Some of the differences are due to the forces of natural selection, some are random. While certainly European scholars did not have a detailed understanding of human biological variation, some did

notice the physical similarities between American Indians and Asians. For example, when Galvão, cited previously, traced Indians to China as a result of their "small eies," he almost certainly was referring to the presence of the *epicanthic fold* of skin on the eyelids of Asian peoples and American Indians, but absent in Europeans and Africans.

We now have many procedures for analyzing skeletons, blood proteins, and DNA. These can all help us trace immigrant populations to their biological/geographical sources (see also the "Current Perspectives" section of this chapter).

Tracing People By Their Materials

It also is possible to trace the movement of people—or, at least the movement of their objects—through physics. Simply, in many cases the raw materials people used to manufacture their stone, ceramic, or metal artifacts come from geographically limited and physically distinguishable sources. For example, in a technique called *neutron activation analysis*, trace amounts of impurities can be measured in stone, clay, or other raw materials. The precise amounts of these trace elements (often measured in parts per million) provide a sort of signature for different sources of raw material. Such signatures can be used to connect an artifact to a raw material source. For example, obsidian (natural, volcanic glass that was highly prized the world over for making very sharp stone tools) from Turkey and Idaho may look virtually identical, but will have extremely different trace element profiles. By using this technique, the movement of obsidian from its various sources has been traced in both the Old and New Worlds.

If American Indians had been from a lost Israelite tribe or from Rome or Egypt, archaeologists would likely have found artifacts brought by such peoples from their homelands and made from raw materials traceable to their Old World sources. That such a find has never been made is a strong argument against such a scenario.

Out of Asia

Ultimately, Acosta's reasoning in *The Natural and Moral History of the Indies* was so sound that it could not be ignored. Rather than relying on scattershot cultural comparisons or unverifiable transoceanic crossings, it was constructed on a solid geographical foundation. Slowly, as geographical knowledge of the northern Pacific grew, it gained acceptance. By 1794, Father Ignaz Pfefferkorn could say in reference to the narrow slip of water separating Asia from America, "it is almost certain that the first inhabitants of America really came by way of the strait" (as cited in Ives 1956:421). The people whom Columbus encountered had been Asians after all—but sepa-

rated by thousands of miles and thousands of years from the people of
Cathay and Cipangu.

An "American Genesis"?

The notion that American Indians came to the New World from Asia can be
traced as far back as Acosta, who wrote nearly four hundred years ago.
Though archaeologists still argue about the timing of this migration, they
virtually all agree that American Indians are Asians who came to the New
World via the area today known as the Bering Straits. This narrow and
shallow part of the Bering Sea is today a minor impediment to human
movement between the Asian and North American mainlands. In the past,
during the geological epoch known as the *Pleistocene* (Ice Age), travel be-
tween the two continents was even easier. During this epoch, marked by
episodes of worldwide climate much colder than those that occur at present,
large bodies of ice called glaciers covered much of the surface of North
America and Europe. This ice came from water that had evaporated from
the world's oceans. As a result, worldwide sea level dropped as much as 150
meters, exposing large amounts of land previously and presently under
water. A 1,500-kilometer-wide land platform called *Beringia* or the Bering
Land Bridge was exposed, connecting Asia and North America (see Figure
5.3). It is across Beringia that animals and people from Asia crossed over
into the New World.

This scenario is well supported by geological, meteorological, biologi-
cal, anthropological, and archaeological evidence (Hopkins et al. 1982; West
1981). Sadly, however, a writer with a degree in anthropology has appar-
ently ignored most of these data and produced a popular work that most
anthropologists would label as speculative fiction.

The *Chicago Tribune* headline read "Anthropologist Stuns Anthropo-
logical World." The article referred to the argument set forth by anthropolo-
gist Jeffrey Goodman in his book *American Genesis*. Goodman (1981) wrote
that American Indians had not come from Asia by way of the Bering Land
Bridge after all. In fact, Goodman asserted that Asians and, ultimately,
everyone else in the world had originated in North America—in California,
to be precise, which Goodman suggests was the location of the Garden of
Eden (1981:4). Goodman asserts that modern human beings first appeared
in California as much as 500,000 years ago, predating the earliest known
modern-looking skeletal remains in the Old World by about 400,000 years.
According to him, these first people spread out from California, populating
the rest of the world (see Feder 1983 for a detailed critique).

Goodman goes on in *American Genesis* to make claims concerning the
great precocity of these first true human beings. Apparently we can credit
the ancient Americans with everything from pottery, insulin, and birth

control pills, to "the applied understanding of the physics behind Einstein's gravity waves" (Goodman 1981:178).

Although in *American Genesis* Goodman states that all people are derived from American Indians, he never suggests where the Indians came from. After all, more conservative anthropologists provide evidence of previous forms of humanity and evolutionary processes in their discussion of human origins. Since the earliest and most primitive of our prehistoric forebears are found in Africa, that continent is proposed as the source of our species (see the "Current Perspectives" section of Chapter 4).

It is no wonder Goodman did not address this issue in *American Genesis*, though he does pose the question: "Was modern man's world debut the result of slow development or the result of a quantum leap inspired from some outside source?" (1981:91). He does not answer that question in *American Genesis,* but he does in a previous book (Goodman 1977) that we will look at more closely in Chapter 10. There, discussing the inhabitants of an Arizona site that Goodman uses in *American Genesis* as key evidence that modern humanity originated in the New World some 500,000 years ago, Goodman passes on the information that the Arizona people came from the Lost Continent of Atlantis and its Pacific counterpart, Mu (1977:88). This hypothesis was at its peak in popularity in the sixteenth century. As I will show in Chapter 8, Atlantis never existed; it was as much of a fantasy as Goodman's argument of an American genesis.

CURRENT PERSPECTIVES
The Peopling of the Americas

Physical Anthropology

Human teeth exhibit a remarkable amount of variation. Though we all possess the same general kinds and numbers of teeth—cutting incisors, tearing canines, and grinding premolars and molars—within these categories there is quite a bit of variation from mouth to mouth. Approximately two dozen different traits can be used to characterize the variation in our teeth. Most of these relate to the form of our tooth crowns and roots. These variations in what our teeth look like exhibit geographical patterning.

Physical anthropologist Christy Turner has examined some 200,000 teeth from the New World (Turner 1987). He has found that American Indian teeth are most similar to the teeth of Asian people. For example, among American Indians, a particular form of incisor—so-called *shovel-shaped*—is found in between 65 and 100 percent of Indian populations in different parts of North and South America. The frequency of shovel-

shaping in Africans and Europeans has been measured at less than 20 percent. In eastern Asia, 65 to 90 percent of the people exhibit the trait.

The examination of other dental traits, including the number of cusps and roots on molar teeth, again shows the similarity of the teeth of Asians and native Americans. Other features of the skeleton exhibit the same pattern. So archaeologists can be fairly certain that the skeletons excavated from prehistoric sites in the Americas are those of Indians and that Indians are derived from Asia on the basis of their possession of the Mongoloid or *sinodont* pattern (Turner 1987:6).

Archaeology

Jeffrey Goodman notwithstanding, there is little debate concerning the source of American Indian populations. There is, however, still quite a bit of disagreement concerning when ancient Asians initially entered the New World (Meltzer 1989).

The archaeological evidence is clear on one point. There definitely were people in the New World by about 12,000 years ago. Soon after that date, a people called the *Paleo-Indians*, at least partially reliant on the hunting of large game animals that flourished during the end of the Pleistocene, spread throughout North America. From California to Nova Scotia, the evidence of their culture is well known to archaeologists (Jennings 1989).

Wherever they settled, they brought with them a stone tool called the *fluted point*, a beautifully fashioned stone spearpoint with channels or "flutes" on both faces (Figure 5.4). Though there is some variation, fluted points from the East (for example, the Vail site in Maine [Gramly 1982]) are quite

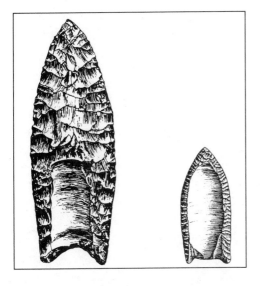

Figure 5.4 The best-known artifacts of the Paleo-Indians—12,000-year-old fluted or channeled spearpoints. The Clovis variety [left; from the Vail site in Maine] is often found in association with the remains of extinct elephants. The Folsom [right; from the Lindenmeier site in Colorado] is found with the remains of an extinct species of bison. (Left, courtesy of Michael Gramly and the Buffalo Museum of Science. Both points drawn by Val Waldorf.)

similar in basic design to those found in the West (for example, at the Lindenmeier site in Colorado [Wilmsen 1974]). The Paleo-Indians were clearly enormously successful in their adaptation to America of the late Pleistocene. Their descendants spread as far as the southern tip of South America where their remains date to about 9,000 years ago.

There is some intriguing evidence, not indisputable, that the Paleo-Indians were not the first people in the Americas. For example, in São Raimundo Nonato, Brazil, depictions of animals like deer and armadillos cover the rock faces of the surrounding cliffs (Guidon 1987). Fragments of the paintings have fallen into archaeological deposits that have been dated to 30,000 years ago. In the Canadian Yukon, a tool made from a caribou bone has yielded a radiocarbon date of about 30,000 years ago—and another date of 1,400 years ago (Irving 1987). In one of the most thoroughly investigated sites, the Meadowcroft Rockshelter in western Pennsylvania, a sequence of dates going back as far as 19,000 years has been derived (Adovasio et al. 1983). There even are claims of sites approaching 250,000 years ago from California (Simpson 1978).

These are all exciting possibilities, but not convincing. For example, the Calico Hills site in California that is purported to be 250,000 or more years old is, in the opinion of some, not a site at all (Haynes 1988). The geology of the area is conducive to the creation of geofacts—naturally broken rocks that mimic the appearance of artifacts. In the case of the carbon dates from Meadowcroft, there is the problem of possible contamination by natural coal, giving the dated materials the appearance of much greater age.

Though it must be admitted that the debate on these points has sometimes been acrimonious, at least those on either side of the debate—and those in between—recognize the same rules of evidence and attempt to live by them. There are no appeals to divine inspiration and no references to nonexistent lost continents. All the players in the game agree that the search for pre–Paleo-Indian evidence is worthwhile. And all abide by the rules of science.

6

After the Indians, Before Columbus?

In Chapter 5, the question "Who discovered America?" was answered quite simply: American Indians discovered America. A question we left unanswered, though, is, "Were there other 'discoveries' of America between those of the Asian ancestors of the American Indians at least 12,000 years ago and Columbus in 1492?"

The list of proposed pre-Columbian explorers of the New World is long, and there is no reason to presume that such voyages of exploration were entirely impossible. Some writers have gone so far as to suggest that many European, Asian, and African groups regularly visited the Americas, settled here, and had commerce with the Indians long before Columbus (Gladwin 1947; Gordon 1974). The burden of proof, however, must be on those who support such hypotheses.

Unfortunately, as we will see, history is often vague on this issue, and many of the claims of discovery and settlement of America are based, ultimately, on interpretations of legends. In the final analysis, legends, however suggestive, are alone unsatisfying. The archaeological record, with its contribution of physical evidence, must be the ultimate arbiter of debates concerning who "discovered" the Americas after the Indians and before Columbus. Let's examine some of the evidence for the best known of the pre-Columbian possibilities. While we cannot here examine each and every claim, we do not need to. The same perspective can be applied, and the same criteria as those employed here must be used in assessing any hypothesis regarding the pre-Columbian discovery of the New World.

71

St. Brendan and
His Ox-hide Boat

St. Brendan was an Irish priest who lived during the late fifth and early sixth centuries A.D. According to legend, Brendan was supposed to have embarked on a seven-year trip westward into the Atlantic Ocean. Three centuries later, his adventures were recorded in a work called the *Navigatio* (Ashe 1971).

According to that work, Brendan encountered various animals, people, places, and phenomena in his voyages: sea-cats, pygmies, giant sheep, talking birds, sea-monsters, floating columns of crystal, curdled sea, smoking mountains, and a place called the *"Land Promised to the Saints"*. Some of the descriptions, though fanciful, may reflect actual events, phenomena, and places (Figure 6.1).

The details of the crystal columns provided in the *Navigatio*, for example, indicate that they were icebergs. The smoking mountains likely were volcanoes. Some of the more mundane parts of the *Navigatio* seem to describe actual islands in the northern Atlantic; a few of these islands can be identified with a degree of confidence simply by reference to the descriptions provided in the *Navigatio* (Ashe 1971:34–38).

Based on documentary and archaeological evidence, it is clear that wandering Irish monks called *anchorites* had indeed accomplished some rather remarkable feats of navigation in the sixth through eighth centuries A.D. (see Figure 6.1). Searching for places of quiet solitude where they could worship God, they discovered and settled the Orkney Islands in A.D. 579, the Shetlands in 620, and the Faeroes in 670 (Ashe 1971:24). They even beat the Vikings to Iceland, settling it in A.D. 795; the Viking sagas to be discussed later in this chapter mention the presence of these monks upon the arrival of the Norse.

Much is uncertain, however, about Brendan and his itinerary. He probably was an actual person, and he likely was a proficient sailor. But it is not clear how much of the *Navigatio* story was of a real voyage by Brendan, how much was an amalgam of numerous other voyages by other priests, how much was hyperbole, and how much was purely fantasy.

It is Ashe's well-reasoned opinion that much of the *Navigatio* was factual, whether it related to a specific voyage of a specific monk or not. The descriptions of various islands and natural features, though clearly viewed through the prism of a sixth-century perspective of the world, are often reasonable and recognizable.

However, as Ashe points out, when the so-called *Land Promised to the Saints*, identified by some as America, is described in the *Navigatio*, the literary style and content change considerably. The description is far more vague than for other places mentioned and sounds fantastic in the literal sense of that word. Though an experiment showed that a *curragh*, the name

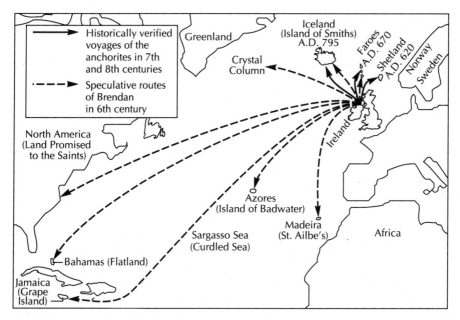

Figure 6.1 Map depicting the actual routes of exploration of Irish priests and proposed routes of Brendan in the sixth century A.D.

given to the hide boats of the Irish, could traverse the Atlantic intact (Severin 1977), there is ultimately no evidence that Brendan actually landed upon the shores of America. No archaeological evidence has ever been discovered in the New World that indicates the presence in this hemisphere of sixth-century Irish monks. Without such evidence, the story of Brendan remains simply an interesting legend.

Fusang: The Chinese Discovery of America?

In 1973, a vessel dredging off the coast of California brought up a sizeable rock, carved into the shape of a doughnut. In 1975, twenty or so similar stones were found by divers off the Palos Verdes peninsula in southern California. These discoveries generated a great deal of publicity at the time. Some suggested that the stones were identical to anchor stones used on Chinese sailing vessels as far back as A.D. 500. Reference was made to the Chinese legend of the land of *Fusang*, supposedly visited by a Buddhist monk about 1,500 years ago.

As Frost (1982) points out, Fusang was placed on the Asian coast by ancient Chinese mapmakers. Nevertheless, some have tried to identify

Fusang as America, carefully selecting elements of the legend that seem to reflect the biogeography of the California coast. Even some professional archaeologists suggested that the Palos Verdes anchor stones represented physical evidence of the ancient Chinese exploration of the west coast of North America.

The Palos Verdes stones were examined by the geology department at the University of California, Santa Barbara, in 1980. Remember our discussion in Chapter 5 concerning tracing the raw materials from which ancient artifacts were made. If the anchor stones could be shown to have been made from rock present only in China, the case for a Chinese presence in the New World before Columbus would be much stronger. Unfortunately for the supporters of this hypothesis, it was determined that the alleged Chinese anchors were made of California rock (Frost 1982:26), most likely Monterey shale, a common local rock type.

The stones looked like Chinese anchors, however, because that is precisely what they were. Chinese-American fishermen commonly trawled the waters of California in the nineteenth century. They sailed in their traditional craft, the junk. Indeed, the Palos Verdes stones are almost certainly the anchors, moorings, and net weights of these fishermen. They provide no help to those who wish to prove that Fusang is, in reality, California.

Prince Madoc and Welshmen in the New World

In the middle 1960s, the Daughters of the American Revolution erected a historical marker on the shore of Mobile Bay in Alabama. It reads, in part: "In memory of Prince Madoc, a world explorer who landed on the shores of Mobile Bay in 1170 and left behind, with the Indians, the Welsh language."

Madoc himself appears to have been an actual historical personality who lived in the twelfth century A.D. He was a renowned or, more accurately, legendary sailor. In one of the stories about his exploits, he is alleged to have sailed westward from Wales in about A.D. 1170 and discovered a new land. Depending on which version of the story suits you, he either never returned, or did come back, making several trips to this new land and bringing hundreds of Welsh settlers to the territory he had discovered.

This legend of discovery and colonization grew in popularity as northern Europeans began to settle the American Southeast and Midwest. Interestingly, as Richard Deacon (1966)—who accepts the historicity of Madoc's travels—admits, it was with the influx of Welsh emigrants to these very areas in North America that stories propagated of blue-eyed, light-skinned, Welsh-speaking Indians.

Unfortunately, many of the stories Deacon and other Madoc supporters relate are secondhand and contradict each other. We can read breathless

accounts published in the eighteenth century of the Navajo, Cherokee, Aztec, or Mandan Indians being indistinguishable in culture, language, and skin tone from Welshmen. In many of these stories we see an underlying racist theme similar to that to be discussed in reference to the *Moundbuilder myth* in Chapter 7; where Indian villages are clean, where their houses are well made and streets neatly laid out, even where agriculture is the primary mode of subsistence, it is presumed that the Indians must really be Europeans. With a ready-made legend like that of the Welsh voyage(s), it was natural to associate those groups with Madoc and his band of travelers.

There is, however, one variety of physical, archaeological evidence presented by the Madoc supporters. These supposed confirming data consist of the ridgetop stone forts of Kentucky and Tennessee. In fact, Deacon (1966:202) attempts to trace Madoc's route in America from Mobile Bay, up the Alabama River into Kentucky and Tennessee, by the distribution of these sites.

Following our discussion in Chapter 5 of archaeologically tracking ancient human movement, clearly the discovery of a single iron sword, a datable Welsh inscription, artifacts made from a raw material present in Wales, or the skeleton of a western European would have gone further in support of the Welsh hypothesis than would all the stories of Welsh-speaking, light-skinned Indians. But archaeologist Charles Faulkner (1971) found no physical evidence supporting the Welsh hypothesis when he excavated one of the better known of the forts in central Tennessee. Instead, the fort, which is really little more than a hilltop enclosed with a stone wall, contained artifacts made by American Indians, not Europeans. Included among the very few artifacts actually recovered were stone spearpoints and cutting and scraping tools. Carbon dates derived from charcoal found at the site and associated with its construction and use indicate that the stone fort was built and used sometime between A.D. 30 and 430.

If Madoc, indeed, did sail across the Atlantic into the Gulf of Mexico, into Mobile Bay, up the Alabama River, and eventually into Tennessee, he might have seen the stone forts credited to him and today presented as material evidence for his visits in the twelfth century. The Indians had already beaten him to it, having built them as much as one thousand years before. Here again, there is no physical evidence—no support in the archaeological record—for a Welsh presence in America before Columbus.

Africans in America?

Although not the first to suggest it, a professor of anthropology, Ivan Van Sertima (1976), has been the most eloquent proponent of the notion that black African peoples discovered and settled in the Americas long before the voyages of Christopher Columbus.

In his book, *They Came Before Columbus*, Van Sertima supports his claim of an African presence in the pre-Columbian New World with a number of different sorts of data. Among these are:

1. References in Columbus's writings to the presence of "black Indians" in the New World

2. The presence of a metal (*gua-nin*) purported to be African in origin, reported by Columbus

3. Pre-Columbian skeletons with "Negroid" characteristics

4. Artistic representations of black Africans at sites in the New World that predate the voyages of Columbus

While some of the kinds of evidence cited by Van Sertima are in line with our discussion in Chapter 5 concerning what is necessary to trace the prehistoric movement of people, the actual data presented fall far short of that needed for a convincing case.

For instance, Columbus does not claim to have seen black-skinned Indians; he merely passes along a story told to him by a group of Indians he did contact. Remember that Columbus also passed on the report of Indians with tails, so such evidence is highly suspect.

The report of the metal called *gua-nin* is similarly unconvincing. We do not have the metal to examine, none has ever been found in archaeological excavations in the New World, and we certainly cannot rely on five-hundred-year-old assays of the metal that Van Sertima maintains indicate its African identity.

As stated in Chapter 5, one way to trace the movement of prehistoric people focuses on skeletal analysis. Van Sertima cites a small number of analyses of a small number of skeletons found in the New World, particularly in Mesoamerica, that ostensibly have indicated the African origin of some individuals. However, here the evidence is again quite weak, with either the Negroid character of the skeletons being questionable or the dating of the bones uncertain. Europeans brought black slaves to the New World as early as the sixteenth century, and some of the Negroid skeletons found in the New World cited by Van Sertima are likely those of early, but post-Columbian, slaves.

Van Sertima's assertion that there is ample evidence of the presence of black Africans in the New World in the form of artistic representations of individuals who look African is, perhaps, the weakest link in an already weak chain of reasoning. The weakness lies in the subjective nature of the assertion. For example, Van Sertima points to the physiognomies of the so-called Olmec heads of lowland Mesoamerica—huge pieces of basalt carved into human heads about 3,000 years ago by the bearers of what is almost certainly the first "civilization" in Mesoamerica (Figure 6.2).

Figure 6.2 An example of a giant carved stone head of the Olmec culture of Mesoamerica. These eighty-ton carvings in hard volcanic rock are certainly evidence of an advanced civilization in Mesoamerica 3,000 years ago. For some, the facial features of the Olmec heads are evidence of an African origin for that advanced culture. (By Richard H. Stewart © 1947 National Geographic Society)

Van Sertima asserts that they are clearly Negroid in appearance; and indeed they do possess full lips and broad noses. Van Sertima, however, ignores the fact that many of the Olmec heads also have flat faces like American Indians, not prognathic profiles (jutting-out lower faces) like Africans. He also chooses not to see what appear to be epicanthic folds on the eyelids of the statues—as mentioned in Chapter 5, typical of Old World Asians and American Indians. It is also the case that American Indians exhibit a broad range of features and some, in fact, have full lips and broad noses—at the same time they possess other, more typically Indian physical features (Sabloff 1989). Most archaeologists interpret the Olmec heads as stylized sculptures, perhaps representing the faces of babies.

There are many more specific responses that could be provided for particular claims made by Van Sertima. It is more important, however, to point out the deductive implications of his hypothesis and the lack of confirming evidence. If Africans truly were present in the New World in large numbers before Columbus and if they had a substantial impact on indigenous cultures, there should be ample evidence in the archaeological

record of artifacts, raw materials, and skeletons—in other words, the kinds of cultural and biological evidence that archaeologists regularly find and analyze—to support this claim. We would find more than enigmatic statues and vague historical references. Archaeologists should find clear evidence of material remains reflecting an African rather than an Indian pattern in housing, tool-making, burial of the dead, ceremonies, etc. Without such evidence, the claim of an African discovery and settlement of the New World remains unproven.

Interestingly, a large part of *They Came Before Columbus* focuses not on evidence of an African discovery of the New World, but on the *capability* of ancient African peoples to have accomplished this feat. Van Sertima argues, certainly correctly, that the cultural achievements of indigenous, black African cultures have been ignored by Western scientists for too long. Of course, we should all acknowledge the accomplishments of the peoples of ancient as well as modern Africa and the great contributions their cultures have made to the world (Connah 1987). Nevertheless, as certain as it is that a number of ancient African cultures possessed the political complexity, navigational skills, technology and material culture necessary to have explored the New World, this is not proof that they did so.

Finally, an interesting irony is inherent in Van Sertima's argument. While he is quite concerned about the racism inherent in assumptions about the lack of skills of ancient African peoples, his assumptions about American Indian cultures are similarly suspect. After all, it is his contention that either a small group of invading black Africans was the necessary catalyst for the development of civilization in the New World, or else a small group of black Africans was quickly able to take over and direct the development of an emerging New World civilization. His protestations to the contrary notwithstanding, bias appears inherent in either proposal.

As an anthropologist, Van Sertima clearly recognizes the sort of evidence necessary to validate his hypothesis; he is not a pseudoscientist. The evidence he provides is simply not strong enough to support his case.

America B.C.?

Reading the works of retired Harvard marine biologist Barry Fell (*America B.C., Saga America,* and *Bronze Age America*) brings to mind the approach of seventeenth-century Spanish Jesuit Gregoria Garcia, discussed in Chapter 5. Just as Garcia seemed to believe that virtually every Old World culture contributed to the population of the New World, Fell seems to describe the Atlantic as a freeway for exploration of the Americas long before Columbus.

Beginning with Libyan sailors in the fourth millenium B.C., Fell provides ostensible evidence, not just for the discovery, but also for the exploration and colonization of the Americas by Iberians (people from Spain and

Portugal) 3,000 years ago, Celts 2,800 years ago, Greeks 2,500 years ago, ancient Hebrews about 2,000 years ago, and Egyptians 1,500 years ago.

Fell's approach lacks a scientific, skeptical, or deductive approach. He and adherents like Trento (1978) and Feldman (1977) do not claim that these various Old World groups simply discovered America or that they merely explored it. It is Fell's contention that these peoples settled the Western Hemisphere, apparently in large numbers, many years before Columbus. It is his further claim that there was a regular flow of commerce between the Old and New Worlds over many years and that the presence of these interlopers had a significant impact on indigenous peoples.

Virtually all archaeologists and historians in the New and Old Worlds who have had something to say concerning the claims of Fell have been skeptical, and some have been downright hostile (Cole 1979; Daniel 1977; Dincauze 1982; Hole 1981; McKusick 1976; Ross and Reynolds 1978). And with good reason. Fell ignores much of the archaeological and ethnographic records of the New World.

The three categories of ostensible evidence he does provide in his books are:

1. Alleged linguistic connections between American Indian languages and many different European tongues
2. Inscriptions found in the New World in many ancient European alphabets
3. Architectural similarities between stone structures mainly in New England and those in Western Europe

Linguistics

Two scientists at the Smithsonian Institution have examined Fell's claims of linguistic similarities between American Indian and European languages such as Egyptian, Celtic, Norse, and Arabic (Goddard and Fitzhugh 1979). Fell's basic approach is to select words in particular Indian and European languages that sound alike (or can be made to sound alike) and can be interpreted as having similar meanings. He then concludes that the Indian language must be derived from that of the Old World group. Fell's approach here has long ago been discredited by linguists; it is little different from that of those speculative thinkers in Europe in the sixteenth through nineteenth centuries who attempted to trace American Indians to various Old World peoples (Chapter 5).

Goddard and Fitzhugh point out that such an approach is pointless; the correct pronunciation of many of the Indian words is very rarely known. Furthermore, merely comparing words ignores facts of grammar that are much more important in language comparisons. With relatively few com-

mon sounds making up the countless words of most human languages, coincidental similarities are bound to show up if you look hard enough. For example, as Mesoamericanist Pedro Armillas (personal communication) points out, the Latin word for "little eyes" is *ocelli*. "Little eyes" look like little spots and in Nahuatl, the language of the Aztecs, a spotted cat is an *ocelot*. Such word-by-word comparisons can show word similarities in many different languages with absolutely no historic connection. The Indian words that Fell claims are derived from European sources can be traced; they have a linguistic history within their own languages. There is no evidence that they suddenly entered a language as might be expected if they had been borrowed from elsewhere.

Inscriptions

Fell, though trained in biology, also claims expertise in epigraphy (deciphering ancient inscriptions). He asserts that there are literally hundreds of examples of ancient inscriptions in various Old World alphabets scattered throughout the New World. Yet here Fell ignores definitive evidence concerning some of his important artifacts. For example, inscribed tablets from Davenport, Iowa, well-known to be nineteenth-century fakes, are cited by Fell as positive evidence of the exploration of midwestern North America by a fleet of Egyptian ships, under the command of a Libyan skipper in the ninth century B.C. (1976:261–68). See Chapter 7 (Figure 7.5) for a description of the unmasking of the fakes (and see McKusick 1970 and in press for a detailed accounting of the entire story).

Moreover, as Goddard and Fitzhugh maintain, among even those inscriptions where fraud cannot be proven, "all of the alleged ancient New World inscriptions examined by specialists to date have been found to contain linguistic or epigraphic errors or anomalies consistent with modern manufacture but inconsistent with a genuine ancient origin" (1979:167).

Beyond the fakes, Goddard and Fitzhugh point out that many of Fell's inscriptions are simply random marks on rock. Archaeologist Anne Ross and historian Peter Reynolds (1978) examined a sample of the marked stones translated by Fell. They point out that obvious marks on the stones that do not match Fell's alphabetic interpretations are simply ignored by him. They view many of the so-called inscriptions as simply the result of natural erosion or plow marks. A plow blade can repeatedly scratch a rock in the soil, leaving a series of lines. Fell interprets these lines as conveying meaningful messages in an alphabet called *Ogam*—a well-known alphabet based on Latin that dates to the fourth century A.D. in western Europe. It was used exclusively to write in early Old Irish.

Fell claims that the Ogamic inscriptions he has interpreted in New World locations are sometimes much older than this. He further claims the New World versions were written without vowels (one simply adds the

"necessary" vowels), recording words in a number of different languages. Anne Ross, a British expert on Ogam who has examined many of the alleged Ogam inscriptions in New England, finds this to be a "semantic phantasy of the wildest nature" (Ross and Reynolds 1978:106).

As Goddard and Fitzhugh state, Ogam is, indeed, a record-keeping system that consists largely of simple strokes, so any process that produces lines in rock can superficially resemble Ogam. Then, as they state, in Fell's approach "it is a matter of little further difficulty to select words from this range of languages to match against the string of consonants which have been read" (1979:167).

Architecture and Archaeology

As I stated at the outset of this discussion, archaeological evidence is necessary to assess hypotheses of the ancient pre-Columbian presence of Old World peoples in the New World. Fell's inscribed rocks cannot be viewed in a cultural vacuum. Claims of an Irish, Welsh, Chinese, Celtic, Egyptian, or Norse presence in the New World before Columbus must be viewed in a broad anthropological context.

Consider the story archaeologist Dean Snow (1981) relates of the remarkable discovery of an ancient Roman coin in California. Does such a discovery provide support for a hypothesis of pre-Columbian Roman settlement of the west coast of North America? The context of the coin argues otherwise; it was found in a parking meter in downtown Los Angeles.

Without consideration of archaeological context and implications, inscribed stones (or Chinese anchors, stone forts, or sculpted heads) mean little. We know from the archaeological record that human groups, especially when they settle in large numbers, leave much more than enigmatic graffiti. They build houses, throw away garbage, make tools, and bury their dead. The remains of these activities constitute the data base of the archaeologist. What does the archaeological evidence indicate for Fell's hypotheses?

A site that seems to be a cornerstone in Fell's archaeological argument is located in North Salem, New Hampshire (Goodwin 1946). The site consists of numerous stone structures and features (Figure 6.3). William Goodwin, a retired insurance executive from Hartford, Connecticut, purchased the site in 1935 and spent the rest of his life rebuilding parts of it and trying to prove that it was the settlement of ancient Europeans—specifically Irish *Culdee* monks in the tenth century A.D. For years it was called *Mystery Hill*, though now the owners prefer the name *America's Stonehenge*. Fell claims that the site is, in fact, the remains of a European settlement of more than 3,000 years ago. Fell and his supporters assert that the architecture of the stone structures at Mystery Hill is the same as that of Europe during this period. At that time, in western Europe, the so-called *Megalith* builders

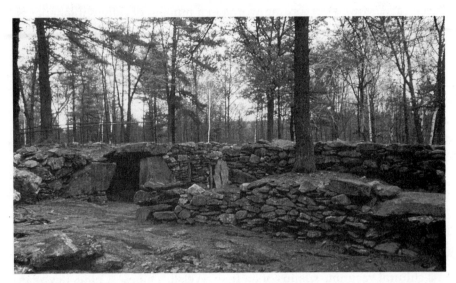

Figure 6.3 The admittedly strange stone structures of Mystery Hill, North Salem, New Hampshire, are part of an idiosyncratic site most likely built by colonists in the eighteenth or nineteenth centuries. Some insist that the site is far older, built by European settlers of the New World more than 3,000 years ago.

were busy working in stone, constructing monuments like Stonehenge in England (see Figure 9.7), Carnac in France, and thousands of smaller sites. Their habitations, like Skara Brae on the Orkney Islands, were also built of large pieces of stone.

The architecture at sites like Mystery Hill must be examined in an overall cultural context. The stone structures, indeed, seem to resemble those found in ancient Celtic sites in England, Wales, Scotland, and Ireland. Does this mean that ancient Celts settled the New World?

Archaeologist Robert R. Gradie (1981) provides a good argument for a negative answer to this question. He points out that there may indeed be a relationship between the stone structures in Great Britain and New England—but not as a result of pre-Columbian, seafaring Celts.

Gradie shows that in Europe, stone chamber building very much like that of the Megalith culture continued as so-called *vernacular architecture* into the twentieth century. Ross and Reynolds point out that such stone structures have been built recently enough for living people to remember their construction (1978:103). In the past few centuries, farmers in western Europe built root cellars and storage buildings using the same methods people had used centuries and even millennia before when they built ceremonial structures. Some of these farmers migrated to New England in the seventeenth and eighteenth centuries, naming counties and towns after their Celtic homelands and maintaining aspects of their material culture—

including the way they built their outbuildings. Gradie suggests that the stone structures at sites like Mystery Hill were, indeed, built by Celts, but of a much more recent vintage than Fell asserts.

Is there other evidence that might relate to the claim that Mystery Hill was an outpost of Culdee Monks or the Megalith builders of Europe? Goodwin himself stated: "The modern world of thought lays more stress on proof by archaeology than on oral or written traditions. This is as it should be ..." (1946:206). In this, he agreed with the approach taken in this chapter. What, then, does the archaeological record at Mystery Hill and other sites indicate?

Unfortunately for Goodwin and Fell, there are no archaeological artifacts at all to bear witness to the presence of pre-Columbian interlopers at Mystery Hill or other similar sites. If the people Goodwin or Fell claims were here actually were here in the numbers implied, they had to have been the neatest people ever to grace the planet. They picked up everything, leaving nothing for the archaeologist to recover and analyze. This represents, by itself, a fatal blow to the arguments of Fell and his supporters.

For example, while on a visit to Mystery Hill, I asked the guide why their small museum had one large glass case of stone artifacts found at the site and clearly of local Indian manufacture and one glass case filled with the pottery, brick, and iron nails of nineteenth-century inhabitants, but no case filled with the European bronze tools of the supposed "Bronze Age" European settlers of the site? The guide responded, "You don't think those ancient people would have left all those valuable bronze tools just lying around, do you?" I responded that they most certainly had left "all those valuable bronze tools" lying around in Europe; that's how we know it was the Bronze Age—archaeologists find such objects. In other words, I was simply asking that the archaeological context be considered. I was told, in essence, that there was no archaeological context.

To be sure, Fell maintains that some such evidence exists. For example, he claims that Old World bronze tools have indeed been discovered in North America. He shows some of these artifacts in a figure on page 96 of *America B.C.* and labels them "bronze weapons." Since American Indians in North America did not manufacture bronze, such items "must represent European imports." But the tools Fell pictures are, in fact, not bronze, but copper—a metal well-known to many Indians who used pure deposits of the element (see Chapter 7). How could Fell not have known this (Sullivan 1980:46–47)?

An archaeological excavation was conducted at Mystery Hill. In the 1950s, the organization that controlled the site, The Early Sites Foundation, hired Gary Vescelius, a Harvard graduate student in archaeology, to excavate. Their hope was that artifacts would be found that would support the hypothesis that the site had been built and occupied by ancient European immigrants to the New World. In hiring an archaeologist to excavate at the

site, they were recognizing that an archaeological context was necessary. They were admitting, in a sense, that architectural similarity was not enough, that it merely suggested the possibility of a connection between the Old and New Worlds. Archaeological evidence of the kind of people who lived at the site was necessary to support the hypothesis—the kind of evidence discussed in Chapter 5, including entire complexes of artifacts found only in ancient Europe, the skeletal remains of identifiable Europeans, and artifacts made of raw materials that could be proven to have been derived from European sources, all in a context that could be dated to before Columbus.

Vescelius (1956) found nothing of the kind. He recovered some 7,000 artifacts in his excavation. They all were clearly of either prehistoric Indian manufacture (dating to an occupation of the site before the stone structures were built) or nineteenth-century European manufacture—ceramics, nails, chunks of plaster, and brick fragments. The archaeological evidence clearly pointed to a nineteenth-century construction date for the site. Precisely the same results were derived from excavations at *Gungywamp*, in Groton, Connecticut, a similar site that Fell claims is of ancient Celtic vintage (Jackson, Jackson, and Linke 1981). All the artifacts found at Gungywamp were of a much more recent date.

Finally, regional surveys have been performed on sites in Massachusetts (Cole 1982) and Vermont (Neudorfer 1980), where stone structures suggested by some to be of ancient Celtic origin are found. Both projects show quite clearly and definitively that the stone structures were part of historic, colonial patterns of land use and construction.

Cole found absolutely no archaeological evidence in the thirteen sites he investigated that the stone structures were built by pre-Columbian settlers; all the structures were part of a known pattern and most were, in fact, parts of complexes of buildings and features (farms, mills, a hotel) known to date to the nineteenth century.

Neudorfer conducted a three-year project, examining forty-four stone chambers in Vermont, taking measurements and searching for historic contexts for the structures. She found that with one exception, all the structures, *including seven specifically identified by Fell as being Celtic temples*, were associated with eighteenth- or nineteenth-century farm complexes (p. 56). In one case she was even able to come up with the name of the actual nineteenth-century builder of one of the chambers Fell maintains is ancient Celtic in origin.

Neudorfer found that the stone chambers, far from being enigmatic, were a common part of farm culture in historic New England. She found in some cases that the style of masonry of the chambers was identical to that of the foundations of nearby historic farmhouses. Further, she found eighteenth- and nineteenth-century publications describing the best methods for building such structures for cold storage of fruits and vegetables. While Fell claims that the southerly or easterly orientation of the chamber entrances

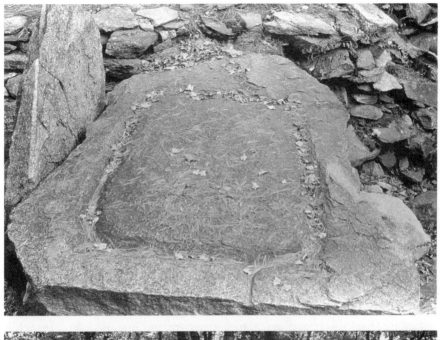

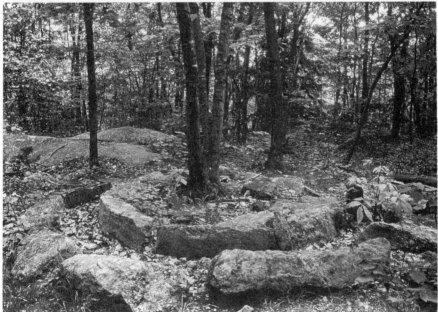

Figure 6.4 The so-called sacrificial altar at Mystery Hill [top] is likely nothing more than a lye stone, well-known in colonial New England for the production of soap. The seemingly mysterious circle of stones at Gungywamp, Connecticut [bottom], thought by some to have mystical significance within an early European context, is more likely the stone remnants of a colonial bark mill used to extract chemicals for hide tanning.

reflects ancient Celtic ceremonies, the farm publications Neudorfer located advised eighteenth- and nineteenth-century farmers to orient the openings of their root cellars to take advantage of the position of the winter sun in the southern sky, thereby preventing freezing in the cellars.

Perhaps the most significant contribution of Neudorfer's work rests in her showing the historic context of the stone chambers. Could ancient Celts have traveled to New England and built stone temples? Certainly it is possible, but it is also *possible—and far more probable*—that these structures were eighteenth- and nineteenth-century farm buildings. As archaeologist Dena Dincauze (1982) points out, Occam's Razor should be applied here. The chambers fit in with everything we know about historic farmers in New England, and this explanation requires no other assumptions. As Dincauze states, Neudorfer's argument and evidence "shifts an apparently immovable burden of proof onto the shoulders of those who would claim otherwise" (1982:9–10).

Finally, Neudorfer points out that the mystery associated with the stone chambers of New England is a product of a sort of cultural amnesia. Common, everyday aspects of life like the stone chambers have been forgotten and now appear to be enigmatic. They are a reflection of a time not so distant by absolute chronological measurement, but hugely distant from the modern world of computers, space shuttles, and fax machines. As a result, for example, common nineteenth-century tools for converting lye to soft soap (Swauger 1980) have become sacrificial altar stones for some (as stated in the pamphlet distributed at Mystery Hill), and animal-powered bark mills (Warner 1981) have been transformed into mysterious temples (Figure 6.4). But analysis of historical and cultural context forces us to remember what such things, in reality, were.

The Viking Discovery of America

The Viking *sagas* are compelling tales of adventure and discovery, life and death. The sagas were handed down orally for generations and recorded hundreds of years after the events they celebrated actually transpired. Among the tales told in the sagas are a number concerning the Viking discovery, exploration, and settlement of Iceland and Greenland. Also described in the sagas is a story of the discovery of another new country. That country, it has been claimed, was North America.

Two sagas in particular, tell the story of this new land: The *Greenlander's Saga* and *Eirik the Red's Saga*. The *Greenlander's Saga* relates the following tale (*Eirik the Red's Saga* differs in some particulars, but describes essentially the same events); the summary is based on the English translation of the sagas by Magnusson and Paulsson (1965).

Soon after A.D. 980, Eirik Thorvaldsson, known as Eirik (Erik) the Red, was banished from his home on Iceland for having killed two men (his

father before him had been banished from Norway for the same offense). The dispute had likely resulted from the growing struggle for land and power on the island nation (McGovern 1980/81). Discovered in A.D. 860 and settled initially by the Vikings in A.D. 870, Iceland's population had grown to nearly 50,000, and land was at a premium (Jones 1982).

Outlawed because of his crime, Eirik left his home on Iceland and sailed westward, searching for and verifying the existence of a land that had previously been sighted. Eirik, in an attempt to reestablish a land and power base, returned to Iceland, encouraging people to follow him to this newly discovered land. He called it Greenland. Though it was largely covered by glacial ice, Eirik gave the land its name in an early case of deceptive advertising; as the saga writers stated, "people would be more tempted to go there if it had an attractive name" (Magnusson and Paulsson 1965:50).

Established in A.D. 985–86, the Greenland colony attracted many disaffected with the political turmoil of Iceland and grew to a population of about 5,000 (McGovern 1982). Though the colony ultimately failed as the climate deteriorated in the fourteenth century, for a time it flourished, leaving the archaeological remains of some four hundred farmsteads and seventeen churches (Ingstad 1982:24).

The physical, archaeological evidence for the Norse (Viking) settlement of Greenland is extensive. It shows that, at least here, the sagas passed down orally and recorded two hundred years after the fact, were generally accurate (the Greenlander's Saga reports on events that occurred between about A.D. 980 and 1022, but was not written down until about A.D. 1190). Also, the remains of the Greenland colony provide a model of what such a colony in the New World might look like.

The same year the colony was established, a Viking ship captained by Bjarni Herjolfsson got lost in a storm on the journey from Iceland to Greenland. After about four days of sailing he sighted land. Bjarni could not identify the country and continued to sail, sighting at least two other lands before finally reaching Greenland by sailing east. Bjarni and his men did not set foot on these new unidentified lands. Later, he was to be criticized for not exploring these possibly valuable territories. Bjarni was more a farmer than an explorer, yet this relatively unknown Viking is likely the first European to have sighted America.

Despite the fact that the Greenland settlement was prospering and growing at the end of the tenth century, or maybe because of its success and growth, the possibility that new lands might be found to the west intrigued many. Eirik's son, Leif, spoke to Bjarni about his accidental discovery and even purchased his boat. He set sail with thirty-five men around A.D. 1000 to search for these new lands. According to the Greenlander's Saga, following Bjarni's directions backwards, Leif made landfalls on the three new lands. He called them Helluland (flat-stone or slab land), Markland (forest land), and

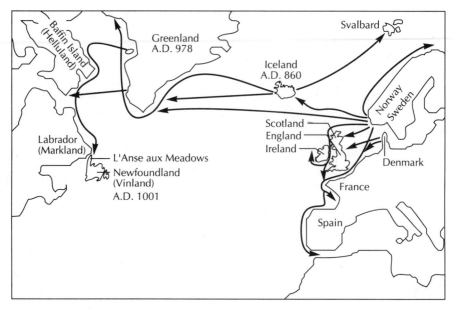

Figure 6.5 Map of Viking explorations of the North Atlantic, including their probable route to the New World in the late tenth and early eleventh centuries A.D.

Vinland (wine land) (McGovern 1980/81). On Vinland, Leif built some sod houses (called *booths*) and used these as a base from which Vinland could be explored (Figure 6.5).

After this initial exploration, Leif returned to Greenland and told of the richness of Vinland; there were salmon in the rivers, wild grains (probably wild rice) in the meadows, abundant grapes, etc. Soon thereafter, Leif's brother, Thorvald, traveled to these newfound lands and investigated them for about a year. He encountered natives of the new land, called them *Skraelings*, and was killed in a battle with them. He was buried on Vinland, and the rest of his men returned to Greenland.

In A.D. 1022, Thorfinn Karlsefni led at least 65 and perhaps as many as 160 colonists from Greenland to attempt a permanent settlement of Vinland. Families came, and farm animals were brought along. They built homes and began farming the land. After about a year, however, following a bitter battle with the Skraelings, the colony was abandoned. This first attempt to establish a permanent European settlement in the New World failed, according to *Eirik the Red's Saga*, since "although the land was excellent they could never live there in safety or freedom from fear, because of the native inhabitants" (Magnusson and Paulsson 1965:100). History might have been substantially different had this not been the case. One final attempt was made to settle Vinland, but this too ended in failure.

Where Was Vinland and
Who Were the Skraelings?

McGhee (1984) points out that the sailing directions in the sagas, as well as the geographical and environmental descriptions of the islands Leif explored, suggest quite strongly that Helluland is Baffin Island, Markland is Labrador, and Vinland is Newfoundland, all in Canada. The Skraelings, then, were American natives, most likely Indians rather than Eskimos (Fitzhugh 1972:191–95; Jones 1986:130–34).

There is one unexplained mystery though. Vinland is named for the wine that could be made from the wild grapes that grew there, and there are a number of references to such grapes in both the *Greenlander's Saga* and *Eirik the Red's Saga*. Newfoundland was too far north, however, for wild grapes to grow even when the climate was warmer a thousand years ago. Analysis of pollen preserved at ancient sites in Newfoundland indicates that the flora during Viking occupation was not that much different from today, when grapes cannot grow (Henningsmoen 1977). Explanations for this have varied (Jones 1986:123–24). Nevertheless, wherever Vinland actually was, the sagas seem to indicate quite clearly that the Vikings indeed discovered, explored, and attempted to settle the New World about five hundred years before the Columbus voyages.

Archaeological Evidence
of the Viking Presence

The ultimate arbiter in the argument concerning precisely where the Vikings explored to the west of Greenland is the archaeological record. Unfortunately, with just a few exceptions (see the "Current Perspectives" section of this chapter), the physical evidence for the Viking presence in the New World is either meager or highly suspect, and usually both.

Bearing little witness to a Viking presence in the New World, most of the supposed Viking artifacts found in North America are instead a reflection of hoaxes and misinterpretations born of ethnic pride. As archaeologist Brigitta Wallace (1982) points out, it is likely not coincidental that a distribution map of such discoveries corresponds quite well with the distribution of historical Scandinavian settlements of the United States.

For example, a large stone slab with ostensible Viking writing, or *runes*, was found near Kensington, Minnesota, by Olof Ohman in 1898 (Wallace 1982). The stone contained a short message concerning a journey from Vinland and bore a date of A.D. 1362. Though the precise source of the stone has never been established, Wallace points out that the language on the stone is a *modern* Swedish dialect spoken only in the American Midwest and the runes are of recent vintage as well.

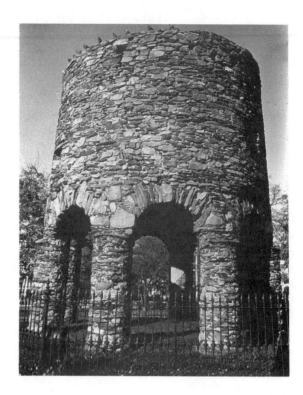

Figure 6.6 The Newport Tower in Newport, Rhode Island, claimed by some to be an ancient Viking church. Historical and archaeological evidence indicates quite clearly that the tower was built during colonial times.

Beyond this, consider the historical context. By 1362, the Vinland colony had long since been abandoned. As a result of climatic deterioration, the Viking world was contracting at this point. The Viking settlement on the west coast of Greenland, from which all saga-described explorations to the west took place, had been abandoned in A.D. 1345. It is highly unlikely that, after this, Vikings were sailing to Minnesota. The Kensington stone is pretty clearly a fake.

The Newport Tower in Newport, Rhode Island, has been proposed as an ancient Viking construction (Figure 6.6). In this case, an archaeological investigation of the area immediately surrounding the tower indicated that it was unquestionably of more recent vintage (Godfrey 1951). No Norse artifacts were found. Colonial artifacts including the familiar white kaolin pipe fragments and glazed crockery, however, were found in soil layers that were deposited before or during tower construction. The investigators even found the preserved impression of a colonial bootprint in the soil *beneath* the stone foundation of the tower. The mysterious tower turns out to be, in actual fact, a windmill likely built by the then governor of Rhode Island, Benedict Arnold, the grandfather of the famous traitor (it is even mentioned in his will, which is dated to 1677). For a discussion of other misinterpretations of supposed Viking artifacts and hoaxes, see Wallace (1982). Also,

see the "Current Perspectives" section in Chapter 3 for a discussion of the fraudulent Vinland Map.

𒀸𒀸𒀸𒀸𒀸𒀸 CURRENT PERSPECTIVES 𒀸𒀸𒀸𒀸𒀸𒀸
The Norse Discovery of America

As stated at the beginning of this chapter, historical or legendary claims of the discovery of "new" lands are notoriously hard to assess. Attempting to force ancient tales to fit our modern knowledge of geography may be an interesting exercise, but often falls short of acceptable levels of proof. Also as stated at the outset, the ultimate arbiter in this discussion must be solid, physical evidence of the presence of non-native people in the New World that dates to before the Columbus voyages. Since the period to which we are referring is many hundreds and perhaps even thousands of years ago, the evidence that is needed to assess such claims is archaeological.

Such archaeological evidence, or lack thereof, points to one conclusion: besides the ancestors of modern American Indians, the only group for whom there is concrete evidence for exploration and settlement of North America is the Norse.

Some of that evidence has been found at the archaeological sites of native Americans. This physical evidence of trade or contact between native Americans and the Norse has been summarized by the archaeologist Robert McGhee (1984). For example, a Norwegian penny minted sometime between A.D. 1065 and 1080 was found at an archaeological site in Maine. The site has been dated to between A.D. 1180 and 1235 (McKusick 1979). The coin had been perforated, perhaps to facilitate use as a pendant. It was the only Viking artifact found at the site; all of the other artifacts were clearly Indian in style and material. The fact that many of the stone tools found at the site were made of a kind of chert found only on northern Labrador may indicate that the "Norse penny," along with the chert, reached the Maine coast by trade from the north.

On Baffin Island, a wooden figurine was unearthed during the excavation of a prehistoric Eskimo winter house (Sabo and Sabo 1978). Though the style of the figurine is typical for the so-called *Thule* Eskimo, it depicts a person in European clothing—a long robe with a slit up the front—with an apparent cross carved onto the chest. This figurine, almost certainly executed by an Eskimo, likely represents a Viking either seen by, or described to, the artist. On Ellesmere Island in Arctic Canada, the discovery of links of medieval chain mail armor and iron boat rivets attests to the presence of Vikings there in the early fourteenth century (Schledermann 1981).

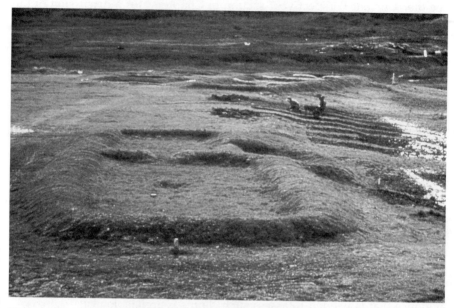

Figure 6.7 House remains at L'Anse aux Meadows, Newfoundland, Canada. Archaeological evidence at this site, including the house patterns, artifacts like soapstone spindle whorls and iron nails, as well as radiocarbon dates, all support the hypothesis that this was a genuine Viking settlement of the New World some five centuries before Columbus. (Photo by B. Schonback, courtesy Brigitta Wallace, Canadian Parks Service)

L'Anse aux Meadows

Though there are several other artifacts that indicate the Norse presence in the New World, the most compelling information comes from the only known Norse settlement in North America: L'Anse aux Meadows in northern Newfoundland. In fact, the site at L'Anse aux Meadows may be the settlement initially established by Leif Eirikson in about A.D. 1000.

In 1960, writer and explorer Helge Ingstad (1964, 1971, 1982), convinced that Newfoundland was the Vinland of the sagas, initiated a systematic search of its bays and harbors for evidence of the Viking settlement. Certainly, at least the sizeable colony of Karlsefni would still be archaeologically visible less than 1,000 years after its abandonment. If the sagas were based on an actual attempt at colonization, the site could be found. It was only a matter of figuring out where it actually was.

On a promontory of land, at the northern tip of the northwestern peninsula of Newfoundland, Ingstad made his remarkable discovery. There he located the remains of what appeared to be eight typically Norse turf houses (Figure 6.7). Between 1961 and 1968 the site was excavated under the direction of Ingstad's wife, archaeologist Anne Stine Ingstad (1977, 1982).

Figure 6.8 A ring-headed bronze pin found at L'Anse aux Meadows. The raw material of the artifact and its form are purely Norse. Its recovery within an overall archaeological pattern that matches Viking sites in Greenland and Iceland and its clear association with a turn-of-the-eleventh-century date further support the hypothesis that the site is Viking. (Photo by G. Vandervloogt, courtesy of Brigitta Wallace, Canadian Parks Service)

The archaeological evidence was more than sufficient to identify the site at L'Anse aux Meadows as Viking. This interpretation was based, not on vague similarities between the excavated structures and those known from Viking colonial settlements on Greenland, but on detailed identities of the artifacts and structural remains.

Along with the turf houses—the so-called *booths* of the sagas—they found four Norse boatsheds, iron nails and rivets, an iron smithy where local bog iron was worked into tools, a ring-headed bronze pin (Figure 6.8), and a soapstone spindle whorl used in spinning wool. As the local prehistoric Eskimos and Indians did not build boatsheds, smelt iron or produce bronze, nor spin wool with spindle whorls, the evidence of an alien culture was definitive.

In the floor of one of the house structures, the excavators discovered a small, stone-lined box. Called an "ember-box," it was for storing embers of the night fire. Remains of a very similar ember box have been found at Eirik's farmstead on Greenland (A. S. Ingstad 1982:33). Twenty-one carbon dates provide a mean age of A.D. 920 ± 30 for the settlement—a bit old by saga accounts, but this may simply be a problem in the application of the dates. Some of the burned wood used for dating purposes likely was driftwood that already was old when used by the Viking settlers (A. S.

Ingstad 1977:233). Nevertheless, a number of the carbon dates fit the chronology of the sagas quite well.

Was L'Anse aux Meadows the settlement initiated by Leif, occupied by his brother Thorvald, and expanded in the hope of permanency by Karlsefni? The archaeological data do not conform perfectly to the sagas. No human burials were found, though the sagas indicate that a number of Vikings died in Vinland. No evidence of European domesticated animals was recovered in the excavations, though the sagas relate that such animals were brought by the settlers. It will likely never be known for certain whether L'Anse aux Meadows is the archaeological site of Eirikson's and later Karlsefni's settlement, but perhaps this is not so important. What is important and what is indisputable is the archaeological evidence at L'Anse aux Meadows of a Viking settlement, the westernmost outpost of their far-flung world. The settlement was planted in the fertile soil of America. It withered and died for reasons largely beyond the control of those hardy folk who attempted it: a worsening climate that would render Greenland uninhabitable for Viking farmers and render the voyage from the west coast of Greenland to Vinland virtually impossible, and a native population willing to fight to protect themselves and their lands. In the final analysis, certainly the saga of the Vinland settlement may be a tragic story of failure. But, most importantly in terms of the focus of this chapter and perhaps in terms of human history as well, the physical evidence indicates quite clearly that it was a drama played out on the world stage about five hundred years before Columbus set sail.

The Myth of
the Moundbuilders

Today, the intriguing culture archaeologists know as the *Moundbuilders* is one of the best kept secrets in the study and teaching of American history. That an American Indian civilization with populous cities, kings, pyramids, and fine works of art evolved in the midwestern and southeastern United States comes as a surprising revelation, even to those in whose backyards the ruins lie.

Yet the remnants of these ancient inhabitants of North America are nearly ubiquitous. The most obvious manifestation of their culture is their earthworks (Figures 7.1 and 7.2): conical mounds of earth, up to nearly 100 feet in height, containing the burials of perhaps great rulers or priests with fine grave goods in stone, clay, copper, and shell; great flat-topped pyramids of earth, up to 100 feet in height, covering many acres, and containing millions of cubic feet of earth and upon which ancient temples once stood; *effigy* earthworks in the shape of great snakes, birds, and bears.

Few of us seem to be aware of the remarkable cultural legacy of this indigenous American civilization. This became sadly clear to me when attending an archaeology conference in St. Louis a few years ago. Much of my excitement about the conference resulted from its location. The largest and most impressive Moundbuilder site, *Cahokia*, an ancient city of as many as 30,000 inhabitants, sits on the Illinois side of the Mississippi River, just east of St. Louis. Wishing to take advantage of my proximity to the site, I asked the gentleman at the hotel front desk how I might get to Cahokia. The response: a blank stare. He had never heard of it. "You know," I explained, "The big Indian site." "No, no," he responded, "There haven't been any Indians around here for many years."

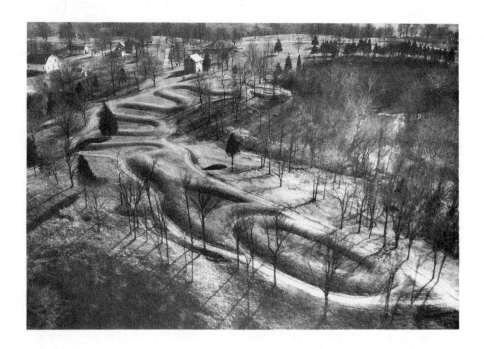

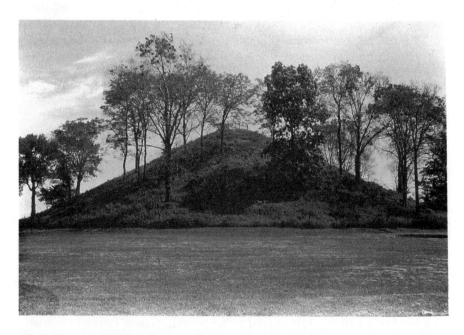

Figure 7.1 Examples of mounds: Serpent Mound, an effigy earthwork in southern Ohio in the form of a coiled 1,500-foot-long snake [top]. A huge, conical burial mound close to 100 feet high in Miamisburg, Ohio [bottom]. (Serpent Mound courtesy of Museum of the American Indian, Heye Foundation)

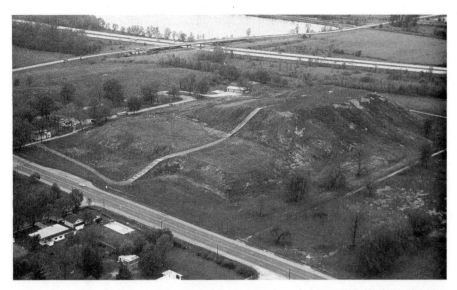

Figure 7.2 Aerial photograph of Monk's Mound, an enormous, tiered pyramid of earth at Cahokia in Illinois. Monk's Mound served as a platform upon which a temple once stood. (Courtesy Cahokia Mounds State Historic Site)

No one in the hotel had heard of Cahokia, and even at the bus station people thought I was just another confused out-of-towner. Luckily, I ran into a colleague who knew the way and I finally got to the site.

It was worth the trouble. About 70 of the 120 or so original mounds remain. Several of these demarcate a large plaza where ceremonies were likely held during Cahokia's peak between A.D 1050 and 1250. *Monk's Mound* (Figure 7.2), containing close to twenty million cubic feet of earth, is one of the largest pyramids in the world (including those of Egypt and Mesoamerica). It dominates the plaza. The highest of its four platforms is raised to a height of 100 feet, where it once held a great temple. Surrounding the central part of this ancient city was a massive log wall or palisade with evenly spaced bastions.

Cahokia must have been a splendid place with tens of thousands of inhabitants, its artisans producing works in shell, copper, stone, and clay. Cahokia was a trading center, a religious center, and the predominant political force of its time. It was, in every sense of the word, a civilization. And it was a civilization created by American Indians whose lives were far different from the stereotype of primitive, nomadic hunters too many of us envision (Figure 7.3).

From atop Monk's Mound one can peer into two worlds and two different times. To the west rests the modern city of St. Louis, framed by its Gateway Arch of steel. Below rests the ancient city of Cahokia with its monuments of earth, shadows of a long-ignored Indian civilization.

Figure 7.3 An artist's rendition of Cahokia at its cultural peak. With an estimated population as high as 30,000, Cahokia was a virtual prehistoric American Indian city on the Mississippi River more than 700 years ago. (Painting by Richard Schlecht, © 1972 National Geographic Society)

How could people not know of this wonderful place? Suffice it to say that if people twenty minutes from Cahokia haven't heard of it, most New Englanders, Californians, Southerners—in fact, most Americans—are completely unaware of it and the archaeological legacy of the indigenous American civilization that produced it and hundreds of other sites.

Cahokia and Moundbuilder culture, however, were not always an invisible part of the history of this continent. In fact, the remains of their civilization once commanded the attention of the American public and scientists alike. It was not only that the mounds themselves, the fine ceramics, the sumptuous burials, carved statues, and copper ornaments were so impressive, though this was part of the fascination. Unfortunately, much of the intense interest generated by the remains of this culture resulted from a supposed enigma perceived by most; the Moundbuilders clearly lived before Columbus, the Indians were the only known inhabitants of North America before the coming of the Europeans, and it was commonly assumed that the Indians were simply incapable of having produced the splendid works of art and monumental construction projects that characterized Moundbuilder culture. With the rejection of the possibility that American Indians had produced the culture, the myth evolved of an ancient, vanished American race (see especially Silverberg 1970 for a very useful and succinct account of the evolution of the Moundbuilder myth).

The myths of a race of giant men (Chapter 3) and of a human ancestor with a modern brain and simian jaw (Chapter 4) were based on hoaxes, clever or otherwise. People suspended their critical faculties and were

fooled by these frauds. On the other hand, the Moundbuilder myth was predicated, not on a hoax (though, as we will see, hoaxes did play a role), but rather on a nearly complete and sometimes willful misunderstanding of genuine data.

The Myth of a Vanished Race

The myth of a vanished race of Moundbuilders was accepted by many Americans in the eighteenth and nineteenth centuries. Five basic arguments were presented to support the notion that American Indians could not have been the bearers of Moundbuilder culture. Let's deal with each in turn.

1. *Indians were too primitive to have built the mounds and produced the works in stone, metal, and clay attributed to the Moundbuilder culture.*

 The attitude of J. W. Foster, president of the Chicago Academy of Sciences, was prevalent. Describing the Indian, he states:

 > He was never known voluntarily to engage in an enterprise requiring methodical labor; he dwells in temporary and movable habitations, he follows the game in their migrations. . . . To suppose that such a race threw up the . . . symmetrical mounds which crown so many of our river terraces is as preposterous, almost, as to suppose that they built the pyramids of Egypt. (1873, as cited in Silverberg 1970:76–77)

 In his 1872 work, *Ancient America*, J. D. Baldwin is even more direct: "It is absurd to suppose a relationship or connection between the original barbarism of these Indians and the civilization of the mound-builders" (as cited in Thomas 1894:615).

 These arguments can be fairly characterized as racist and unfortunately held sway among many people.

2. *The mounds and associated artifacts were very much more ancient than even the earliest remnants of Indian culture.*

 Though the analysis of soil layering known as stratigraphy was not to become an established part of archaeology until later in the nineteenth century (for example, Dall 1877), in 1820 Caleb Atwater used a simple form of stratigraphic analysis to support the notion that the Moundbuilders were from a period far before the Indians arrived in the New World. He maintained in his book *Antiquities Discovered in the Western States*:

Indian Antiquities are always either on, or a very small distance below the surface, unless buried in some grave; whilst articles, evidently belonging to that people who raised our mounds, are frequently found many feet below the surface, especially in river bottoms. (1820:125)

The evidence of the annual growth rings of trees also was used in the argument that the mounds were quite ancient. In 1786, the Reverend Manasseh Cutler counted the rings on a tree he had cut down on a mound in Marietta, Ohio. He found 463 rings and calculated that the mound must have been built before A.D 1300 (Fagan 1977). Others went further, suggesting that large trees presently growing on mounds must have been preceded by several generations of trees, indicating that the mounds were more than 2,000 years old.

3. *Stone tablets were found in the mounds that bore inscriptions in European, Asian, or African alphabets.*

The best known of such artifacts were those from Grave Creek Mound in West Virginia (Schoolcraft 1854) and the Cook Farm Mound in Davenport, Iowa (Putnam 1886). Because American Indians north of Mexico were not known to have possessed a writing system before European colonization, the presence of writing in the mounds seemed to provide validation of the hypothesis that a non-Indian culture had been responsible for their construction. Where characters from specific alphabets could be discerned, sources for Moundbuilder culture could be, and were, hypothesized.

4. *American Indians were not building mounds when first contacted by European explorers and settlers. When queries were made of the local Indians concerning mound construction or use, they invariably professed complete ignorance.*

Very simply, the argument was presented that if Indians were responsible for the mounds, they should have been building such earthworks when Europeans first came into contact with them. At the very least, living Indians, if no longer building mounds, should remember a time when their ancestors had built them. The supposed fact that Indians were not building mounds when first contacted by Europeans was seen by many as definitive, empirical evidence against any claim of Indian responsibility for Moundbuilder culture.

5. *Metal artifacts made of iron, silver, ore-derived copper, and various alloys had been found in the mounds.*

Historic Indian cultures north of Mexico were not known to use metal other than copper, which could be found in pure veins and nuggets in parts of Michigan, and, on occasion, iron from meteorites. Smelting ore to produce copper or iron and techniques of alloying metal (mixing copper and tin, for example, to produce bronze) were unknown. Therefore, the discovery of artifacts of these materials in the mounds was a further indication that a people other than and more technologically sophisticated than American Indians had been the Moundbuilders.

With these five presumably well-supported "truths" in hand, it was clear to the satisfaction of many that Indians had nothing to do with mound building or Moundbuilder culture. This left open the question of who, in fact, the Moundbuilders were.

Who Were the Moundbuilders?
Identifying the Vanished Race

From our vantage point in the latter part of the twentieth century, it is extremely difficult to imagine how intensely interested many were in the origins of the mounds and Moundbuilder culture. The fledgling Smithsonian Institution devoted several of its earliest publications to the ostensible Moundbuilder enigma. Another government agency, the Bureau of American Ethnology, whose job it was to preserve information concerning rapidly vanishing native American cultures, devoted a considerable part of its resources to the Moundbuilder issue. Influential private organizations like the American Philosophical Society also supported research into the question and published works reporting on such research.

The mystery of the mounds was a subject that virtually all thinking people were drawn to. Books, pamphlets, magazine pieces, and newspaper articles abounded, written by those who had something to say, sensible or not, on the question that seemed so important to answer: "Who had built the mounds?" Though few could agree on who was responsible for construction of the mounds, there was no lack of opinions.

In one of the earliest published conjectures, Benjamin Smith Barton wrote in 1787 that the Moundbuilders were Vikings who had long ago journeyed to the New World, settled, and then died out. Josiah Priest in his 1833 work variously posited that the mounds had been built by wandering Egyptians, Israelites, Greeks, Chinese, Polynesians, or Norwegians

(Silverberg 1970:42). Others suggested that the mounds had been fashioned by Welshmen, Belgians, Phoenicians, Tartars, Saxons, Africans, or even by refugees from the Lost Continent of Atlantis (Donnelly 1882; see Chapter 8 of this book). Even a work believed by Mormons to be the most recent testament of Jesus Christ (commonly called *The Book of Mormon* and first published in 1830) maintains that the mounds were built by Indians who had migrated from the Middle East in the sixth century B.C.

Caleb Atwater was an Ohio lawyer who performed a detailed analysis of the earthworks in his state in an attempt to establish the identity of the vanished race. Though Atwater's conclusions were typical for the time, his methodology was far more scientific than were the speculations of some of his contemporaries. In his work *Antiquities Discovered in the Western States* (yes, Ohio was then considered a "western" state), Atwater divided the archaeological remains found there into three categories: Indian, European Colonial, and Moundbuilder. The last of these he ascribed to "a people far more civilized than our Indians, but far less so than Europeans" (1820:120).

To his credit, Atwater was not an armchair speculator concerning the Moundbuilders. He personally inspected many sites in Ohio and produced detailed drawings and descriptions of artifacts and earthworks. But his myopia about American Indian cultural achievement clearly fashioned his view:

> Have our present race of Indians ever buried their dead in mounds? Have they constructed such works as described in the preceding pages? Were they acquainted with the use of silver, iron, or copper? Did the North American Indians erect anything like the "walled town" on Paint Creek? (Atwater 1820:208)

For Atwater the answer to these questions was a clear "No." American Indians simply were too primitive. He concluded his discourse on the question by suggesting that the Moundbuilders had been "Hindoos" from India.

To be sure, there were a few prescient thinkers on the question of the origin of Moundbuilder culture. Perhaps the first to approach the question objectively was none other than Thomas Jefferson, framer of the Constitution and third president of the United States. Jefferson was curious about the ancient earthworks on and adjacent to his property in Virginia. Not content to merely speculate about them, Jefferson conducted what is almost certainly the first archaeological excavation in North America, carefully digging a trench through a mound that contained many human skeletons (Willey and Sabloff 1980). Jefferson would not hazard a guess as to the authors of the Moundbuilder culture, justifiably calling for more information. As the president of the American Philosophical Society, he later would encourage others to explore this question.

Interest in the mounds and debate over the source of the culture that had produced the tens of thousands of these earthworks continued to increase during the nineteenth century as white settlement expanded into the American Midwest, the heartland of Moundbuilder culture. American archaeology developed as a discipline largely in response to questions about the mounds (as well as to questions concerning the origins of the Indians; see Chapter 5).

In their chronicle of the history of American archaeology, Willey and Sabloff (1980) select 1840 as the benchmark for a shift in American archaeology from a period of speculation to one characterized by research whose goal was description and classification. The work of Ephraim G. Squier and Edwin H. Davis on the Moundbuilder mystery is a good example of this shift in emphasis. Squier was a civil engineer and writer from Connecticut. Davis was an Ohio doctor. Both were interested in the Moundbuilder culture and between 1845 and 1847 carried out intensive investigation of some 200 sites. They conducted excavations and produced detailed maps of the sites and drawings of the artifacts. Their research culminated in a book, *Ancient Monuments of the Mississippi Valley*, which was selected as the first publication of the recently established Smithsonian Institution.

Squier and Davis approached their task without many of the preconceptions and pet theories of their predecessors on the Moundbuilder question: "With no hypothesis to combat or sustain, and with a desire only to arrive at truth, whatever its bearings upon received theories and current prejudices, everything like mere speculation has been avoided" (1848:*xxxviii*).

Ancient Monuments of the Mississippi Valley certainly is a descriptive work, with more than 200 drawings in its 300 or so pages. Squier and Davis were nothing if not systematic in their investigations. Generally, they classified the various kinds of earthworks according to the empirical data of form and content as deduced from their detailed surveys and excavations. However, they also made unwarranted assumptions concerning the function of the different earthwork types.

In any event, they arranged and described the earthworks as follows:

1. *Defensive enclosures*—earth embankments surrounding high flat plateaus

2. *Sacred enclosures*—earth embankments surrounding areas of from a few up to more than 50 acres (Figure 7.4); also, effigy mounds (mounds in the shape of animals; see Figure 7.1 top)

3. *Altar mounds*—tumuli within sacred enclosures, with burned layers showing possible use as sacrificial altars

4. *Sepulture or burial mounds*—conical mounds, six to eighty feet in height overlying human burials that contained grave goods (see Figure 7.1 bottom)

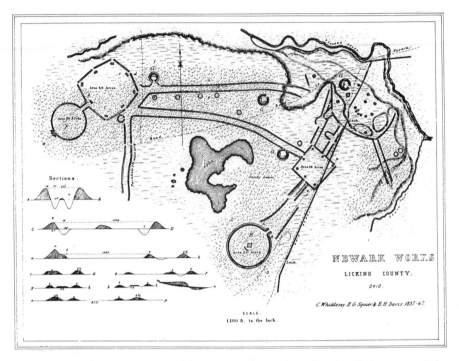

Figure 7.4 Ephraim Squier and Edwin Davis conducted a detailed survey of the mounds of the Ohio Valley and "western" United States in the 1840s, producing beautiful drawings of earthworks like these enclosures in Newark, Ohio. (From *Ancient Monuments of the Mississippi Valley*, AMS Press and Peabody Museum of Archaeology and Ethnology, Harvard University)

5. *Temple mounds*—truncated pyramids, some enormous, with pathways leading to the top where flat platforms, sometimes of a few acres, were found and where temples may have stood (see Figure 7.2)

6. *Anomalous mounds*—oddly shaped or unique mounds

Squier and Davis describe in great detail and depict in beautifully rendered drawings the artifacts that are found in association with the mounds: ceramics, metal implements and ornaments, stone and bone objects, sculptures, and inscribed stones. In a number of places in their book, they compare these objects with those found in other parts of the world, but never attempt to make a direct connection. Nevertheless, Squier and Davis are explicit in maintaining that the quality of art work found in the mounds is "immeasurably beyond anything which the North American Indians are known to produce, even to this day" (1848:272).

Squier and Davis conclude their report by suggesting a "connection, more or less intimate" (p. 301) between the Moundbuilders and the civiliza-

tions of Mexico, Central America, and Peru. Ultimately, it seems, they do subscribe to the idea that the Moundbuilders were a group separate from and culturally superior to the American Indians. They refrain, however, from speculating about who they actually might have been and where, ultimately, they came from.

The Moundbuilder Mystery Solved

The late nineteenth century saw a continuation of interest in the Mound-builders. Then, in 1882, an entomologist from Illinois, Cyrus Thomas, was hired to direct a Division of Mound Exploration within the Bureau of American Ethnology. An amendment to a federal appropriations bill in the U.S. House of Representatives directed that $5,000 of the $25,000 B.A.E. budget be devoted solely to the solution of the Moundbuilder mystery. With this funding, Thomas initiated the most extensive and intensive study yet conducted on the Moundbuilder question. The result was a voluminous report of more than 700 pages submitted as an annual report of the Bureau in 1894 (Thomas 1894).

Above all else, Thomas's approach was empirical; he felt it necessary to collect as much information as possible before suggesting hypotheses about mound function, age, origins, and cultural affiliation. And empirical he was. Where Squier and Davis focused on about 200 mounds mostly in Ohio, Thomas and his assistants investigated 2,000 mound sites in twenty-one states. He collected over 40,000 artifacts, which became part of the Smith-sonian Institution's collection. And after collecting so much information, Thomas was not afraid to come to a conclusion on the Moundbuilder mystery; where Squier and Davis devote six pages to their conclusions regarding the mounds, Thomas provides a 136-page discussion on the identity of the Moundbuilder culture. The work of Thomas was a water-shed, both in terms of answering the specific question of who had built the mounds and also in terms of the development of American archaeology.

For Thomas, the important question to be answered was simple and succinct, "Were the mounds built by the Indians?" (1894:21). He went about answering this question by responding to the arguments against identifying Indians as the Moundbuilders presented earlier in this chapter.

✳ 1. *Indian culture was too primitive.* Thomas' Rebuttal was:

> To the claim that Indians were too primitive to have at-tained the level of civilization reached by the Moundbuilders, Thomas responded that it was difficult to conceive
>
> Why writers should so speak of them who had access to older records giving accounts of the habits and customs of the Indian tribes when

first observed by European navigators and explorers . . . when the records, almost without exception notice the fact that . . . they were generally found from the Mississippi to the Atlantic dwelling in settled villages and cultivating the soil. (p. 615)

For example, in 1539, Hernando de Soto and some 622 men set forth on an expedition of exploration of what is now the southern United States. Their travels lasted more than four years, and they encountered numerous Indian groups. With de Soto was a chronicler known to us only as the "Gentleman of Elvas." He mentions great walled towns of as many as five or six thousand people (1611:122). It is clear from his descriptions of Indian settlements that there was a large, sedentary, "civilized" population in the American Southeast in the sixteenth century.

In another example, William Bartram, a botanist from Philadelphia, began his travels through the Southeast in 1773. In his book enumerating his experiences, he also describes scores of heavily populated Indian towns; in one case he mentions traveling through nearly two continuous miles of cultivated fields of corn and beans (1791:285). He estimates the population of a large town called *Uche* to be as many as 1,500 people (p. 313), and he was very much impressed with how substantially built their structures were.

So, in Thomas's view and in fact, evidence indicated that at least some Indian cultures were agricultural and sedentary, with people living in large population centers. They clearly would have been culturally and practically capable of constructing monumental earthworks.

2. Mound culture was older than Indian culture.

In reference to the presumed great age of the earthworks, Thomas denigrates the accuracy of dating the mounds on the basis of tree-ring counts. In fact though, the age of at least some of the mounds may have been more accurately estimated by some of the ancient race enthusiasts. Thomas incorrectly thought many had been built after European arrival in the New World. Ultimately, however, the age of the mounds was only a problem if one accepted the then-current notion that the Indians were relatively recent arrivals. We now know that native Americans first arrived in the New World more than 12,000 years ago (see Chapter 5), and the mounds are all substantially younger.

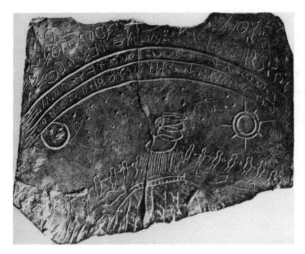

Figure 7.5 The Davenport tablets were frauds, placed in a mound to take advantage of public confusion in the late nineteenth century concerning the origin of Moundbuilder culture. The tablet shown here exhibits alphabetic characters from a number of European languages. (From Proceedings of the Davenport Academy of Natural Sciences, No. 1)

3. *There were alphabetically inscribed tablets in the mounds.*

Thomas had quite a bit to say concerning the supposed inscribed stone tablets. Though the myth of a vanished race of Moundbuilders was based largely on misinterpretation of actual archaeological and ethnographic data, hoaxes involving inscribed tablets also were woven into its fabric.

For example, in 1838, during an excavation of a large mound in Grave Creek, West Virginia, two burial chambers were found containing three human skeletons, thousands of shell beads, copper ornaments, and other artifacts. Among these other artifacts was a sandstone disc with more than twenty alphabetic characters variously identified as Celtic, Greek, Anglo-Saxon, Phoenician, Runic, and Etruscan (Schoolcraft 1854). Needless to say, translations varied tremendously and had in common only the fact that they were meaningless. The disc was certainly a fraud.

In another case, in 1877, the Reverend Jacob Gass discovered two inscribed slate tablets in a mound on a farm in Davenport, Iowa. One of the tablets had a series of inscribed concentric circles with enigmatic signs believed by some to be zodiacal. The other tablet had various animal figures, a tree, and a few other marks on one face. The reverse face had a series of apparently alphabetic characters from half a dozen different languages across the top, and the depiction of a presumed cremation scene on the bottom (Figure 7.5). Gass discovered or came into possession of a number of other

enigmatic artifacts ostensibly associated with the Moundbuilder culture, including two pipes whose bowls were carved into the shape of elephants.

The discoveries in Davenport generated great excitement. However, the fact that such a concentration of apparently conclusive finds regarding the Moundbuilder controversy had been discovered by a single individual within a radius of a few miles of one Iowa town caused many to question the authenticity of the discoveries.

Thomas launched an in-depth investigation of the tablets. Evidence from Gass's excavation indicated pretty clearly that the tablets had been planted only recently in the mound on Cook's farm. Thomas also believed that he had identified the source of the bizarre, multiple-alphabetic inscription. Webster's unabridged dictionary of 1872 presented a sample of characters from ancient alphabets. All of the letters on the tablet were in the dictionary, and most were close copies. Thomas suggested that the dictionary was the source for the tablet inscription (1894:641–42).

McKusick (1970) reports a confession by a Davenport citizen who alleged that the tablets and the other artifacts were frauds perpetrated by a group of men who wished to make Gass appear foolish. Though there are some significant problems with the confession (most notably the fact that the confessor was too young to have been an active participant in the hoax), the Davenport tablets were certainly fraudulent. More recently, McKusick (in press) has discerned the presence of lowercase Greek letters on the Davenport tablet. Lowercase Greek letters were not invented until medieval times. McKusick has also identified Arabic numbers, Roman letters, musical clefs, and ampersands (&) on the Davenport tablet. Their presence is clear proof of the fraudulent nature of the stone. In fact, no genuine artifacts containing writing in any Old World alphabet have ever been found in any of the mounds (see Chapter 6 regarding the authenticity of other supposed ancient inscriptions in North America).

4. *Indians were never witnessed building mounds and had no knowledge of who had built them.*

We next come to the claim that Indians were not moundbuilders at the time of European contact and even did not know who had built the mounds in their own territories. Thomas shows that this is nonsense. DeSoto's chronicler, the

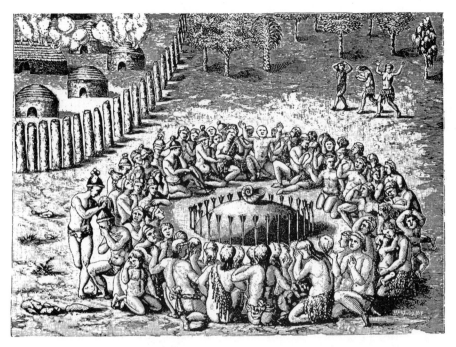

Figure 7.6 The notion that Indians could not have built the mounds was supported by the contention that no historic Indian group had ever been observed building or using earthworks. Yet such a claim was clearly inaccurate. There were a number of written reports and even artistic depictions like this one produced by Jacques Le Moyne in northeastern Florida in the 1560s that bore witness to mound use—here in a burial ceremony—by indigenous tribes. (From *Report on the Mound Explorations of the Bureau of American Ethnology*, by Cyrus Thomas)

Gentleman of Elvas, mentions the construction and use of mounds almost immediately in his sixteenth-century narrative. Describing the Indian town of *Ucita* he writes, "The lordes house stoode neere the shore upon a very hie mount, made by hand for strength" (1611:25).

Garcilaso de la Vega, though not a member of de Soto's expedition, compiled the notes of some of the 311 survivors (de Soto had died during the expedition). He describes how the Indians constructed the mounds upon which temples and the houses of chiefs were placed: "They built up such sites with the strength of their arms, piling up large quantities of earth and stamping on it with great force until they have formed a mound from twenty-eight to forty-two feet in height" (cited in Silverberg 1970:8). Beyond this, sixteenth-century artists depicted Indian burial practices that included the building of mounds for the interment of chiefs (Figure 7.6).

Nearly two hundred years later, at the turn of the eighteenth century, French travelers lived among the Natchez Indians at the mouth of the Mississippi River. They described the principal town of these agricultural Indians as possessing a mound one hundred feet around at its base, with the houses of leaders located on smaller mounds (Du Pratz 1774). William Bartram, at the end of the eighteenth century, mentions the fact that the houses of chiefs are placed on eminences. Even as late as the beginning of the nineteenth century, the explorers Lewis and Clark noted:

> I observed artificial mounds (or as I may more justly term graves) which to me is strong evidence of this country being once thickly settled. The Indians of the Missouris still keep up the custom of burying their dead on high ground. (Bakeless 1964:34)

There clearly was ample historical evidence of Indians building and using mounds. The ironic reason for the demise of at least some of the mound-building cultures of the Southeast was that de Soto accidentally introduced smallpox into these populations. Exposed to this deadly disease for the first time, the indigenous people had no immunity to it and died in great numbers. Large mound sites were abandoned as a result of the tragic consequences of this deadly epidemic.

5. *There were metal objects found in the mounds beyond the metallurgical skills of the Indians.*

Thomas carefully assessed the claim that some mound artifacts exhibited a sophistication in metallurgy attained only by Old World cultures. Not relying on rumors, Thomas actually examined many of the artifacts in question. His conclusion: all such artifacts were made of so-called *native copper* (Figure 7.7). Certainly this implied extensive trade networks. Michigan was the source of the raw material for the metal artifacts found as far away as Florida. There was no evidence, however, for metallurgical skills the Indians were not known to have possessed.

Thomas clearly had marshalled more evidence on the Moundbuilder question than had anyone before him. In a rather restrained fashion, he comes to this conclusion: "It is proper to state at this point, however, that the author believes the theory which attributes these works to the Indians . . . to be the correct one . . ." (1894:610).

With the publication of Thomas's *Report on the Mound Explorations of*

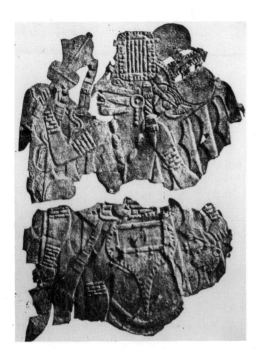

Figure 7.7 Moundbuilder metallurgy was restricted to the use of naturally occurring, pure copper without smelting, casting, or alloying. This photograph shows a hammered copper sheet depicting what may be a shaman or priest in a bird costume. This artifact was found at a well-known mound site, Etowah, in Georgia. (Smithsonian Institution)

the Bureau of American Ethnology, Moundbuilder archaeology had come of age. Its content was so detailed, its conclusions so reasonable that, though not accepted by all, the myth of a vanished race had been dealt a fatal blow.

Rationale for the Myth of a Vanished Race

The myth of a non-Indian, vanished race of moundbuilders was predicated not on a hoax or series of hoaxes, but on ignorance and selective acceptance of the data. Silverberg's thesis that the vanished race myth was politically motivated is well-founded; it was, as he says, "comforting to the conquerors" (1970:30).

Perhaps if the Indians were not the builders of the mounds and the bearers of a culture that impressed even the rather ethnocentric European colonizers of America, it made wiping out the presumably savage and primitive natives less troublesome. And, if Europeans could further convince themselves that the Indians were very recent interlopers—in fact, the very invaders who had savagely destroyed the gentle and civilized Moundbuilders—so much the better. And if, finally, it could be shown that the Moundbuilders were, in actuality, ancient European travelers to the Western Hemisphere, the circle was complete. In destroying the Indian people, Europeans in the eighteenth and nineteenth centuries could

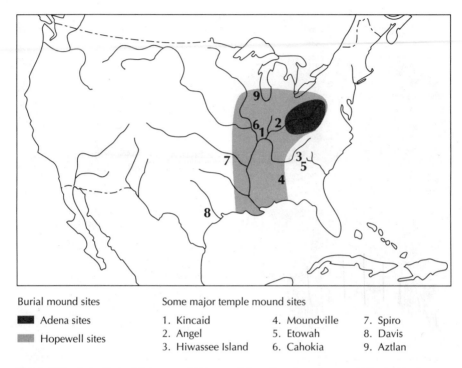

Burial mound sites

Some major temple mound sites

▮▮ Adena sites

▓▓ Hopewell sites

1. Kincaid
2. Angel
3. Hiwassee Island

4. Moundville
5. Etowah
6. Cahokia

7. Spiro
8. Davis
9. Aztlan

Figure 7.8 Location of Adena and Hopewell heartlands and some of the better known temple mound sites in the United States. Clearly, the geographical focus of Moundbuilder culture was the river valleys of the American Midwest and Southeast.

rationalize that they were only giving back to the Indians what they had meted out to the Moundbuilders and, in a sense, merely reclaiming territory once held by ancient Europe. The Moundbuilder myth was not just the result of a harmless prank or a confusing hoax. It was part of an attempt to justify the destruction of American Indian societies. We owe it to them to set the record straight.

▨▨▨▨▨▨▨▨ CURRENT PERSPECTIVES ▨▨▨▨▨▨▨▨
The Moundbuilders

An enormous amount of research has been conducted on the Moundbuilder culture in the last hundred years. We now realize that there was no one Moundbuilder culture but several, separated geographically and chronologically (Figure 7.8). The conical burial mounds are earlier and have been divided into two cultures: the *Adena* and the *Hopewell*. These both involved burial cults, long-distance trade, and the production of fine crafts and art

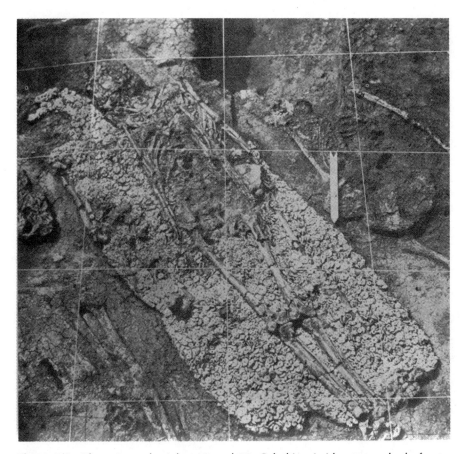

Figure 7.9 The primary burial at Mound 72, Cahokia. Laid out on a bed of some 20,000 drilled shell beads, the young male who was laid to rest here was likely an important person, perhaps a ruler of Cahokia. This sort of burial bears witness to a level of social stratification associated with complex civilizations. (Courtesy Illinois State Museum)

work. Both possessed mixed economies relying on wild plants and animals as well as domesticated crops, which eventually included corn. Their focus on life after death was made possible by the food surpluses such an economy produces.

Cahokia is part of a later culture of Moundbuilders. Here, large towns developed with substantial populations; Cahokia is certainly the largest, but others like Etowah in Georgia and Moundville in Alabama had populations in the thousands.

Old World civilizations like those of ancient Egypt and Sumer and New World civilizations like the Aztec and Maya are marked by stratified social systems. Kings, emperors, or pharaohs ruled with the help of noble and priestly classes. The nature of social stratification is exhibited quite clearly in the archaeology of their deaths; the tombs of pharaohs and kings

are large and sumptuous with concentrations of finely crafted art work, rare or exotic (and presumably expensive) materials, and even the presence of retainers—people killed and buried with the ruler to accompany him or her to the afterlife.

Cahokia too has evidence of just such a burial (Fowler 1974:20–22, 1975:7–8). Mound 72 represents the interment of members of a royal family of Cahokia. A young man was laid out on a platform of thousands of perforated shell beads that had, perhaps, been woven into a burial cloak (Figure 7.9). Nearby, three women and three men were buried, accompanied by stone weapons made from materials imported from Oklahoma and Arkansas as well as by sheets of mica from North Carolina. A two-by-three-foot sheet of copper from Michigan had also been included in their burial.

Another part of the mound contained the burials of four men, decapitated and with their hands cut off. Close by were the remains of fifty women, all in their late teens and early twenties. These likely were all individuals whose lives were sacrificed for the presumed needs of the rulers in their lives after death.

The evidence at Cahokia and other temple mound sites, as well as at sites of the Adena and Hopewell cultures, is clear. American Indians produced cultures of great sophistication and complexity. The only mystery that remains is why more Americans are not aware of the legacy of these indigenous civilizations.

Lost: One Continent—Reward

It was a beautiful land. Its people, gentle and fair, artistic and intelligent, created the most wonderful society the world has ever known. Their cities were splendid places, interwoven with blue canals and framed by crystal towers gently arching skyward. From its seaports, ships were sent out to the corners of the globe, gathering in abundant raw materials needed by its artisans and giving in return something far more valuable—civilization. The wondrous achievements of the archaic world can be traced to the genius of this singular ancient land. The cultures of the ancient Egyptians and the Maya, the civilizations of China and India, the Inca and the Sumerians were all derived from this source of civilization.

But tragedy was to strike down this great nation. In a cataclysmic upheaval of incomprehensible proportions, this beautiful land and its people were destroyed in a day and a night. Earthquakes, volcanic eruptions, and tidal waves, with forces never before or since unleashed by nature, shattered the crystal towers, sunk the great navy, and created a holocaust of incalculable sorrow.

All that remains are the traces of those derivative cultures that benefited from contact with this most spectacular source of all culture. But ancient Egypt, the Aztecs, the Chinese Shang, and the rest, as impressive as they were, could have been only the palest of shadows, the most tepid of imitations of the source of all human civilization.

This is the great irony of prehistoric archaeology; the most important of ancient cultures is beyond the grasp of even those archaeologists who investigate the corpses of great civilizations. For the original civilization of which we speak, the source of all human achievement, is *Atlantis*, the island

continent civilization that was obliterated beneath the seething waters of the Atlantic more than 11,000 years ago. Atlantis the fair; Atlantis the beautiful; Atlantis the source. Yes, and Atlantis the myth. It simply did not exist.

Atlantis: The Source of the Legend

Unlike many legends, the source of the Atlantis story is quite easy to trace. It all started with the Greek philosopher Plato. Plato was born in 429 or 428 B.C. He became a disciple of another great philosopher, Socrates, in about 390 B.C. and established his own school in 386 B.C. He was well known in his own time and is, of course, still studied and considered a great thinker more than 2,000 years after his death.

Plato apparently felt that the best way to teach was to engage his students in dialogues. Plato wrote many of his philosophical treatises in a dialogue format as well. In fact, most of his published work consists of imaginary conversations between Socrates and his students. The actual discussions Plato reported on never really took place; the published dialogues were not simply stenographic records. They usually included real people, but some of them lived at different times. It has been suggested that Plato used this format to present sometimes quite controversial ideas without getting in trouble with the authorities—he could always claim that the opinions were not his, but those of the people engaging in the dialogues (Shorey 1933). The format also allowed Plato to argue both sides of an issue without taking a stand himself.

The story of the Lost Continent of Atlantis was presented in two of Plato's dialogues: *Timaeus* and *Critias*. These dialogues are referred to by the names of the individuals who play the most significant roles in the discussions.

The Timaeus Dialogue

The Timaeus dialogue begins, oddly enough, with Socrates taking attendance. Socrates then refers to the previous day's discussion of the "perfect" society. It is clear in this context that the discourse Plato is referring to is his most famous dialogue, the *Republic*, actually written several years before *Timaeus*. Here, we are being asked by Plato to go along with the fiction that the *Republic* dialogue, where the nature of a perfect society had been discussed in great detail, was the product of yesterday's conversation.

Socrates next summarizes the characteristics of the hypothetical perfect culture presented in the *Republic*. Artisans and husbandmen would be separated from the military; and those in the military would be merciful, would be trained in "gymnastic" and music, would live communally, and would own no gold or silver or any private property.

Socrates, however, then despairs of hypothetical discussions, like the one presented in the *Republic*, of such a perfect society:

> I might compare myself to a person who, on beholding beautiful animals either created by the painter's art or, better still, alive but at rest, is seized with a desire of seeing them in motion or engaged in some struggle or conflict to which their forms appear suited (Hutchins 1952:443; all quotes from Plato's dialogues are from this translation).

Socrates next gives what amounts to an assignment:

> I should like to hear some one tell of our own city [his hypothetical perfect society] carrying on a struggle against her neighbors, and how she went out to war in a becoming manner, and when at war showed by the greatness of her actions and the magnanimity of her words, in dealing with other cities a result worthy of her training and education. (p. 443)

Socrates even explicitly instructs his students to engage "our city in a suitable war" to show how the perfect society would perform. One of those present, Hermocrates, tells Socrates that a fellow student, Critias, knows the perfect story. Critias then begins to give the account: "Then listen, Socrates, to a tale which though strange, is certainly true . . . " (p. 444).

Critias says that he heard this "true" story from his grandfather, who related the tale at a public gathering on a holiday that Plato scholar Paul Friedlander refers to as a kind of April Fool's Day (1969:383) when prizes are awarded for the best narrative. Critias's grandfather (also named Critias) said that he heard it from his father, Dropides, who heard it from the Greek sage Solon, who heard it from some unnamed priests in Egypt when he was there shortly after 600 B.C. So at best, when we read Plato, we are reading a very indirect account of a story that had originated more than 200 years earlier.

According to the tale told by Critias, the Egyptian priests told Solon that the Greeks are little more than "children" and know nothing of the many cataclysms that befell humanity in ancient times. They then go on to tell him of ancient Athens, which "was first in war and in every way the best governed of all cities" (p. 445). In fact, it is this ancient Athens of 9,300 years earlier, which in Critias's story will serve as the model of the perfect state.

The priests tell Solon of the most heroic deed of the ancient city of Athens; it defeated in battle "a mighty power which unprovoked made an expedition against the whole of Europe and Asia" (pp. 445–46). They continue by describing and identifying the evil power that so threatened the rest of the world: "This power came forth out of the Atlantic Ocean . . . an island situated in front of the straits, which are by you called the Pillars of Heracles" (p. 446). (Today they are called the Straits of Gibraltar.) The Egyptian

priests told Solon the name of this great power in the Atlantic Ocean: the island nation of Atlantis.

Ancient Athens was able to subdue mighty Atlantis, which had held sway across northern Africa all the way to Egypt. After her defeat in battle, all of Atlantis was destroyed in a tremendous cataclysm of earthquakes and floods. Unfortunately, ancient Athens also was destroyed in the same catastrophe.

After outlining the Atlantis story, Critias remarks to Socrates:

> When you were speaking yesterday about your city and citizens, the tale which I have just been repeating to you came into my mind, and I remarked with astonishment how, *by some mysterious coincidence*, you agreed in almost every particular with the narrative of Solon. (p. 446, emphasis mine)

Following this brief introduction to the story, Critias cedes the floor to Timaeus who provides a very detailed discussion of his theory of the origins of the universe. In the next dialogue, *Critias*, details of the Atlantis story are provided.

The Critias Dialogue

Critias appears to have listened well to his teacher's description of the perfect society; for in his tale ancient Athens, even in detail, matches precisely the hypothetical society of Socrates. According to the story Critias told, in ancient Athens, artisans and husbandmen are set apart from the military, military men owned no private property and possessed no gold or silver, etc.

Only after first describing ancient Athens does Critias describe Atlantis. He relates that Atlantis was originally settled by the Greek god Poseidon and a mortal woman, Kleito, who bore him five sets of male twins. All Atlanteans were descended from these ten males. The Atlanteans became quite powerful and built a fifteen-mile-wide city of concentric rings of alternating land and water, with palaces, huge canals, towers, and bridges. They produced art works in silver and gold and traded far and wide. They possessed a great navy of 1,200 ships and an army with 10,000 chariots. Their empire and their influence expanded exponentially.

After a time, however, the "divine portion" of their ancestry became diluted and the human portion became dominant. As a result, their civilization became decadent, the people depraved and greedy. The dialogue relates that Zeus, the chief god in the Greek pantheon, decides to teach the inhabitants of Atlantis a lesson for their avarice and prideful desire to rule the world. Zeus gathers the other gods together to relate his plan. The dialogue ends unfinished at just this point, and Plato never returned to it, dying just a few years later.

The Source and Meaning
of Timaeus and Critias

Though briefly summarized here, this is the entire story of Atlantis as related in Plato's dialogues. All else written about Atlantis is derivative or invented.

It is ironic, however, that this source of the popular myth of Atlantis, while having spawned some 2,000 books and articles (de Camp 1970) along with a couple of periodicals (*Atlantis* and *The Atlantis Quarterly*), isn't really about Atlantis at all. The lost continent is little more than a plot device. The story is about an ostensible ancient *Athens*. Athens is the protagonist, the hero, and the focus of Plato's tale. Atlantis is the antagonist, the empire gone bad in whose military defeat by Athens, the functioning of a perfect society as defined by Socrates can be exemplified.

There is another key point to be made here. Though Atlantis was supposed to have been destroyed more than 9,300 years before Critias tells the story (about 9600 B.C.), no reference to Atlantis or anything even re- motely resembling the Atlantis story has ever been found that dates to before Plato's writing of these dialogues in about 350 B.C.

There are absolutely no records in Egypt, where Solon is supposed to have been told the tale, or anywhere else, of the Atlantis story. Though the story was allegedly first told at a public gathering and though Critias claims in the dialogue that bears his name that his great-grandfather possessed a written version of the story, there is no mention of Atlantis anywhere else in Greek literature.

The appearance of the name *Atlantis* in *Timaeus* is the first historical reference to the place. The 9,300 years or so between the supposed destruc- tion of Atlantis and Plato's *Timaeus* are completely silent concerning the supposed lost continent.

Remember also that the story Critias relates here is the direct result of Socrates having asked his students the previous day to come up with a tale in which his hypothetical perfect state is put to the test by warfare. Critias relates the story of a civilization conveniently enormously distant from his Athens in both time and space, whose remnants are below the Atlantic, certainly beyond recovery or testing by the Greeks of Plato's time. He also has ancient Athens, which would not have been beyond the purview of contemporary Athenians to study, conveniently destroyed. Finally, though maintaining it is a true tale, he admits that "by some mysterious coincidence," it matches Socrates' hypothetical society almost exactly. As A. E. Taylor has said, "We could not be told much more plainly that the whole narrative of Solon's conversation with the priests and his intention of writing the poem about Atlantis are an invention of Plato's fancy" (1962:50).

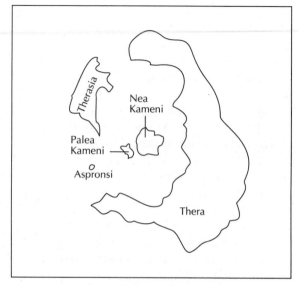

Figure 8.1 The island of Thera in the Mediterranean today is the remnant of a volcano that exploded some 1,500 years ago. It has been suggested that the historical explosion of the volcano served as a model for Plato's story of the destruction of Atlantis.

Where Did Plato Get the Story?

Was the claim in *Timaeus* of veracity for a mythical story unique in Plato's work? Absolutely not. As historian William Stiebing, Jr., states, "Virtually every myth Plato relates in his dialogues is introduced by statements claiming it is true" (1984:51). It is not only the Atlantis account, but also tales about heaven and hell (Isles of the Blessed and Tartarus) in *Georgias*, immortality and reincarnation in *Meno*, antiquity in *Laws*, and the afterlife in the *Republic* that are prefaced with statements attesting to their truth (Stiebing 1984:52).

The final question to be asked is, If the Atlantis story is a myth, was it at least based on a real event or series of events? The answer is almost certainly yes; in a sense, all fiction must be based on fact. All writers begin with knowledge of the real world and construct their literary fantasies with the raw material of that knowledge. Plato was no different.

For example, Galanopoulos and Bacon (1969) have attempted to show that Plato's Atlantis story was derived from historical events that led to the destruction of the Minoan civilization of Crete. In about 1500 B.C., a spectacular volcanic eruption decimated the island of Thera (also called Santorini) in the Mediterranean (Figure 8.1). Galanopoulos and Bacon propose that the dating, distances, and proportions in Plato's account are erroneous as a result of mistranslation and off by a factor of ten. When this is corrected, they claim that Plato's story fits the Thera explosion.

As recent archaeological excavations have shown, the eruption on Thera destroyed a sizeable harbor town on the island itself. This, however,

Figure 8.2 Those who support the hypothesis that the eruption on Thera is the source of the story of the destruction of Atlantis have suggested that the Minoan civilization on Crete was the historical model for Atlantis culture. Pictured here is an ancient temple on Crete dating to Minoan times. (M. H. Feder)

was likely not a significant enough event to have produced the Atlantis legend. Thera, however, was part of the civilization of Minoan Crete, an impressive culture with beautiful temples, a written language, and trading networks that extended as far as Egypt. Galanopoulos and Bacon suggest that the explosive eruption on Thera would have destroyed the Minoan civilization (Figure 8.2). They maintain that following the eruption, the walls of the volcanic mountain collapsed into the sea, precipitating seismic sea waves or *tsunamis* which would have inundated Minoan port cities (1969:110–11). The authors claim that this catastrophe made an impression even on the distant Egyptians who, more than 1,000 kilometers away, would probably have heard the main eruption. They certainly would have lost contact with their Minoan trading partners, whose merchant fleet would have been destroyed.

There are, however, many problems with identifying Minoan Crete as the single source for Plato's Atlantis. Significantly, the major theme of Plato's story, the defeat by Athens of a great military power remains unexplained here. Minoan Crete did not suffer a major military defeat at the

hands of Athens. Beyond this, as Stiebing points out, archaeology on Crete indicates that Minoan civilization survived the eruption on Thera. The supposed great tsunami may have instead been a longer series of much smaller, less destructive waves, if the volcano did not collapse all at once.

Plato's *Timaeus* and *Critias* certainly are not historical accounts of actual events involving a real place and similarly are not the slightly jumbled accounts of genuine history. They are, instead, part of a fantasy concocted by the philosopher, but anchored in his reality. That reality likely included some knowledge of the destruction of Thera and, just as importantly, knowledge of the actual historical defeat by Athens, largely alone, of Persian invaders of Greece in 492–479 B.C. (Hartmann 1987). But ultimately, it must be admitted, as Plato scholar Paul Shorey concludes: "Atlantis itself is wholly his [Plato's] invention, and we can only divine how much of the detail of his description is due to images suggested by his reading, his travels, and traveler's tales" (1933:351).

After Plato

After Plato died, leaving the Critias dialogue and the Atlantis story incomplete, we find no mention of the lost continent for more than three hundred years (de Camp 1970:16). We have to rely on later writers like the Greek geographer Strabo, who was born in about 63 B.C., for some insight into what those who followed Plato thought about his account of a lost continent. Strabo claimed, for example, that, in reference to Atlantis, Plato's best-known student Aristotle said "he who invented it also destroyed it" (as cited in de Camp 1970:17). It seems that many, though not all, who followed Plato viewed Atlantis as an invention, a part of a story whose moral is, as A. E. Taylor has said:

> ... transparently simple. It is that a small and materially poor community [ancient Athens] animated by true patriotism and high moral ideals can be more than a match for a populous and wealthy empire [Atlantis] with immense material resources but wanting in virtue. (1962:50)

It is not until the Age of Exploration and the discovery of the New World that consideration of the veracity of the Atlantis story became popular. For example, as we saw in Chapter 5, Huddleston (1967) points out that in 1552 the Spaniard Lopez de Gomara suggested that American Indians were a remnant population of emigrés from the Lost Continent of Atlantis. Gomara based his interpretation on a linguistic argument concerning a single word; in the Aztec language of Nahuatl, the word *atl* means water (Huddleston 1967:25).

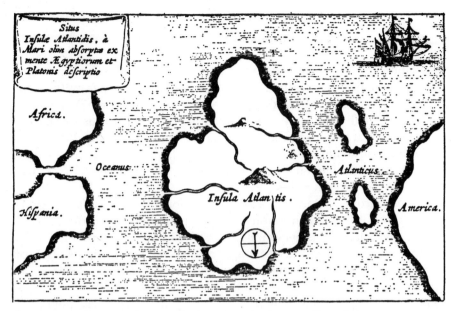

Figure 8.3 1644 map showing the location of Atlantis in the Atlantic Ocean. Note that south is to the top of the map. (From *Mundus Subterraneus* by Athanasius Kircher)

Later, in 1572, Pedro Sarmiento de Gamboa maintained that the great civilizations of the New World were partially derived from Atlantis. In the seventeenth century maps were drawn placing Atlantis in the Atlantic Ocean (Figure 8.3). Some, like the Englishman John Josselyn (1865), even identified the New World *as* Atlantis.

Diego de Landa, the Spanish bishop of the Yucatán, contributed to the confusion concerning the Atlantis controversy. He incorrectly determined that the written language of the Maya was alphabetic. Though we know the Mayan written language was hieroglyphic, with individual signs representing complete words, names, concepts, or sounds, de Landa constructed an alphabet of genuine Mayan hieroglyphs, artificially assigning them letter designations. Based on this complete misrepresentation of the Maya language, a French scholar, Abbé Charles-Étienne Brasseur (called de Bourbourg) "translated" a Mayan book, the Troano Codex, in 1864. It was a complete fantasy and contained elements of the Atlantis story, particularly destruction by flood. Using the same delusional alphabet, Augustus Le Plongeon also translated the Codex, coming up with an entirely different story, connecting the Maya to the ancient Egyptians. It was all complete fabrication, but it kept alive the notion that perhaps the civilizations of the Old and New Worlds could somehow be connected and perhaps explained by reference to Atlantis.

Ignatius Donnelly:
The Minnesota Congressman

Speculation concerning the possible reality of Plato's Atlantis story might have ended in the eighteenth or nineteenth centuries, as other myths were abandoned while scientific knowledge expanded (see Chapter 5). We have one man to thank—or blame—for this not happening: Ignatius Donnelly.

Donnelly was born in 1831. He studied law, and at only 28 years of age, became the lieutenant governor of Minnesota. He later went on to serve several terms in the federal House of Representatives and twice ran for vice-president of the United States.

By all accounts, Donnelly was an exceptional individual, a voracious reader who collected an enormous body of information concerning world history, mythology, and geography. Clearly, however, he was less than selective in his studies and seemingly was incapable in his research of discriminating between the meaningful and the meaningless. Donnelly is certainly the father of modern Atlantis studies and, as writer Daniel Cohen (1969) has aptly put it, his book *Atlantis: The Antediluvian World*, published first in 1882, is the "bible" of belief in the legend. (Parenthetically, it is interesting to note that in his book *The Great Cryptogram*, Donnelly is also an early source for the claim that Sir Francis Bacon wrote all of Shakespeare's plays.)

Donnelly's *Atlantis the Antediluvian World* is an amazing piece of inductive scholarship. While being obsessive in his collecting of "facts," Donnelly had very little of a scientific, skeptical sense. His approach was indiscriminate. Essentially, he seems never to have met a claim about Atlantis that he didn't like and accept.

He begins his book by asserting that he will prove that the Atlantis story as told by Plato is not legend, but "veritable history" (1882:1); that Atlantis "was the region where man first rose from a state of barbarism to civilization" (p. 1); and that it was the source of civilization in Egypt, South America, Mexico, Europe, and North America, where he specifies the Moundbuilder culture (Figure 8.4).

Donnelly's argument is a confusing morass of disconnected claims and ostensible proofs. He does little more than enumerate supposed evidence; this is diagnostic of the purely inductive method of reasoning he employed. Nowhere does he attempt to test the implications of his hypotheses—what must be true if some of his specific claims also are true. To be sure, we cannot fault Donnelly for failing to apply to the argument data unknown during his lifetime. We can, however, fault his general approach and do what he failed to—test out the implications of his claims.

For example, he cites numerous flood legends in various world cultures, all of which he presumes are part of some universal memory of the destruction of Atlantis. His reasoning is that lots of legends referring to a similar event must indicate that the event actually happened. If this were

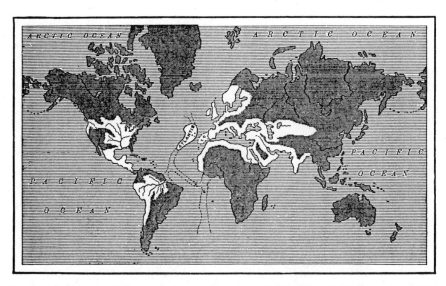

Figure 8.4 Ignatius Donnelly saw all of the world's ancient civilizations as having been derived from that of Atlantis. Here, Donnelly maps (in white) the extent of Atlantis's influence, including the cultures of ancient Egypt, Mesopotamia, Mesoamerica, as well as the Moundbuilders of the United States. (From *Atlantis: The Antediluvian World*, by Ignatius Donnelly)

true, we should be able to show that the legends were all independently derived stories that match, at least in terms of their important generalities. This turns out not to be true. Several of his supposed corroborating myths sound quite similar, not because they relate to an actual historical event, but because they can be traced to the same source.

For example, the reason the biblical flood story (Donnelly says it is really about the cataclysm that destroyed Atlantis) and the Babylonian flood story are quite similar in their particulars is because the ancient Hebrews spent time in Babylonia and picked up the older flood legend from local people. When American Indian tribes related flood stories, they often did so to missionaries who had already instructed them in Genesis. Some tribes already possessing flood stories could easily have incorporated the details of Genesis into their mythology. Applying Occam's Razor here, which is the simpler explanation? One requires a lost continent for which there is no evidence; the other simply presumes that Indians would have incorporated new stories told them by missionaries into their own myths.

While Donnelly spends quite a bit of time arguing that catastrophes like those that presumably befell Atlantis could and did happen, this is not the crux of his argument. Reasoning based on *cultural* comparisons is central to his methodology. He maintains: "If then we prove that, on both sides of the Atlantic, civilizations were found substantially identical, we

have demonstrated that they must have descended one from the other, or have radiated from some common source" (1882:135).

This argument for the significant role of *diffusion* in cultural development was common in anthropology in the late nineteenth and early twentieth centuries (Harris 1968). The presumption seems to have been that cultures are basically uninventive and that new ideas are developed in very few or even single places. They then move out or "diffuse" from these source areas. It was fairly common to suggest that Egypt was the source of all civilization, that agriculture, writing, monumental architecture, and the like were all invented only there. These characteristics, it was maintained, diffused from Egypt and were adopted by other groups.

Donnelly was a diffusionist. Rather than Egypt, Sumer, or some other known culture, for him the common source of all civilization was Atlantis. In his attempt to prove this, he presents a series of artifacts or practices that he finds to be identical among the civilizations of the Old and New Worlds. In these comparisons, Donnelly presents what he believes is the clearest evidence for the existence of Atlantis. His evidence essentially consists of trait list comparisons of the sort discussed in Chapter 5. Let us look at a few of these and do what Donnelly did not; test the implications of his claims.

1. *Egyptian obelisks and Mesoamerican stelae are derived from the same source* (Donnelly 1882:136).

 Donnelly finds that the inscribed obelisks of Egypt are virtually identical to the inscribed stelae of the Mayan civilization. He does little more than make this assertion before he is off on his next topic. But it is necessary to examine the claim more closely and to consider the implications. If it were, in fact, the case that Egyptian obelisks and Mayan stelae were derived from a common source, we would expect that they possessed similarities both specific and general. Yet, their method of construction is different; they are different in shape, size, and raw materials; and the languages inscribed on them are entirely different (Figure 8.5). They are similar only in that they are upright slabs of inscribed rock. It is not reasonable to claim that they must have been derived from a common source. They are simply too different.

2. *The pyramids of Egypt and the pyramids of Mesoamerica can be traced to the same source* (Donnelly 1882:317–41).

 Here again, if this hypothesis were true, we would expect that these pyramids would share many specific features. The pyramids of the Old and New Worlds, however, do not look the same (Figure 8.6). New World pyramids are all truncated

Figure 8.5 Donnelly felt that Egyptian obelisks and Mayan stelae were so similar that they must have originated in the same place—Atlantis. Yet here it can be seen that obelisks, like these from Karnac in Egypt [left], were inscribed, four-sided columns, while stelae, like this one from the Temple of the Warriors at Chichén Itzá [right], were flat blocks of inscribed limestone. They are quite different and do not warrant any connections via a lost continent. (Left, M. H. Feder)

with flat tops, while Egyptian pyramids are pointed on top. New World pyramids have stairs ascending their faces, Egyptian pyramids do not. New World pyramids served as platforms for temples; Egyptian pyramids were burial chambers for dead pharaohs (only a very few Mesoamerican pyramids contain burials). Construction methods were different; most Egyptian pyramids represent a single construction episode, while Meosamerican pyramids usually represent several building episodes, one on top of another. Finally, if Meosamerican and Egyptian pyramids are hypothesized to have been derived from the same source (Atlantis or elsewhere), they should date from the same period. But Egyptian pyramids were built between about 5,000 and 4,000 years ago. Those in Mesoamerica are all less than 3,000 years old—most are considerably younger, dating to less than 1,500 years ago. All pyramids

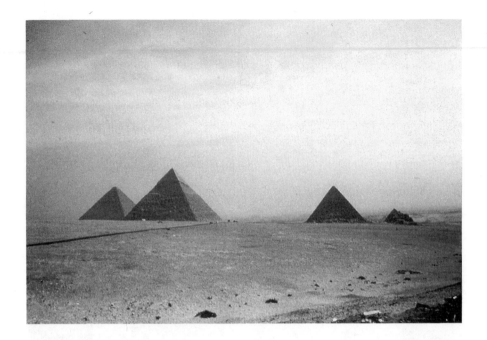

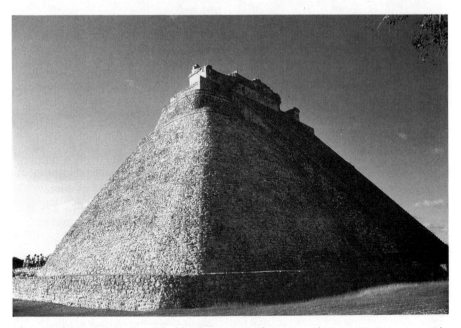

Figure 8.6 Egyptian pyramids, like these at Gizeh [top], and Mesoamerican pyramids, like the Pyramid of the Magician at the Mayan site of Uxmal [bottom], are quite different in construction, form, function, and chronology. Donnelly was thoroughly unjustified in claiming a connection—via Atlantis—between pyramid building in the Old and New Worlds. (Top, M. H. Feder)

date to well after the supposed destruction of Atlantis some 11,000 years ago.

3. *Ancient cultures in the Old and New Worlds possessed the arch* (Donnelly 1882:140).

This is simply not true. Cultures in the Old World possessed the true arch with a keystone—the supporting wedge of stone at the top of the arch that holds the rest of the stones in place. New World cultures did not have knowledge of the load-bearing keystone.

4. *Cultures in the Old and New Worlds both produced bronze* (Donnelly 1882:140).

This is true, but Donnelly does not assess the implications of the claim that Old and New World metallurgies are derived from a common source. For this to be the case, we would expect the technologies to share many features in common. Bronze is an alloy of copper and some other element. Old World bronze is usually an alloy of copper and tin. In the New World, bronze was generally produced by alloying copper and arsenic (though there is some tin bronze). With such a basic difference in the alloys, it is unlikely that there is a common source for Old and New World metallurgy.

5. *Civilizations in both the Old and New Worlds were dependent on agricultural economies for their subsistence. This indicates that these cultures were derived from a common source* (Donnelly 1882:141).

It is almost certainly the case that cultures that we would label "civilized" are reliant on agriculture to produce the food surplus necessary to free the number of people required to build pyramids, produce fine art works, be full-time soldiers, etc. But again, for this to support the hypothesis of a single, Atlantean source for Old and New World agriculture, we would expect there to be many commonalities, not the least of which would be the same or similar crops. That this was not the case certainly was known to Donnelly. Old World civilizations planted wheat, oats, and barley in Southwest Asia and Egypt, and rice and millet in China. New World civilizations depended on corn, beans, and squash. Civilizations in the Old World raised cows, sheep, goats, and pigs. In the New World, only the llama, alpaca, and the guinea pig were domesticated.

The agricultural bases of Old and New World civilizations were entirely different. This is far more suggestive of separate evolution of their economies than of their having been derived from a common source. Recent archaeological investigations have further supported this fact by showing that, in both the Old and New Worlds, agriculture evolved in place over thousands of years. It was not introduced wholesale from somewhere else.

By failing to consider the implications of his claims of connections between the cultural practices of Old and New World civilizations, Donnelly was easily led astray by their superficial similarities. Ever-hopeful and convinced of the legitimacy of his argument, Donnelly ended *Atlantis: The Antediluvian World* by stating:

> We are on the threshold. Scientific investigation is advancing in great strides. Who shall say that one hundred years from now the great museums of the world may not be adorned with gems, statues, arms, and implements from Atlantis, while the libraries of the world shall contain translations of its inscriptions, throwing new light upon all the past history of the human race, and all the great problems which now perplex the thinkers of our day? (p. 480)

It has been more than one hundred years since Donnelly wrote these words and Atlantis the fair and the beautiful is as distant as it was when Plato constructed it out of the stuff of his imagination more than 2,000 years ago.

Atlantis After Donnelly

Donnelly was certainly the most important of the Atlantis scholars, but he was not the last. While today we may criticize his reasoning, it is far and away superior to that of many who followed him. Scottish mythologist Lewis Spence (1926), for example, eschewing the "tape-measure school" (p. 2) of archaeology, opts for "inspirational methods" (p. 2). Where Plato placed one imaginary continent in the Atlantic, Spence put two; he added an Antilla to accompany Plato's invention. Spence suggests that not one, but a series of cataclysms befell Atlantis. One of the first of these occurred about 25,000 years ago. It resulted in the earliest settlement of Europe by modern humans. Spence identifies so-called Cro-Magnon Man, the oldest fossils of completely modern-looking humans in Europe, as refugees from Atlantis (1926:85). Spence identifies the famous cave paintings and sculptures of ancient Europe (see Figures 12.1 and 12.2 of this book) that date to sometime after 25,000 years ago as reflecting the art work of the displaced Atlanteans.

Among the most extreme Atlantis speculators were the *Theosophists,* members of a very strange sect founded by Helena P. Blavatsky (1888) in the late nineteenth century. Their philosophy included some quite peculiar beliefs about stages of human evolution—they called them "root races." In one stage we humans were, apparently, astral jellyfish and, in another stage, four-armed, egg-laying hermaphrodites. The fourth stage or race lived on Atlantis, where they flew around in airplanes, bombed their enemies with explosives, and grew a form of wheat imported from extraterrestrial space aliens. They also believed that there was a Pacific counterpart to Atlantis called *Mu.* Blavatsky and her followers—not surprisingly, I think—made little effort to support the veracity of such claims.

The web of Atlantis fantasies continues to be spun in the twentieth century. Self-proclaimed psychic Edgar Cayce claimed that knowledge gained from Atlantean texts (Cayce 1968; Noorbergen 1982) enabled him to predict the future and effect cures on terminally ill people. That his Atlantis-derived predictions were not terribly accurate can be shown by the following fact: speaking in the 1940s, Cayce predicted that great upheavals, including the destruction of much of the eastern coast of the United States, would accompany the reemergence of parts of Atlantis. When was this to happen? In 1968 or 1969 (Cayce 1968:158–59).

More recently, a self-professed trance channeler, J. Z. Knight, has claimed to be a conduit for an ancient spirit called Ramtha, who was born on Atlantis more than 35,000 years ago (Alcock 1989). Ramtha provides platitudes and investment counseling to the paying faithful.

Indeed, the legend of Atlantis did not die with Plato, nor did it die with Donnelly. It seems constantly to shift, filling the particular needs of the time for a golden age when great warriors, ingenious scientists, astral jellyfish, or monetarily inclined spirits walked the earth. It seems ironic, ultimately, that in trying to convey a rather simple message, one of the great rational minds of the ancient world produced fodder for the fantasies of some of the less-than-great, nonrational minds of the modern world. If only we could trance channel Plato, I wonder what he would say? I doubt that he would be pleased.

CURRENT PERSPECTIVES
Atlantis

According to Plato's story, Atlantis was defeated in battle by a humble, but quite advanced Athenian state some 11,000 years ago. What does modern archaeology tell us about ancient Greece from this period? Is there any physical evidence in the Atlantic Ocean for the civilization of Atlantis?

What does modern geology tell us about the possibility of a lost continent in the Atlantic?

Ancient Greece

Simply stated, there was no Athenian state 11,000 years ago. Such a statement is based not on legends and stories but on the material remains of cultures that inhabited the country. South of Athens, for example, a site has been investigated that dates to around the same time as the claimed Athenian defeat of Atlantis. The site, Franchthi Cave, has been excavated by archaeologist Thomas Jacobsen (1976).

More than 10,000 years ago, the inhabitants of the cave were not members of an "advanced" culture. They were simple hunters and gatherers, subsisting on red deer, wild cattle, and pigs. They also collected mollusks, snails, small sea fish, and wild plant foods, including barley and oats. They were a Stone Age people and obtained obsidian—a volcanic glass that can produce extremely sharp tools—from the nearby island of Melos. It is not until 6000 B.C. that there is evidence of the use of domesticated plants and animals by the inhabitants of the cave. Evidence at other sites in Greece conforms to the pattern seen at Franchthi. Cultures that we would label as "civilized" do not appear in Greece for thousands of years. The Greek world of 11,000 years ago is nothing like Plato imagined.

Archaeological Evidence in the Atlantic: The Bimini Wall

Claims have been made that there is archaeological evidence of submerged walls and roads off the coast of Bimini in the Bahamas. Just as the self-proclaimed seer Edgar Cayce maintained that the island of Bimini was a remnant of Atlantis, modern Atlantis popularizers have claimed that the features constituted direct empirical evidence for the existence of the lost continent (Berlitz 1984).

Apparently in the 1960s some divers indeed found tabular limestone blocks that they interpreted as being parts of a road and wall as well as supposed columns from a submerged building. However, on close inspection, geologists and archaeologists determined that the so-called wall and road were natural features (Harrison 1971; McKusick and Shinn 1981). What had been interpreted by the divers as the interstices of masonry blocks were nothing more than the natural joints of limestone beachrock that forms rapidly under water. Such rock erodes as a result of tidal forces, and breaks or joints tend to occur at regular intervals and at right angles to each other. Similarly jointed natural beachrock has been observed off the coast of Australia (Randi 1981).

More than 200 million years ago

180 million years ago

65 million years ago

Present

Figure 8.7 We now recognize that the present configuration of the continents is the result of the movement of so-called "plates" that make up the earth's crust. The boundaries of two plates meet in the mid-Atlantic where Atlantis was supposed to have been. But here the two plates are separating, with new material being extruded through the intersection—quite the opposite of what would be required for a landmass to be drawn down below the Atlantic. (From Feder and Park, *Human Antiquity*, Mayfield Publishing)

Analysis of the so-called columns shows that they are simply hardened concrete of a variety manufactured after A.D. 1800 (Harrison 1971:289). The columns likely resulted when barrels of the dry ingredients of the concrete were thrown or washed overboard. The concrete hardened after mixing with water and the wood barrels decayed, leaving what may appear to some to be fragments of building columns.

The Bimini wall, road, and columns simply are not archaeological artifacts derived from Atlantis. They are, instead, readily understood natural and recent cultural features.

The Geology of the Atlantic

There is no evidence in the Atlantic Ocean for a great submerged continent. In fact, our modern understanding of the geological processes of *plate tectonics* rules out this possibility.

The earth's crust is not a solid shell, but consists of a number of geologically separate "plates." The plates move, causing the continents to drift. In fact, we know that the present configuration of the continents was different in the past (Figure 8.7). More than 200 million years ago, the continents were all part of a single landmass we call *Pangea*. By 180 million years ago, the continents of the Northern Hemisphere (*Laurasia*) parted company with the southern continents (*Gondwanaland*). The separation of the continents of the Eastern and Western Hemispheres and the formation of the basin of the Atlantic Ocean occurred sometime before 65 million years ago. The Atlantic has been growing ever since, as the European and North American plates have continued to move apart, the result of expansion of the seabed along the intersection of the plates. Movement along the Pacific and North American plates resulted in the destructive earthquake that hit the San Francisco/Oakland area in October 1989.

A ridge of mountains has been building for millions of years at the intersection of the two crustal plates that meet in the Atlantic; material is coming up out of the plate intersection, landmasses are not being sucked down below the ocean. The geology is clear; there could have been no large land surface that then sunk in the area where Plato places Atlantis. Together, modern archaeology and geology provide an unambiguous verdict: There was no Atlantic continent; there was no great civilization called Atlantis.

Prehistoric E.T.:
The Fantasy
of Ancient Astronauts

Gods in Fiery Chariots

It was in 1968 that the controversy over ancient astronauts first erupted with the initial publication of *Chariots of the Gods?* The Swiss author of the book, Erich von Däniken, proposed that there was indisputable and copious archaeological support for his claim that extraterrestrial aliens had visited the earth in prehistory and had played a significant role in the development of humanity.

In *Chariots of the Gods?* it seemed that the ramblings of the authors of *The Morning of the Magicians* (see Chapter 1) had been blown up into a full-scale anthropological theory (though, curiously, von Däniken never credits that book as the source of his ideas; he never even mentions it in *Chariots of the Gods?*). Where Pauwels and Bergier (1960) limited themselves to a few bizarre suggestions concerning a small number of archaeological sites, von Däniken had constructed an incredible fantasy about the entire prehistory of the human species.

There seemed to be three implicit hypotheses behind von Däniken's ideas (1970, 1971, 1973, 1975, 1982):

1. All over the world there are prehistoric pictorial and three-dimensional representations—drawings on cave walls, pottery, and sculptures—as well as early written accounts that can be most reasonably interpreted as the drawings, sculptures, or literary descriptions by primitive people of actual extraterrestrial visitors to earth.

2. The biological evolution of the human species cannot be understood unless we assume the involvement of a scientifically advanced extraterrestrial civilization.

3. Some ancient artifacts and inventions are far too advanced and complex to have resulted from simple, prehistoric human intelligence and ingenuity. These advanced artifacts and great inventions must instead be the direct result of purposeful introduction by extraterrestrial aliens. Let's assess these claims one at a time.

Hypothesis 1

The first implicit claim concerns the existence of prehistoric drawings or sculptures of aliens from outer space and early writings about their visits. It is an intriguing thought. Hundreds, thousands, even tens of thousands of years ago, flying saucers or spaceships landed on our planet in a burst of fire and smoke. Out came space-suited aliens, perhaps to take soil samples or study plant life (just like E.T. in the Spielberg movie). Upon completion of their mission, they got back into their spaceships and took off for home.

Secreted in the bushes, behind the rocks, an ancient human sat transfixed, having watched the entire scene unbeknownst to our alien friends. This Cro-Magnon, or Neolithic, or Medieval man rushed home to tell others of the marvelous sight of the fiery "chariots" of the "gods" (thus, the title for von Däniken's book) that had come down from heaven. He would tell of how the Gods or angels (or devils) had silver skins (spacesuits) and bubble-heads (space helmets). Artistic renderings would be made on cave walls and pots. Descriptions would be passed down from generation to generation, especially if the space Gods came back again and again, reinforcing the entire idea of Gods from the heavens. Descriptions would be written of the wondrous spectacle of the Gods coming to earth. Our ancestors would wait for their return, as perhaps we wait to this very day.

Fascinating? Undoubtedly! Wonderful, if true? Absolutely! Backed up by inductive and deductive scientific reasoning, evidence, and proof? Unfortunately, no.

This first von Däniken scenario can be called the *Inkblot Hypothesis*. I am sure that you are all familiar with "inkblots" used in psychological testing (called Rorschach tests after their originator). The idea is to show a person a series of inkblots (images made by dripping ink on paper, which is then folded and pressed while the ink is still wet) and then ask what they see. The rationale for such an exercise is quite simple. Since there really are no specific, identifiable images in the random inkblot pictures, the image that you recognize comes entirely from your imagination. Therefore, your description of what you see in the inkblots should give a psychologist an

Figure 9.1 Applying von Däniken's perspective to artifacts like this antler mask from the Moundbuilder site of Spiro (see Chapter 7) in Oklahoma, one might conclude that it represents a space-helmeted, extra-terrestrial alien, complete with antennae. The application of Occam's Razor demands we first consider more mundane explanations. The mask likely was used in ceremonies where a priest or *shaman* portrayed a deer spirit. (Photo by Carmelo Guadagno. Courtesy of the Museum of the American Indian, Heye Foundation)

idea of what is going on in your mind. It might tell him or her something about your personality, feelings, and so on.

The point is that the picture seen in an inkblot is entirely dependent upon the mind of the viewer. The images themselves are not necessarily anything in particular. They are whatever you make them out to be, whatever you want them to be.

Von Däniken's approach is analogous to an inkblot test. Although he is describing actual images, these images belong to a different culture. Without an understanding of the religious, artistic, or historic contexts of the drawings or images within the culture that produced them, von Däniken's descriptions of the images tell us more about what is going on in his mind than about what was in the minds of the ancient artists.

For example, an image identified by von Däniken as an astronaut with a radio antenna might be more easily explained as a shaman or priest with an antler headdress (Figure 9.1). Von Däniken sees spacemen because he wants to, not because they really are there.

Here is another example. High up on a plain in the Andes Mountains, prehistoric people called the *Nazca* constructed a spectacular complex of shapes on the highland desert (Kosok and Reiche 1949; Reiche 1978;

Figure 9.2 This Nazca *geoglyph* or earth-drawing depicts a monkey. Large-scale drawings like those at Nazca are known from a number of places in the world. They likely were intended to please the gods and were constructed with the use of scale models. They certainly did not require the intervention of extraterrestrials—and why would aliens from outer space instruct ancient humans to draw giant monkeys, spiders, snakes, and the like, in the first place? (Photo by Bates Littlehales © National Geographic Society)

McIntyre 1975). Most are long lines, etched into the desert surface, criss-crossing each other at all angles. The most interesting, however, are actual drawings, rendered on an enormous scale (some are hundreds of feet across), of animals such as fish, monkeys, and snakes (Figure 9.2).

The figures and lines were made by clearing away the darker surface rocks, exposing the lighter desert soil beneath. They are remarkable achievements because of their great size, but certainly not beyond the capabilities of prehistoric people. Remember, these drawings were not carved into solid rock with extraterrestrial lasers; they were not paved over with some mysterious substance from another world. They were, in essence, "swept" into existence. Science writer Joseph Nickell, an investigator of extreme claims whom we will encounter again when we examine the Shroud of Turin in Chapter 11, has duplicated the technique of making Nazca-like designs with a small crew, some rope, and a few pieces of wood (Nickell 1983a). Amazing, perhaps. Unbelievable, no.

And what does von Däniken have to say about the Nazca markings? Almost yielding to rationality, he admits that "they could have been laid out on their gigantic scale by working from a model and using a system of

coordinates" (1970:17), which is precisely how Nickell accomplished it. Not to disappoint us, however, von Däniken prefers the notion that "they could also have been built according to instructions from an aircraft" (p. 17). Relying on the "inkblot approach," he says, "Seen from the air, the clear-cut impression that the 37-mile-long plain of Nazca made on me was that of an airfield" (p. 17).

Please remember Occam's Razor here. On the one hand, for the hypothesis that the ancient people of South America built the lines themselves, we need only assume that they were clever. The archaeological record of the area certainly lends support to this. On the other hand, for von Däniken's preferred hypothesis, we have to assume the existence of extraterrestrial, intelligent life (unproven), assume that they visited the earth in the distant past (unproven and not very likely), assume that they needed to build rather strange airfields (pretty hard to swallow), and then, for added amusement, instructed local Indians to construct enormous representations of birds, spiders, monkeys, fish, and snakes. Those assumptions are bizarre, and the choice under Occam's Razor is abundantly clear.

We can go on and deduce some implications for our preferred hypothesis: we should find evidence of small-scale models, we should find the art style of the desert drawings repeated in other artifacts found in the area, and we might expect the Nazca markings to be part of a general tradition in western South America of large-scale drawings. When we test these predictions, we determine that we do find such supporting evidence; for example, Wilson (1988) has recently reported on a newly discovered set of large-scale earth-drawings in Peru.

In short, since prehistoric pictorial depictions and even early written descriptions are sometimes indistinct or vague and—perhaps more importantly—since they are part of a different culture and have a context not immediately apparent to those who do not explore further, you can see or read anything you want into them, just as you can with inkblots.

Try this experiment. Using any of von Däniken's books, look at the photographs, but do not read the captions where von Däniken tells you what the item pictured must be (spaceship, extraterrestrial alien, or whatever). Now figure out what *you* think it looks like. You probably will not agree with what von Däniken says. For example, Figure 9.3 is a photograph of a sarcophagus lid from the Mayan site of Palenque. Does it evoke in your mind any extraterrestrial images? Probably not. Yet, for von Däniken, the coffin lid is a clear representation of a space-suited alien piloting a spacecraft (1970:100–101).

The inkblot principle is at work again. When you are unfamiliar with the culture, you can make just about anything you want out of these images, but you are most decidedly not practicing science. Von Däniken does not understand the cultural context of the Palenque artifact. He does not recognize the Mayan symbols in the carving of the Sabre Tree and the

Figure 9.3 Using what we here call the *Inkblot* approach, von Däniken interprets the image on the sarcophagus lid from the Temple of Inscriptions at the Mayan site of Palenque as depicting an astronaut with antennae and oxygen mask, peering through a telescope and manipulating the controls of a rocket. Mayan archaeologists prefer to interpret this scene within the context of Mayan cosmogony—a king poised between life and death in his journey to the afterlife. (Courtesy Merle Greene Robertson)

Earth Monster. What are mysterious devices for von Däniken are simply common artistic representations of Mayan jewelry, including ear and nose plugs. Again, not understanding the context of the artifact, von Däniken does not realize that the person depicted on the sarcophagus lid was a dead Mayan king represented in a position between life—the Sabre Tree above him—and death—the Earth Monster below (Robertson 1974; Sabloff 1989).

One needs to be familiar with Mayan cosmogony in order to recognize the context of the Palenque stone within Mayan culture. Von Däniken, however, is wholly ignorant of Mayan beliefs and therefore can come up with such an unsupported speculation concerning the image on the coffin lid.

Once you become familiar with von Däniken's own particular brand of illogical thinking, you can probably guess what he says renderings in ancient art actually represent. Doing so might be fun, but it is in fact just a game of trying to guess the meandering of an illogical mind. That is not

scientific archaeology; that is psychotherapy. The Inkblot Hypothesis merely shows how suggestible people are ("Hey, doesn't that cave painting look like a spaceman?" "Gee, now that you mention it, I guess it does.") Inkblots, however, or strange drawings on cave walls, weird creatures on pots, odd sculptures, or mystical visions written down in ancient books can never prove the visitations of ancient astronauts, as much as von Däniken might like them to.

Hypothesis 2

Von Däniken's second hypothesis suggests that extraterrestrial aliens played an active and important role in the actual biological development of our species. There has been some controversy on this particular point. Von Däniken maintained in an interview on an episode of the public television series *Nova* focusing on his ideas ("The Case of the Ancient Astronauts") that he never really made such a claim. Let's see.

In *Chariots of the Gods?* von Däniken proposed the following scenario. A group of extremely advanced, interstellar space travelers lands on Earth, for the first time perhaps millions of years ago. They find a primitive race of creatures, very apelike, with small brains, but with a lot of potential. Then, von Däniken claims, "A few specially selected women would be fertilized by the astronauts. Thus a new race would arise that skipped a stage in natural evolution" (1970:11).

If the previous claim can be called the *Inkblot Hypothesis*, I can call this one the *Amorous Astronaut Hypothesis*.

According to this hypothesis, extraterrestrial aliens have streaked at near light speed to get to Earth. The speed of light is fast (186,000 miles per second), but the universe is large, and our space*men* (for von Däniken, the extraterrestrial visitors always seem to be males) have been cooped up in their spaceship, perhaps in suspended animation, for at least four years. The nearest star to our sun is about four light years away, and so—even traveling at the speed of light—four years is the absolute minimum. Our extraterrestrial friends land, are wakened from their deep sleep, exit their spaceship to explore the new frontiers of an unexplored planet in an alien solar system. And what do you think they do? They look for females to breed with. The human species is not the product of evolution, but instead of interstellar miscegenation.

As Carl Sagan has so astutely pointed out in "The Case of the Ancient Astronauts," the chances of any two different species from even our own planet being able to mate and produce offspring are quite remote. Horses and donkeys are one of the very rare exceptions to this. Even here, when these two very closely related species mate, the offspring are sterile. The possibility of two species that evolved on different planets in two different solar systems even having the appropriately matching physical equipment

for mating, much less having matching DNA necessary to produce off-spring, is so incredibly unlikely that it is beyond calculation. Yet these are precisely the implications that must be deduced from von Däniken's hypothesis. As Sagan pointed out, a human ancestor would likely have been more successful mating with a petunia than with a creature from outer space; at least the human ancestor and the petunia both evolved here on Earth. Extraterrestrial astronauts, amorous or not, simply could not have mated with our ancestors to produce us.

Hypothesis 3

This leads us to the final von Däniken hypothesis, the notion that the archaeological record is replete with evidence of highly advanced artifacts beyond the capability of ancient humans. This can be called the *Our Ancestors, the Dummies, Hypothesis* after Omunhundro (1976). Von Däniken is claiming that our human ancestors were too dumb to have, all by themselves, using their own creative abilities, intelligence, and labor, produced the admittedly spectacular works of engineering, architecture, mathematics, astronomy, botany, and zoology evidenced in the archaeological record.

Mind you, von Däniken is not saying that archaeologists are hiding the physical evidence of ancient flying saucer parts or ray guns found at prehistoric Indian villages or ancient Chinese temples. That would be an easy claim to check scientifically; such artifacts either exist or they do not. No, instead, von Däniken simply points to artifacts such as pyramids or temples, statues, or carvings. He makes reference to prehistoric accomplishments such as the domestication of plants and animals, the development of metallurgy, and especially astronomical abilities—all things for which archaeological evidence is abundant. Von Däniken simply cannot understand how, and therefore doesn't believe that, prehistoric people could have managed all this without some sort of outside help. This help, for von Däniken, comes in the form of aliens from outer space.

In a sense, von Däniken is the ultimate diffusionist. Where some have suggested that all advanced ideas originated in Southwest Asia or Egypt or even Atlantis (see Chapter 8) and spread out from there, von Däniken sees the source for human advancement as being in the stars.

There seem to be two contributing factors to von Däniken's misunderstanding and misrepresentation of the archaeological record:

1. He is ignorant of simple archaeological facts.

2. There seems to be not just a little European ethnocentrism at work here.

The best place to show how these factors work is in von Däniken's misunderstanding of the archaeological record of ancient Egypt.

Ancient Egypt

Most people are at least passingly familiar with Egypt of the great pharaohs, the enormous pyramids, the mysterious Sphinx, the fabulous treasures of the tomb of Tut-ankh-amun, and so on. Did you ever wonder where the Egyptian civilization came from, how the Egyptians managed to build those fabulous pyramids, and how they accomplished the rest of their spectacular legacy? Archaeologists certainly have wondered and devoted years to unraveling the mysteries of this remarkable culture. Egyptologists have been digging up the past of Egypt for over 150 years now and can construct a fairly detailed scenario for the evolution of this civilization (for example, see Hoffman 1979). Unfortunately, von Däniken is ignorant of most of the data here. After a couple of tourist visits to Egypt, von Däniken can tell us that all of those archaeologists, who have devoted their entire professional careers to solving the true mysteries of Egypt, are completely misinformed. He says, "If we meekly accept the neat package of knowledge that the Egyptologists serve up to us, ancient Egypt appears suddenly and without transition with a fantastic ready-made civilization" (1970:74).

He further describes the accomplishments of the ancient Egyptians as being "genuine miracles in a country that is suddenly capable of such achievements without recognizable prehistory" (1970:74).

So, what is von Däniken's solution to the archaeological enigma of a great "ready-made" civilization springing up "suddenly" and "without transition" in a land "without recognizable prehistory"? Where does von Däniken say Egyptian culture came from, whom does he credit for its great architectural, scientific, mathematical, astronomical, and engineering accomplishments? If you guessed that von Däniken says all of these things were made possible by the "gods" from outer space, you are correct.

Indeed it would be an extraordinary archaeological mystery if Egyptian civilization had really sprung up overnight, with no ancient roots. It would force us to consider the possibility that Egyptian civilization arrived full-blown or "ready-made" in Egypt from somewhere else. In one sense, von Däniken is correct; if we hypothesize that Egyptian culture was transplanted full-blown from somewhere else, we should expect that it appeared quickly, without any evolutionary antecedents. However, again considering Occam's Razor, we might want to first consider some possible earthly sources such as the older civilization of Mesopotamia in the Near East (which is, after all, only about five hundred miles from the Nile) before we start bringing up the residents of Alpha Centauri.

Nevertheless, one rather important point needs to be brought up here. Von Däniken's claim about the suddenness of Egyptian civilization is absolutely inaccurate.

Archaelogists have now traced the ultimate roots of this "sudden"

civilization back more than 12,000 years, when nomadic hunters and gatherers began to settle down along the Nile (Butzer 1976). Recent excavations at sites like Wadi Kubbaniya show that at this time people were living in small villages along the Nile and harvesting the wild wheat, barley, lentils, chick-peas, and dates that abounded there (Wendorf et al. 1982). Their villages are littered with the grinding stones, mortars, and pestles they used to make flour. They supplemented their diet with wild game and fish, so they weren't entirely settled or "civilized," but they were on the path toward civilization. By beginning to rely upon the crops of wild wheat and barley, they were laying down the roots of an agricultural revolution that was to form the subsistence base of Egypt of the pharaohs.

Meanwhile, culture was also developing several hundred miles away in the Middle East. Some of the earliest evidence in the world for the cultivation of crops is found there.

Slowly, barely perceptibly at first, more than 10,000 years ago, people living in the Middle East who harvested wild wheat and hunted wild sheep and goats began first to tend and then to domesticate these plants and animals. Artificially selecting the qualities they most desired by only allowing plants and animals with those qualities to grow and propagate, these people were literally remaking plant and animal species to fit their needs (Hole, Flannery, and Neely 1969).

We have solid archaeological evidence in the form of carbonized seeds and husks, seed impressions on clay pots, and the bones of the animals, to conclude that a slow process of domestication was occurring in the Middle East more than 10,000 years ago and in Southeast Asia (Solheim 1972), Europe (Whittle 1985), Mexico (MacNeish 1967), and South America (Patterson 1973) soon thereafter. We can trace the slow increase in seed size for wheat and the skeletal changes in sheep and goats and, later, in cows, pigs, and horses. We can examine how the area of attachment of individual kernels of wheat (quite brittle in nature to allow the seeds to be knocked off by the breeze or by passing animals) was changed through natural selection by people who wished the seeds to remain attached until the harvest.

Back in Egypt, we are not yet sure if the idea of domestication and cultivation originated independently or if it came from the east. It makes little difference here, and in either case we have archaeological evidence for small villages along the Nile where the people were living no longer on wild, but on domesticated plants and animals fully 8,000 years ago. The cultivation of crops and the raising of animals provided a more secure, more dependable, and much more productive food base for these people. The archaeological evidence indicates very clearly that in response to this, both the number of villages and the population of individual villages grew (Lamberg-Karlovsky and Sabloff 1979). Eventually these villages began competing with each other for good farmland along the Nile.

Seen from satellite photographs, the Nile is a very thin ribbon of green

and blue flowing through a huge yellow desert. Clearly, the Nile is the "giver of life" to the plants, animals, and people of Egypt. As the very circumscribed, precious, fertile land along the Nile became filled up between 8,000 and 6,000 years ago, competition for this rich land intensified.

Some Nile villages were quite successful and grew at the expense of others. One example is *Hierakonpolis*, a town that grew in a very short time from an area of a few acres in size to over one hundred, and from a probable population of a few hundred to several thousand (Hoffman 1979, 1983). A local pottery industry also developed here.

Pottery manufactured in the kilns that archaeologists have discovered at Hierakonpolis can be found at sites all along the Nile. As the demand for the pottery of this successful town grew, so did the wealth of the people who owned the pottery kilns. It is here at Hierakonpolis that we first see large tombs where perhaps these wealthy pottery barons were laid to rest. Their tombs were sometimes carved out of bedrock and covered with mounds or small, crude pyramids of earth. Finely crafted goods were placed in the tombs of these men, perhaps to accompany them to the afterlife.

However, just as the small towns had previously competed for land, Hierakonpolis and other larger villages began to compete for space and wealth. Again, based on the archaeological evidence for this period, we can conclude that power struggles leading to warfare were common after 5,200 years ago. One hundred years later, a ruler of Hierakonpolis, whose name has been passed down to us through later Egyptian writings as *Narmer*, was able through military conquest to subdue and then unify the competing villages along the Nile. Now with the wealth of not just one town, but of every town along the Nile to call upon, Narmer and his successors lived and were buried in increasingly sumptuous style.

Eventually, the old practice of burying a leader in a bedrock tomb with a small earthen pyramid on top was deemed insufficient for pharaohs. However, the pyramid did not appear "suddenly," as von Däniken would have us believe. Initially, the practice of erecting an earthen mound over the tomb was replaced by construction of a square-block structure called a *mastaba*. As the mastabas over the tombs got larger through time, pharaohs began to build stepped mastabas, with one block on top of another, culminating in a stepped pyramid for the pharaoh Djoser at Saqqara (Figure 9.4). Finally, around 4,800 years ago, the first non-stepped, stone-faced, true pyramid was attempted (it was still soil in its core) at a place called Meidum. Unfortunately, this first attempt was an apparent failure. The angle of the face of the pyramid, 54 degrees, apparently was too steep and the stone facing collapsed midway through construction (Mendelssohn 1974). The remains of this colossal mistake can still be seen today. It hardly resembles a structure that beings capable of interstellar space flight would have produced.

Another early pyramid begun at about the same time was started at the

Figure 9.4 Von Däniken's claims about the "sudden" appearance of the Egyptian pyramid are simply incorrect. The Egyptian pyramid was not introduced by aliens, extraterrestrial or otherwise, but evolved through several phases in Egypt itself. One of these phases is represented by the stepped pyramid of Saqqara, which had itself evolved from the single-tiered *mastabas*. (M. H. Feder)

same architecturally fatal angle as the one at Meidum. In the middle of construction, its builders changed the angle of the upper face of the pyramid to a less steep and more stable 42 degrees (Story 1976). This gives the pyramid a bent appearance.

By 4,600 years ago, the Egyptians had worked the kinks out of pyramid building and constructed some of the most spectacular monuments the world has ever known. The famous triad of pyramids at Gizeh (see Figure 8.6, top) is both literally and figuratively one of the seven wonders of the world.

All in all, though today the pyramid is certainly the symbol of Egyptian civilization, only about seventy of them were built. They are all spectacular architectural and engineering achievements, built as monumental tombs for great pharaohs. However, as this brief outline of the development of Egyptian civilization has shown, the pyramid very clearly evolved through time. They were a logical step in the evolution of Egyptian funerary architecture. So much for von Däniken's claim that things such as the pyramids just "shot out of the ground."

Unfortunately, everybody in ancient Egypt knew that the pyramids contained great wealth, and most were broken into soon after the pharaoh was laid to rest. Eventually the Egyptians gave up pyramid building completely and buried pharaohs—like King Tut—underground, where their tombs might be better hidden and protected.

Remember, in science we propose a hypothesis to explain something, we deduce those things that must also be true if our hypothesis is true, then we do further research to determine if our deduced implications can be verified. Only then can we say that our hypothesis is upheld. Here, our hypothesis is that the ancient Egyptians built the pyramids using their own skill, intelligence, ingenuity, and labor. We can deduce that if this were true, then we should find archaeological evidence for the slow development of these skills and abilities through time.

This is precisely what has just been shown. Egyptian civilization developed not "suddenly," but after some 12,000 years of development marked by

1. The adoption of agriculture
2. Increasing village size
3. Inter-village competition
4. Village differentiation
5. Concentration of wealth
6. Increase in tomb size
7. Consolidation under a single leader or pharaoh
8. Obvious trials and errors in the development of the pyramid as a monument to their dead kings

All of this evidence supports our original hypothesis: the ancient Egyptians built the pyramids and developed their civilization without help from ancient astronauts.

Von Däniken's Response

What does Erich von Däniken have to say about all this? He can only claim—lamely—that the Egyptians by themselves could not have built the pyramids because they did not have the tools with which to cut the limestone slabs. As shown in "The Case of the Ancient Astronauts," in fact, the stone and copper tools that they did use have been recovered by archaeologists and are on display at museums in Egypt.

Von Däniken also says that once the slabs were cut, the Egyptians could not have transported them (most weigh about 2,000 pounds each; some weigh considerably more) since they had no wood or rope. Archaeological examples of the wooden sledges and heavily twined rope that they did use are both on display in the same museums. Furthermore, he complains, even if they could have cut the slabs and transported them, it would have taken tens of thousands of workers to construct a pyramid, and there is no evidence for the huts that would have been needed to house these

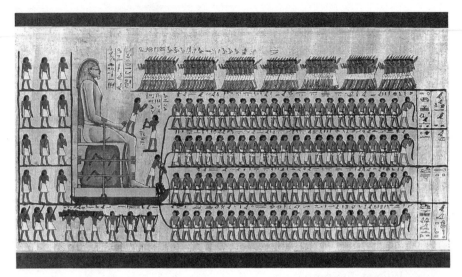

Figure 9.5 Von Däniken cannot conceive how the ancient Egyptians were able to build pyramids and move the enormous stone blocks and statues that are a part of the archaeological record of their civilization. But the ancient Egyptians themselves left records like this image copied from a wall panel of how they did it. Here, a crew of 168 men pull ropes attached to a sledge upon which sits a statue more than twenty feet tall. A worker on the sledge pours a lubricant—perhaps an oil—onto the ground in front of the sledge.

workers. Again von Däniken's archaeological ignorance is apparent. In fact, Egyptian archaeologists often dig through the mundane hut remains of the workers who built the pyramids.

Perhaps most remarkable of all, we must remember that the Egyptians were proud of their accomplishments and recorded their construction projects in actual picture-writing called hieroglyphics as well as in paintings. Anyone who is interested can visit Egypt and see paintings on the walls of ancient buildings and tombs that depict exactly how large construction projects were carried out (Figure 9.5). To say that the ancient Egyptians could not have built the pyramids would be like saying Americans could not have built the Empire State Building in New York City even though there are photographs of its construction.

More Mysteries of Ancient Egypt?

As pointed out in "The Case of the Ancient Astronauts," von Däniken makes many other unsubstantiated claims about ancient Egypt in *Chariots of the Gods?*:

1. "The height of the pyramid of Cheops multiplied by a thousand million—98,000,000 miles—corresponds approximately

to the distance between the earth and the sun." (p. 76). It does not. The height of the pyramid at Cheops is about 481 feet. Multiply this by 1,000,000,000 and you get 91,098,485 miles. The actual mean distance between the earth and the sun is about 93,000,000 miles, a difference of close to two million miles. Not terribly accurate for interstellar travelers. By the way, von Däniken appears to have taken this directly from *The Morning of the Magicians,* where it appears on page 110. Again, he makes no reference to that book in *Chariots of the Gods?*

2. Discussing mummification, von Däniken claims that the process was introduced by extraterrestrial aliens to preserve the bodies of Egyptian leaders who could be reawakened when the aliens returned. So it was the aliens who introduced "the first audacious idea that the cells of the body had to be preserved so that the corpse could be awakened to a new life after thousands of years" (1970:81). The only problem here is that in the mummification process, the Egyptian priests disemboweled the body, sticking the heart, lungs, liver, and other organs in jars. These priests also picked out the brains through the nose of the deceased with a pair of tweezers. There could be little hope for bringing somebody in that state back to life.

No, there simply are no laser burns on pyramid stones, no wrecked flying saucers under the Sphinx, no resurrected, 4,000-year-old Egyptian pharaohs walking around (not outside of Boris Karloff in the movie *The Mummy,* anyway). We might expect all of these as deduced implications of von Däniken's hypothesis of extraterrestrial involvement in the development of Egyptian civilization. Instead, all we are left with is the remarkable evidence of the obvious great ingenuity and toil of the culture of ancient Egypt. The lesson of ancient Egypt has nothing to do with spaceships or extraterrestrial aliens. On the contrary, the lesson is one of human abilities, intelligence, and accomplishment.

More Ancestors, More Dummies

Again, in reference to the *Our Ancestors, the Dummies, Hypothesis,* it is not just ancient Egypt that boggles von Däniken's mind to the point where he cannot believe that mere people were responsible for the artifacts that archaeologists find. Here are just a few additional examples.

Extraterrestrial Platinum?

Under a listing of "visitors from the universe in remote antiquity" in *Chariots of the Gods?* (p. 27), von Däniken includes the claim that "ornaments of

smelted platinum were found on the Peruvian plateau" (this is another claim apparently taken from, but not attributed to, *The Morning of the Magicians*). So what? Platinum ore is found naturally in South America, and the sixteenth-century Spanish explorers of the area even wrote about it. They described in great detail how the Indians smelted it in special furnace/kilns placed on the tops of windy hills. The wind, whipping through holes placed strategically along the walls of the kilns, would raise the temperature inside to the 1,730 degrees Celsius (3,140 Fahrenheit) necessary to melt the platinum. Again, proven human ingenuity is not enough to deter von Däniken from his hypothesis.

Extraterrestrial Calendars?

In his third book, *Gold of the Gods* (1973), von Däniken makes reference to the hypothesis of science writer Alexander Marshack (1972). Marshack maintains that some inscribed bone, antler, and ivory tools from Paleolithic Europe, dating from 10,000 to 30,000 years ago, represent the oldest calendars in the world. He hypothesizes that these first calendars were based upon the cycle of changes in the phases of the moon. Amazed as always, von Däniken asks

> Why did Stone Age men bother about astronomical representations? It is usually claimed that they had their hands full just to procure sufficient nourishment on endless hunts. Who instructed them in this work? Did someone advise them how to make these observations which were far above their "level"? Were they making notes for an expected visit from the cosmos? (1973:203–4)

Von Däniken has lots of questions, but precious few answers. Let's look at one of these artifacts and see if it indeed looks like something only an extraterrestrial alien might have devised. Probably the most famous of the artifacts in question is the Abri Blanchard antler plaque found in southern France and dated to about 30,000 years ago (Figure 9.6). This ancient piece of ivory has close to seventy impressions carved into it along a sinuous arc. If you begin in the center of the antler and work your way along the arc, a rough pattern emerges. Each design element appears to be a fraction of a circle. As you follow the arc of impressions, the marks seem to grow in terms of the proportion of a circle represented and then, once a whole circle is produced, to diminish. The similarity between the sequence of impressions and the phases of the moon is apparent. It is Marshack's well-reasoned, though still-debated, hypothesis that this is precisely what these ancient people were trying to convey.

No one can deny that it is fascinating to think that 30,000 years ago prehistoric people may have looked at the mysterious light in the night sky

Figure 9.6 Von Däniken sees evidence for knowledge far beyond the capabilities of ancient people in 30,000-year-old bone implements of the Upper Paleolithic. But, perhaps the best known of these, the antler plaque at Abri Blanchard in France, though a compelling argument for the great intelligence of our prehistoric ancestors, is really just the simple depiction of lunar phases. The pattern of lunar waxing and waning was likely well known to these people. © Alexander Marshack.

and wondered about it. Based upon this and similar artifacts from the period 30,000 to 10,000 years ago, it appears quite possible that these ancient people recognized the cyclical nature of the lunar phases. But as interesting as it might be, does the antler plaque look like the calendar of an extraterrestrial alien?

Certainly it took intelligence to watch the nightly change in the moon's phases and conclude that it was not random, that it was patterned and predictable. But remember, these were people who, of necessity, were attuned to the natural world around them. Their very survival depended on their observations of nature, and nature is filled with predictable cycles. Day followed by night followed by day is an unending, constant pattern that is easily recognized. The fact that summer follows spring, is replaced by fall and then winter, which leads inevitably back to spring, was a cycle that had to be known, followed, and relied on by our prehistoric ancestors. Long before 30,000 years ago their brains had become as big as ours, and they probably were no less intelligent than we. The fact that they may have recognized the phases of the moon as another cycle in nature and that they recorded these changes to be used, perhaps, as a kind of calendar is a wonderful achievement, but not really so unexpected.

Extraterrestrial Aliens in the Pacific?

Or how about this? On the island of Temuen, in Micronesia in the western Pacific, there is an interesting archaeological site called *Nan Madol*. It is a village of close to one hundred structures, built probably between five and six hundred years ago (Ballinger 1978). The buildings themselves are indeed remarkable. The raw material used in construction consisted of

volcanic basalt blocks found on the other side of the island. Von Däniken is amazed by the blocks themselves as well as by the entire construction project. About the individual blocks, he claims:

> Until now scholars have claimed that these basalt slabs were formed by lava that had cooled. That seemed like a lot of nonsense to me as I laboriously verified with my measuring tape that the lava had solidified exclusively in hexagonal or octagonal columns of roughly the same length. (1973:117, 119)

Von Däniken is apparently no better versed in geology than he is in archaeology. The octagonal and hexagonal structure of basalt columns at Temuen is a recognized, well-understood geological phenomenon called *columnar jointing*. You don't need to go all the way to Micronesia to see such columns; precisely the same phenomenon can be seen at the Devil's Post Pile National Monument in California. If von Däniken had only gone around to the other side of Temuen Island, he would have seen these columns in their natural outcrop, untouched by human (or, I might add, alien) hands.

On another Polynesian island, von Däniken believes there is evidence of extraterrestrial involvement. Easter Island is one of the most remote places on earth, 3,200 km west of the coast of South America and 2,000 km southeast of the nearest inhabited island. The island was first settled sometime after A.D. 300 by Polynesian explorers from the west.

On the island there are between eight hundred and one thousand large stone sculptures called *Moai* (Van Tilburg 1987). Carved from a relatively soft volcanic rock called *tuff*, they are impressive indeed. The largest is over twenty meters (sixty feet) high and weighs about 55,000 kilograms (sixty tons), but even the smaller statues would have taken considerable labor to quarry, sculpt, transport, and erect (see the cover of this book).

Not surprisingly, von Däniken does not believe that the Easter Islanders could have accomplished these tasks by themselves. In *Gods from Outer Space* (1971), he suggests that the statues (or at least some of them) were erected by extraterrestrial aliens marooned on Easter Island. What was their motive for erecting the statues? According to von Däniken, it was simple boredom (p. 118).

Intensive archaeological investigations have been carried out on Easter Island since 1955 (see Van Tilburg 1987 for a summary of this work). Quarries with partially completed statues have been discovered—along with the simple stone picks, hammers, and chisels used to quarry the rock and carve the images. Roads have been identified on which the statues were transported. Statues accidentally broken during transport have been located along the roads. Experiments have been carried out in techniques of quarrying, carving, transport, and erection. (Heyerdahl 1958). Six men roughed out a five-meter-long statue from the stone quarry in just a few days. A group of several islanders erected an ancient Moai in a short time

period, using levers and ropes. Statues have been moved along the old roads using wooden sledges and rope.

The Moai are certainly impressive and show what human ingenuity and labor can accomplish. But there should be no mystery about that. The mystery is why von Däniken did not realize that simple fact.

And how were Temuen, Hawaii, Fiji, Easter, and all of the other inhabited islands of the Pacific originally populated? In attempting to answer this question, science has focused on archaeological evidence on the islands themselves, analysis of the watercraft used in the Pacific, and study of the traditional navigational skills of the native people (Shutler and Shutler 1975). From these sources of data, we think we have a pretty good handle on the original human exploration of and migration into the Pacific.

But our answers do not satisfy von Däniken. He finds hypotheses of human intelligence, endurance, and curiosity too outlandish. What is his explanation for how these islands were settled, how the first human inhabitants got there? He says, "I am convinced with a probability bordering on certainty that the earliest Polynesians could fly" (1973:133). There is very little that can be said—or needs to be said—in the face of such absurdity.

Extraterrestrial Megaliths?

As is clear from his latest book, *Pathways to the Gods* (1982), von Däniken has not changed his *Our Ancestors, the Dummies* assumption. Here, he attempts to deal with the Megalithic culture of Europe. This is the culture that produced Stonehenge and several thousand other stone monuments around 4,000 to 3,000 years ago (see Chapter 12). Much as he dealt with ancient Egypt in *Chariots of the Gods?* von Däniken ignores very clear archaeological evidence of hundreds and even thousands of years of cultural evolutionary development. Instead, he looks only at the end products of such development and is once again amazed.

He misrepresents prehistory by claiming that the Megalithic monuments appeared instantaneously. He further assumes that such achievements in stone construction were beyond the capabilities of human beings. In fact, von Däniken belittles the entire notion that people could intellectually or scientifically evolve, at least in reference to the Megaliths;

> Who are they, where are they, the beings who thought out the buildings at Stonehenge and Rollright in advance? They are all traced back to the sacrosanct theory of evolution. In other words, the builders of the megalithic complexes had predecessors who, generation by generation, collected, increased and handed on small portions of knowledge. So where are these climbing monkeys on the ladder of wisdom? They do not exist. (1982:80)

Again, von Däniken's ignorance is stunning. The archaeological record of Europe shows quite clearly that the Megalithic culture did indeed

Figure 9.7 The impressive *Megalithic* monument of Stonehenge may have been used as an astronomical sighting device by the inhabitants of the Salisbury Plain of southern England more than four thousand years ago. It denigrates the intelligence of the ancient people who lived there to presume that they needed the assistance of aliens from outer space to have quarried, transported, and erected the stones that make up the structure. (From *Discovering Our Past*, Ashmore and Sharer, Mayfield Publishing)

develop over a long period of time. Stonehenge itself went through at least four major building phases (Chippindale 1983). The spectacular monument that can be seen today is the result of close to 2,000 years of construction (Figure 9.7).

And if Stonehenge were the construction project of extraterrestrial aliens, why are mistakes evident? Stonehenge appears to be an astronomical sighting device—a sort of Stone-Age calendar. Yet, a number of the large upright stones apparently were misaligned during construction, blocking an observer's view of some astronomically important points on the horizon (Hawkins 1965). The problem was solved, not by lifting the stones with antigravity devices, but by cutting crude notches in the stones where vision was blocked. Mysterious, indeed, if the builders were interstellar travelers.

CURRENT PERSPECTIVES
The von Däniken Phenomenon

Von Däniken again and again underestimates the intelligence and abilities of our ancestors and then proposes an extraordinary hypothesis to explain the past. That is clear. However, what is not so clear is the second reason that I have suggested (on page 142) for von Däniken's inability to accept prehistoric peoples' ability to produce the great achievements seen in the archaeological record (the first was simple ignorance). I have already mentioned it briefly—European ethnocentrism.

What I mean by this becomes clear when you read *Chariots of the Gods?* It is curious that von Däniken is ever ready to provide examples as proof of his third hypothesis (*Our Ancestors, the Dummies*) from archaeological sites in Africa, Asia, North America, and South America; but he is curiously and atypically silent when it comes to Europe. My feeling about this was so strong upon reading *Chariots of the Gods?* that I actually went through the book and tallied the specific references to amazing accomplishments of prehistoric people that von Däniken feels were too advanced, too sophisticated, or too remarkable for mere humans to have produced. I paid careful attention to where in the world (which continent) these specific examples were from. The following chart resulted (Feder 1980a):

Continent of the Example	Number of Examples	Percentage
Africa	16	31
Asia	12	23
Europe	2	4
North America	11	22
South America	10	20
Total	51	100

The very great majority of von Däniken's examples here are from places other than Europe. It appears that he is utterly astounded by the archaeological records of ancient Africa, Asia, and North and South America. He is so astounded, in fact, that he thinks that only through the assistance of men from outer space could those black, brown, yellow, and red people have produced the prehistoric works that archaeologists find on these continents.

But it is curious indeed that von Däniken never wonders who helped the ancient Greeks build the Parthenon, or which spacemen instructed the Romans in constructing the Coliseum. Why not? These monuments are every bit as impressive as those that von Däniken does mention. The Parthenon is almost 2,500 years old, the Coliseum close to 2,000. Even in the case of Stonehenge in England, von Däniken is strangely quiet and only briefly mentions it in *Chariots of the Gods?*—though, as stated, he finally does get around to Stonehenge in his latest book, *Pathways to the Gods*.

This may be a key point in von Däniken's success. *Chariots of the Gods?* is listed in the *Publishers Weekly* inventory of all-time best sellers, having sold over seven million copies—that is more than *The Diary of a Young Girl* (Anne Frank), *Catch-22*, or *All Quiet on the Western Front*, for example ("So Big" 1989). It is such an incredibly silly book that we must ask why it has done so well.

Many people are aware of phenomena like the pyramids of Egypt, the ruins of Mexico, and the ancient Chinese civilization. Some, however, may wonder how the prehistoric ancestors of contemporary people whom they consider to be backward and even intellectually inferior accomplished such spectacular things in the past. After all, today Egypt is a third-world nation, the Indians of Mexico are poor and illiterate, and the Chinese are just beginning to catch up with the technology of the modern world. How could the ancestors of such people have been advanced enough to have developed pyramids, writing, agriculture, mathematics, and astronomy all by themselves?

Along comes von Däniken with an easy answer. Those people did not produce those achievements on their own without some sort of outside help. An extraterrestrial "peace corps" was responsible. If I am correct in this suggestion, it really is a pity; human prehistory is a spectacular story in its own right. All peoples have ancient pasts to be proud of, and there is no place for, nor any need to fall back on, the fantasy of ancient astronauts.

Von Däniken has sold many books; his work has been the subject of movies and television specials; recently a compendium of three of his books was published (von Däniken, 1989); and his writings have inspired a number of copycats (Berlitz 1972; Chatelain 1980; Drake 1968; Kolosimo 1975; Tomas 1971). Even actress Shirley MacLaine (1983) has championed von Däniken's thesis in her book *Out on a Limb* (of which there have been more than a dozen printings).

Concerning the source of human civilization, MacLaine poses the obvious question, "[The source of] that intelligence could have been extremely advanced civilizations right here on earth. . . . Why does superior intelligence have to come from some other world?" (p. 240).

Indeed, that is the right question to ask. But MacLaine concludes that von Däniken is right, that civilization indeed arrived wholesale from outer space. MacLaine had to back off from this stand publicly during the filming in South America of *Out on a Limb* for a television mini-series. It seems that the government of Peru recognized the implicit cultural insult of an American claiming that ancient Peruvian culture was so advanced that mere Peruvians could not have produced it but needed the assistance of extraterrestrial aliens.

Clearly, von Däniken's writings have been quite popular and have had an effect on millions of people—through either his own books or those of people like Shirley MacLaine. The popularity of his books or of his ideas, however, is wholly irrelevant. Science is not a democratic process. Knowledge depends on the procedures outlined in Chapter 2, not on the popularity of the ideas behind that knowledge. I would hope that your decision concerning the evidence for von Däniken's claims is based on the rules of science rather than on inkblots, amorous astronauts, or a low opinion of human intelligence.

10

Good Vibrations:
Psychics, Dowsers,
and Photo-Fields

As part of an ongoing research project, in 1986 and 1987, I directed an archaeological survey of state forest land in the northwestern hills of Connecticut. Over the course of about twenty weeks in the two summers, and funded by grants of more than $30,000, a crew of twenty archaeologists dug over 2,000 test excavations in our search for evidence of prehistoric occupation of the forested uplands that constituted our research study area (Feder 1986).

The test pits were 50 cm on a side and shovel-dug as deeply as was practical—until bedrock, glacial deposits, or water made further digging impossible or unnecessary. The pits were placed at regular intervals along *transects* (lines). Transect orientation was selected to provide areal coverage of the many different habitats in the forests (Figure 10.1).

Carrying bulky equipment through virtually untrekked uplands, cutting through thick underbrush, slogging through wetlands, and fighting off hordes of swarming mosquitoes was a difficult undertaking, and bore little resemblance to the romantic adventures of Indiana Jones. The work was hard and hot, always tiring, and occasionally tiresome and tedious.

We were, however, extremely successful. During the two summers of our research we discovered more than eighty previously unknown archaeological sites ranging in age from 4,000 to 600 years old. We have begun to illuminate aspects of the lives of the ancient inhabitants of southern New England in an area few had looked at previously. We certainly feel the results were worth the effort. But was there an easier, more efficient way of going about finding these buried sites?

Figure 10.1 The excavation of test pits along transects is a common procedure in archaeological site survey. Here are shown the transect lines along which approximately one thousand test pits were excavated in Peoples State Forest in Barkhamsted, Connecticut. Thirty previously unknown prehistoric sites were discovered in this project. (From *The Beaver Meadow Complex Prehistoric Archaeological District*, Feder)

Once sites are discovered, the laborious process of excavation begins. Even a small site like a prehistoric village found in our 1986 survey and excavated in 1987 and 1989 can take many months to investigate. Scraping back the soil incrementally in two-meter-square excavation units, passing all soil through hardware-cloth screening, and keeping accurate and meticulous records of the site all take time but are crucial parts of the process. The excavation of a site necessarily involves its destruction, so great care and thorough documentation is absolutely vital if we are to preserve the information about past lives that the site can provide (see Sharer and Ashmore 1987; Thomas 1989; Feder and Park 1989 for discussions of survey and excavation methodology; also see Figure 10.2). But is there a better and easier way to learn about the people who lived at a prehistoric site than excavation?

Finally, we hope to be able to reconstruct as completely as possible an ancient way of life. To do so, archaeologists have had to devise methods to coax information out of the often meager remains we recover; the artifacts are mute, the bones silent. Detailed examination of stone tools under the microscope can tell us how they were made and used. Chemical analysis of human bone can provide insight into ancient diets. Physicists can help us to determine the age of sites. Nuclear reactors are used to trace raw materials to their prehistoric sources. Powerful computers are needed to

Figure 10.2 Archaeological excavations are time-consuming enterprises. Here, at a five-thousand-year-old site in Avon, Connecticut, students slowly scrape back the soil layers, exposing the remnants of an ancient society.

map the distributions of artifacts within sites and of sites within regions to help us illuminate the nature of human behavior. Archaeologists are like detectives of the human past. We try to reconstruct, not a crime, but a way of life, from the fragmentary remains people accidentally and incidentally left behind.

But is there a better, easier way of going about our various tasks? Can we locate sites by simply looking at a map of an area and intuiting their existence? Can we know where to dig at a site simply by walking over the ancient habitation and "feeling" where artifacts are? Can we reconstruct, in exquisite detail, the lives, not just of general "cultures," but of specific, identifiable human beings simply by handling the objects they touched in their daily lives? Is there a methodology that could obviate the tedious and hard work of archaeology and get right at that which interests us most— ancient people and their cultures? Though virtually all archaeologists would wish the answer to this question were "yes," most would realistically answer "no." Some new methodologies have been suggested, however— mostly by nonarchaeologists.

Psychic Archaeology

For example, some claim that "psychic power" is a tool that can be applied to the archaeological record (Goodman 1977; Jones 1979; Schwartz 1978, 1983). There are many fine books where the reality of things like telepathy and clairvoyance are assessed with a scientific and skeptical eye (for example, Hansel 1980; Marks and Kammann 1980), and a detailed examination of so-called paranormal phenomena is beyond the scope of this book. Nevertheless, we can assess the application of such alleged powers in archaeological research.

Remember, whatever one's biases might be for or against the existence of psychic power, hypotheses regarding the reality of such phenomena and their utility in archaeological site survey, excavation, and analysis must be tested just as all hypotheses must be tested—within a scientific, deductive framework. When a psychic predicts the location of a site, we must test the claim archaeologically. When a certain artifact or feature is predicted at a particular spot in a site, such a claim also must be tested by digging. Finally, when a psychic attempts to reconstruct the activities at a site or the behavior of the people at a site, those involved in testing the legitimacy of such an ability must devise a way to test such reconstructions with independent, archaeological data.

In such testing, sources of information other than psychic must be controlled for. Here the application of Occam's Razor should be clear. If the information reported by the psychic is correct, but could have been obtained in some more pedestrian way (through such simple avenues as reading the available literature on a site or time period, or through the application of common sense), then Occam's Razor would demand that we accept the simpler explanation before we accept the validity of a paranormal phenomenon. Unfortunately, as we shall see, such tests of psychic archaeology either are not conducted or are conducted so poorly as to render the results meaningless (Feder 1980b).

Psychic Site Location

For example, the book by anthropologist David Jones (1979), *Visions of Time*, purports in its subtitle to present "Experiments in Psychic Archaeology." Yet he never really tests the ability of self-proclaimed psychics to find sites. Nowhere does he, for instance, ask them to locate unknown sites on a map and then test for their existence archaeologically. Instead, Jones merely presents psychics with artifacts and photographs from *known* sites and then asks them to identify their locations.

In one example (Jones 1979:55), Jones provided a psychic with material from a known site. The psychic does not identify the location of the site on a map, but does correctly identify the site as a coastal location. Jones

considers this to be impressive. However, it should be pointed out that among the items from the site that the psychic was given were shell fragments and *columella* beads. Certainly this was a large hint as to the kind of habitat the site was situated in.

Later in the book (pp. 106–14), Jones mails one of his psychic subjects four photographs of sites in Florida. These are all correctly identified by the psychic as being near water. There is little to be impressed with here, however; virtually all human habitations are near water of some kind, and Florida possesses about 8,000 miles of detailed shoreline and 30,000 lakes (Feder 1980b:36). One cannot miss by suggesting that the location of an unknown (to the psychic) archaeological site in Florida is near water.

Even when psychics seem to be correct in predicting the location of an archaeological site, their supporters need to show that this was accomplished through the use of paranormal abilities. For example, Stephan Schwartz (1983) led a psychic archaeology project in Egypt. A team of ten self-proclaimed psychics was used to find sites now located under water in the city of Alexandria's harbor. Indeed, sites were found, but, according to Egyptian archaeologists, this was not surprising since the harbor was used in ancient times and divers have often found ancient remains in the mud at the bottom. The presence of psychic archaeology need not be invoked simply because sites were found in the general area the psychic predicted.

Perhaps in reference to psychic site location, it is most important to consider the fact that archaeologists regularly discover sites by employing some rather commonsense techniques. Human beings—prehistoric, ancient historic, and modern—do not locate their habitations randomly. Among the more important factors considered by a human group when deciding where to settle are distance to potable water, distance to a navigable waterway, topographic relief, defensibility, protection from the elements, soil type, food resources, and the availability of other resources like stone, clay, or metal for tools.

Using such a list, even an untrained person can examine a map of an area and point out the most likely places where ancient people might have settled. In my own introductory course in archaeology, after lecturing on settlement location choice, I distribute United States Geological Survey maps (1:24,000 scale) of areas in Connecticut where we have conducted archaeological surveys (Figure 10.3). I ask students to peruse the maps and to suggest areas where sites might be located. It is quite common for students to come up with precise locations where, indeed, sites have already been discovered. Therefore, even if a psychic could come up with an accurate prediction for the location of an unknown site, we would have to consider the simple explanation that, consciously or not, the psychic was merely relying on commonsense cues rather than ESP to make the prediction. The lack of control of these variables renders such tests impossible to assess.

Figure 10.3 An understanding of the factors that influenced ancient people in settlement location choice helps us find archaeological sites. United States Geological Survey maps (1:24,000 scale) like this section of the New Britain Quadrangle, Connecticut, provide a valuable picture of topography and drainage—significant considerations for people in the past, as well as the present. (U.S.G.S.)

Psychic Excavation

In *Visions of Time*, Jones sets out to test the ability of psychics to locate objects at a site before they are excavated. Unfortunately, Jones clearly establishes ground rules that obviate the scientific testing of hypotheses regarding such abilities. He states; "If the psychic subject stated that a particular artifact was present in the site, the lack of its discovery during excavation would not disprove the presence of the artifact" (p. 101). Such a perspective renders the hypothesis technically *nonfalsifiable* and therefore nonscientific. You could never prove your hypothesis wrong.

In another case, Jones considers a psychic to be quite accurate in listing the artifacts to be found at a site, even though, of the artifacts actually found, only two were predicted by the psychic: the eleven projectile points, forty-two flint pieces, fire hearths, shell tools, beads, worked bone, milling stone, and a human burial were not divined by the psychic. In fact, the most abundant artifact found at the site was pottery, with more than 5,000 sherds recovered. The psychic does not mention pottery at all until he is taken to the site and given a piece.

Jeffrey Goodman (1977, 1981) claims to have used psychic revelations to locate an outpost of immigrants from the Lost Continent of Atlantis in Arizona (see Chapter 8). Goodman's psychic predicted that excavators would find at the "site": "carvings, paintings, wooden ankhs, cured leather, and parchment scrolls with hieroglyphiclike writing" (1981:128). Also predicted among the finds were an underground tunnel system, domesticated horses and dogs, and corn and rye (p. 134). Goodman admits, "My beliefs may appear to outstrip the physical discoveries at Flagstaff so far" (1981:134), showing that he is nothing if not a master at understatement. *None* of the predicted items were, in fact, discovered at the site. The utility of psychic archaeology as a method for supplementing excavation has certainly not been supported experimentally.

Psychic Cultural Reconstruction

Archaeologist Marshall McKusick (1982, 1984), who played a key role in clearing up the myth of the Davenport Tablets discussed in Chapter 7, has produced useful summaries of the claims of the psychic archaeologists. Regarding the psychic reconstruction of prehistoric cultures, he has come up with the phrase, "the captive-of-his-own-time principle" (1982:100). He uses this phrase to underscore the fact that when psychics have attempted to reconstruct past lifeways, invariably they have done so within the framework of popular notions of those lifeways with all their biases, inconsistencies, and errors. In other words, the "vibrations" psychics allegedly receive by walking over a site, studying a map, or "psychometrizing" an artifact (holding the object in order to link up in some way with the person who made and used it thousands of years ago) do not come from some other plane of reality, but rather from more mundane sources like popular books, newspaper articles, and the like.

For example, McKusick points out that when, in the 1930s, Stefan Ossowieki, who might be considered the father of psychic archaeology, had visions of the Old Stone Age, they were in line with then-current, but now known to be erroneous, perspectives of ancient people. Ossowieki described *Magdalenian* people of the Late Paleolithic as being short with large hands and low foreheads (McKusick 1982:100). McKusick points out that Ossowieki was likely simply providing a commonly held stereotype of Neandertals.

As McKusick (1982) shows, when another self-proclaimed psychic and witch, Sybil Leek, tried applying her psychic gifts to ostensible Viking sites in the New World (Holzer 1969), she described the wrong kind of sailing vessel, but one that matched then-current presumptions. When Leek encountered the ghost of one of the Viking settlers, she identified him by reading a part of his name " . . . KSON" (Holzer 1969:118). Later, in a dream, the ghost wrote his initial: "E" (Holzer 1969:126). Presumably we are to

believe that the spirit of Leif *Eirikson* appeared to Ms. Leek (by the way, at a supposed Viking site in Massachusetts rather than the more likely setting of Newfoundland as discussed in Chapter 6). Also, presumably, we are to believe that this Norse explorer learned Roman letters on "the other side," since in their time Vikings wrote in their own Runic alphabet.

Also in this regard, self-proclaimed seer Edgar Cayce, whom we encountered in Chapter 8, saw his paranormal abilities fail him terribly. In the 1920s, after the discovery of Piltdown, but years before its unmasking as a fraud (see Chapter 4), Cayce obtained information from another plane of reality informing him that *Eoanthropus* was one of a group of ancient Atlantean settlers of England (McKusick 1984:49). Apparently, Cayce's otherworldly sources were not aware that the whole thing had been a fake.

As mentioned in Chapter 8, in the 1940s Cayce predicted that sometime during the 1960s parts of Atlantis would rise from the depths of the ocean, and much of the Atlantic seaboard would be inundated. New York City was to have disappeared, the Great Lakes were to drain into the Gulf of Mexico, and most of Japan would be drowned (Cayce 1968:158–59). Needless to say, these predictions were not terribly accurate.

To McKusick's "captive-of-his-own-time" principle, I would add a "captive-of-his-own-ignorance" corollary. The psychics, very simply, come up with descriptions that reflect their own lack of knowledge about prehistory and history. A good example of this can be found in *Visions of Time* (Jones 1979).

One of Jones's psychic subjects was given artifacts from the Lindenmeier site in Colorado. This site is quite well known among archaeologists and dates to the Paleo-Indian period. As mentioned in Chapter 5, Paleo-Indian culture was marked by the hunting of several now extinct big-game animals like bison, mammoth, and ground sloth, with a particular kind of spearpoint: the so-called *fluted point*, with channels or "flutes" on both faces, probably to facilitate hafting on a wooden spear (see Figure 5.4).

The selection of a Paleo-Indian site to test a psychic's abilities to reconstruct the behavior of the people who lived there is a particularly bad one in terms of scientific control relative to nonpsychic sources of information. The Paleo-Indian period is described in virtually every popular book on American prehistory, and fluted points are frequently discussed and illustrated in such books. Anyone with even a passing familiarity with American prehistory would know immediately upon being handed a fluted point what culture was being dealt with.

While "reading" the Lindenmeier artifacts, the psychic states that the spearheads were used "to shoot bison, or an elephant or mastodon or something" (Jones 1979:82). Mentioning extinct animals might sound impressive, but there is a subtle problem beyond the fact that the fluted points gave it away. Here we see an example of a self-proclaimed psychic who either is a captive of his own ignorance or has faulty sources in the spirit

world. The fatal error made here concerns a detail of fluted point variability.

Fluted points are among the most distinctive and recognizable stone tools in the world; they are not found in the Old World at all, and in the New World they are found in a relatively narrow time band from about 11,500 to 10,000 years ago (Haynes 1988). This is the reason why a Paleo-Indian site with fluted points is such a poor choice for a test of psychic abilities to identify an ancient culture. A fluted point is, most simply, a dead giveaway of Paleo-Indian culture.

While anyone, including an erstwhile psychic, can open a popular book on American prehistory and find a photograph or drawing of a typical fluted point, there actually are two main varieties of the point: Clovis and Folsom. The Clovis points are older, usually longer (7–12 cm), and the channels ordinarily extend from the base to below the midpoint of the tool (see Figure 5.4, left). Folsom points are shorter (5 cm) and here the channels extend nearly the full length of the tool (see Figure 5.4, right). The differences are technical, and not as well known to nonarchaeologists as are generalities concerning Paleo-Indian culture.

It is apparent that though the psychic recognized fluted points in the Lindenmeier assemblage, he did not realize the subtle difference between Clovis and Folsom points and the crucial distinction apparent from the archaeological record concerning the hunting patterns of the earlier Clovis and later Folsom hunters. Clovis points are found in association with the bones of extinct elephants, and Folsom points are found in association with the bones of extinct bison; the distinction is perfect (Jennings 1989). Apparently, the woolly mammoth hunted by the Clovis people became extinct; subsistence shifted to a now-extinct form of bison, and the Folsom point was invented.

Lindenmeier was a Folsom site. The spearpoints are clearly recognizable as Folsom, and the list of animals present in the archaeological bone assemblage includes bison (*Bison antiquus*) but not mammoth. Yet the psychic specifies the presence of elephant or mastodon (here is another bit of faulty wiring to the other world—mastodons were adapted to woodland habitat and were far more numerous in the East, while mammoths, with their quite different teeth, were grassland grazers numerous in the West). Whatever the species, no elephant remains have been found at Lindenmeier or any other Folsom site. The psychic later even contradicts himself and asserts that there were no bison at Lindenmeier at all.

What is going on here seems clear. The psychic was passingly familiar with Paleo-Indian culture. In the experiment, he recognized the fluted points and must have remembered from his reading (rather than from paranormal channels) that the Paleo-Indians hunted now-extinct animals with such weapons. Clearly, though, he was unaware of the distinction between Clovis and Folsom fluted point traditions and the difference in the subsistence patterns of these two chronologically separate people. So, he

mentions the most obvious—almost stereotypical—extinct animal he can think of, the mastodon. There is no paranormal power at work here. Instead, the psychic simply shows himself to be an individual trapped by his own limited knowledge of American prehistory.

Psychic Archaeology: The Verdict

The works of the psychic archaeologists make it clear that many of them feel left out of the scientific mainstream and, to put it bluntly, feel persecuted by other scientists.

As an archaeologist I can only say to the psychics that I wish psychic archaeology worked. As an archaeologist committed to a scientific and skeptical approach, I can only say that wishing doesn't make it so. The verdict on psychic archaeology based upon experiments under controlled conditions is decidedly negative.

Dowsing Instead of Digging

Dowsing for subterranean water is a venerable tradition. Using a Y-shaped stick, a pendulum, or two metal wires with a 90-degree bend in each, some claim the ability to walk over the ground and, depending upon the motion of the device, identify the location, depth, and even the flow rate of underground water (Chambers 1969; see Vogt and Hyman 1980 for a skeptical analysis by an anthropologist and a psychologist).

While "water witching" goes back hundreds of years—the first recorded reference is in 1568 (Chambers 1969:35)—its application to the discovery of archaeological artifacts or buried structures is more recent. Schwartz (1978:108–35) details the alleged abilities of Major General James Scott Elliot in Britain; respected archaeologist Ivor Noël Hume (1974:37–39) describes its use at Williamsburg; Bailey (1983) details the use of dowsing in medieval church archaeology in England; Goodman (1977) discusses "map dowsing," where sites are supposedly discovered by using a dowsing technique on maps.

For some (Schwartz and Goodman, for example) dowsing is simply a method for enhancing or facilitating the psychic abilities of the user. Others maintain that the dowsing device simply allows them to locate, through some unknown, but normal process, magnetic anomalies caused by the buried objects. Major General Elliot, as cited in Schwartz (1978), eschews the psychic label; Hume (1974) uses dowsing to find only metal objects ostensibly as a result of their magnetism.

The first part of this chapter was devoted to a skeptical assessment of the use of psychic power in archaeological research. We saw no good evidence for the existence of such a power in archaeological application; no

test has been successfully conducted that adheres to the scientific, deductive rules enumerated in Chapter 2. Those negative results, however, do not bear on dowsing if, in fact, that procedure is based on the identification of perfectly mundane magnetic disturbances resulting from the burial of man-made objects.

Small, but discernible magnetic effects, indeed, are known to result from human activity and have been used in locating archaeological artifacts or features through a process called *proton magnetometry* (Aitken 1970). In a related approach, the *electrical resistivity* of soil has been measured and used to locate buried foundations and walls (Clark 1970). In the former case a device called a proton magnetometer can be used to locate anything displaying magnetism that differs from the background magnetism of the earth: iron objects, fired clay, or ancient pits (pit fill is more loosely packed than surrounding soil, resulting in differences in what is called *magnetic susceptibility*). In the latter case of *electrical resistivity surveying*, soil resistance to an introduced electrical current varies depending on the compactness of the soil or medium (rock, brick) through which the current is passing. Buried walls and pits will possess different resistivity to the current than will surrounding soil. Differences can be mapped, and buried objects or features causing the differences in resistivity can be investigated.

Measurable phenomena do exist. But can people detect these without the thousands of dollars of equipment ordinarily considered to be required?

Testing the Dowsers

A number of experimental tests of water dowsing have been performed by skeptics; in one case the president of the American Society of Dowsers was involved (Randi 1979, 1984; Martin 1983/4; a test was even performed on the ABC television newsmagazine program *20/20*). In each case the self-proclaimed dowsers agreed to the scientific controls imposed and the design of the experiment. All maintained that they could easily detect flowing water under test conditions (water flowing in randomly selected routes, through buried or covered pipes).

In all cases here cited, the dowsers failed utterly. They simply could not detect flowing water using their rods, sticks, or pendulums, even when a prize of $110,000 was at stake (the prize, recently increased by another $30,000, jointly offered by Australian Dick Smith and American magician, writer, and debunker, James Randi, will be awarded to anyone who can, under controlled conditions, produce a paranormal phenomenon—the prize remains unclaimed after many years).

There has even been a test of the ability of dowsers to locate buried archaeological objects (Aitken 1959). Martin Aitken, pioneer in the use of proton magnetometry and electrical resistivity surveying in archaeology, tested dowser P. A. Raine of Great Britain. Raine could not successfully

dowse the location of an archaeologically verified buried kiln that had been initially identified by magnetometry (it had produced extremely high readings). Aitken concluded from this that dowsing for archaeological remains simply did not work. Though practitioners of dowsing hold quite strongly to their beliefs, they seem to be unable to produce under scientifically controlled conditions. Until they do, dowsing cannot reasonably become a part of the archaeologist's repertoire.

Electromagnetic Photo-Fields

If dowsing, though failing in rigorous tests, nevertheless potentially involves a genuine phenomenon in search of a methodology, the analysis of *"electromagnetic photo-fields"* (EMPFs) seems to be a methodology in search of a phenomenon.

Karen A. Hunt, her master's degree in anthropology in hand, has apparently singlehandedly discovered the EMPF phenomenon, which physicists are wholly unaware of. According to Hunt, any man-made, above-ground structure or change in the environment (like a road or fence) absorbs or blocks out "minute particles from outer space or light with which the earth is constantly bombarded" (1984:2). Hunt does not discuss precisely what "particles" are blocked or absorbed and how their effects are preserved after the structure that did the blocking is long gone. Nonetheless, she maintains that if the structure/environmental change existed for six months or longer, its three-dimensional photo-field pattern "is infinite and cannot be destroyed by ordinary means such as burning, plowing, buldozing [sic], blowing up, or removing it and the soil beneath it, or covering the site up . . ." (Hunt 1984:2).

In practice, EMPF survey in its particulars sounds suspiciously like dowsing—one walks over the ground, interpreting the movements of bent wires held in the hands. Hunt is careful, however, to distinguish the two procedures: (1) EMPFs are detected with metal rods instead of a stick (she apparently is unaware that many dowsers use metal rods), (2) few people can successfully dowse for water, while practically everyone can quickly learn to locate EMPFs, (3) dowsing involves finding things below the surface while EMPF survey involves below- and above-ground features.

EMPFs are an interesting phenomenon indeed; physicists have never detected them, and no current theory explains them or their infinite property, or predicts their existence. In the case of dowsing, the question is asked, "Can a magnetic phenomenon that is known to exist and is detectable with instruments, be detected by individuals simply with bent wires or sticks?" For EMPFs we are asking, "Can a physical phenomenon not known even to exist and *not* detectable by instruments be detected by individuals using bent wires?" Beyond this, if, in fact, above-ground objects

leave discernible EMPFs or any other kind of invisible pattern, don't trees and rock formations do the same? How could one distinguish an EMPF pattern of a house that was present for, say, fifty years, from previous rock formations present in the same spot for fifty million years, glaciers for tens of thousands of years, or even trees for hundreds of years—especially if, as Hunt maintains, the longer an object was in place, the stronger the EMPF?

As shaky as EMPFs sound, a local government in Australia was intrigued enough to pay Hunt $1,800 in expenses for her to come to Australia and divine the layout of a now-destroyed historic homestead in a public park. Walking over the ground with her bent wires, Hunt located 129 buildings and structures, fences and pathways, twenty-five burials, and a number of aborigine huts, none of which exhibited any surface evidence.

After sixteen days of fieldwork, Hunt submitted her report. Her benefactors were said to be quite pleased and felt they got a good deal; a real archaeological and historical investigation of the old homestead would have cost upwards of $10,000 (Austen 1985). The perspective of the local government officials who deemed an EMPF survey worthy of tax dollars seems to be not unlike that of the emperor concerning his invisible new clothes in the children's story. These same government officials confirmed that there was no plan to test with hard data any of Hunt's EMPF revelations (Money 1985).

At the same time, Hunt's rather cluttered EMPF map of the homestead was assessed by Michael McIntyre, director of a local archaeological survey project. He stated that Hunt's drawing of the site based on EMPF analysis looked nothing like an Australian settlement, but did resemble a nineteenth-century American Midwest town. Hunt is from Missouri—ironically the "show me" state. Hunt, of course, has shown nothing about archaeological methodology, but perhaps more about the cynicism of government officials in their attempt to save money by preventing the necessary and proper archaeological and historical investigation to be carried out.

CURRENT PERSPECTIVES
Site Discovery

Traveling at 720 km an hour (450 miles an hour), from a height of 7.3 km (24,000 feet), archaeologists are using "invisible rays" to see through the jungles of Belize and Guatemala in an attempt to better understand how the ancient Mayan civilization fed itself and why it collapsed (see Chapter 12). These archaeologists are not psychic; they are not dowsing for answers, nor are they reading photo-fields. They are using a far more interesting technique: airborne, side-looking radar.

Such a method is part of a growing repertoire of remote sensing techniques in the arsenal of the archaeologist. While archaeologists commonly spend much of their time on their hands and knees, inches from the tiny pieces of the past that have preserved the millennia since their deposition, we sometimes need to get a literally broader view. Such has been the case in the study of Mayan canals (Adams, Brown, and Culbert 1981).

Though we know much about ancient Mayan architecture and astronomy, less is known about how the culture supported itself in the lowland jungles of Mesoamerica (see Chapter 12). It had been thought that the Maya relied on *slash and burn* agriculture, where the jungle is cut back and burned, the soil cultivated and planted, and the plots abandoned in a regular cycle. Yet, it did not seem that such a pattern could have provided enough surplus food for the thousands upon thousands of people who must have been involved in nonsubsistence pursuits: building pyramids, trading, soldiering, etc.

Archaeology in the heart of Mayan territory is difficult since the jungle has obscured all but the most obvious of the archaeological remains. However, radar can be used to, in effect, "see" through the trees. Radar imaging conducted by Adams, Brown, and Culbert has identified sometimes intricate patterns of canals not otherwise visible and not previously known. Such canals imply a far more intensive sort of agriculture than previously envisioned and allow for a better understanding of Mayan subsistence. This, in turn, may help us better grasp the causes for the collapse of this great civilization. Remote sensing techniques like radar imaging allow us to accomplish, in fact, some of the feats of site discovery and interpretation that psychics, dowsers, and electromagnetic photo-field readers can only promise.

11

Old Time Religion— New Age Harmonics

Imagine the following scenario. Scientists working in a remote corner of the globe, scraping away the soil surrounding a remarkable discovery, peering through a microscope at a previously enigmatic artifact, or examining their computer printouts can scarcely believe what they perceive. Incredulous, they realize that there is no other rational explanation; in the artifact they hold before their eyes, in the magnified image of their discovery, or in the results contained in their printouts, the remarkable truth is impossible to deny. The scientists have uncovered concrete proof of a miracle and, at least indirectly, proof of the existence of God.

This may sound like a potential theme for the next installment of a popular movie series. After all, Indiana Jones did manage to recover the Ark of the Covenant—the receptacle for God's word as described in the Old Testament—from the Nazi band that wished to control the enormous power contained within. Maybe Indy's next adventure could involve archaeological proof of the God of the Bible.

But the imaginary scene I've described is not a mere movie scenario. It reflects the actual claims made on a number of occasions by self-styled scientists. While the purpose of this book is certainly not to assess the veracity of anyone's religious beliefs nor to judge the philosophical basis of anyone's faith, when individuals claim that there is physical, archaeological evidence for a basic belief of a particular religion or philosophy, the argument is removed from the field of theological discourse and placed squarely within the proper boundaries of archaeological discussion.

We can assess such a claim or claims as we have assessed all other

claims made in the name of the science of the past—within the context of the scientific method and deductive reasoning. This is precisely what we will do in this chapter for claims of the existence of Noah's Ark, the validity of biblical chronology as evidenced by the contemporaneity of dinosaur and human footprints, the reality of the Shroud of Turin, and esoteric information encoded in the calendar and writing of the ancient Mayan Indians.

Scientific Creationism

Most of us are familiar with the so-called "Scopes Monkey Trial" that took place in Tennessee in 1925. The trial focused on a high school teacher, John T. Scopes, who broke Tennessee state law by teaching Darwin's theory of evolution in a public school classroom. The celebrated trial attracted international attention; famous defense lawyer Clarence Darrow served as counsel for Scopes, and thrice-failed presidential aspirant William Jennings Bryan served on the prosecutorial team.

Though Scopes was convicted and fined (he never did have to pay the fine), most presume that the notoriety—and ridicule—that accrued to Tennessee as a result of the trial resulted in a victory for science and the teaching of evolution. As scientist Stephen Jay Gould (1981, 1982) points out, however, this was not the case. Emotions ran high both during and after the trial. In order to avoid controversy that might hurt sales, most publishers began a practice of regularly ignoring evolution in their high school texts. Generations of American students went unexposed to evolution—the most essential principle underlying the biological sciences.

This changed rather drastically in the 1950s after the Soviets successfully launched Sputnik, the first artificial satellite to orbit the earth. American complacency regarding our superiority in all fields was shaken, and among the results was a revamping of science curricula from elementary school on up. Evolution once again took its rightful place in the biology classroom.

This development, in turn, however, spawned a new attempt by fundamentalist Christian groups to at least alter the teaching of evolution, a concept that they saw as directly contradictory to their religious faith. Realizing, however, that as a result of constitutional protections, religion could not be injected into public education, the fundamentalists attempted a different approach. A new and ostensibly religion-free perspective was invented and called *scientific Creationism*. Herein it was proposed that there was ample *scientific* evidence for the recent (usually dated to within the last 10,000 years) and spontaneous creation of the universe by an intelligent force, the recent and instantaneous creation of human beings by that same force, and the destruction of at least a part of that creation by an enormous, worldwide deluge (Gish 1972; Morris

1974, 1977; Whitcomb and Morris 1961).

Though sounding suspiciously like the story related in the Book of Genesis in the Old Testament of the Judeo-Christian Bible, scientific Creationists claim that they do not base their perspective on faith, or at least not on faith alone. They claim simply to be scientists with an "alternate" hypothesis for the origins of the universe, the earth, life, and humanity. Scientific Creationists have founded institutes (for example, the Institute for Creation Research), published books, founded schools, and debated evolutionists. Finally, they have attempted through legislation on the state level, not to eliminate evolution from the classroom, but to impose what they call a "two model approach" in teaching. This would involve providing equal time for Creationist models of biology, geology, astronomy, and anthropology in public schools—in other words, ten minutes of Darwin, ten minutes of Creationism.

The Creationists have failed virtually whenever their equal time requests have been legislated, carried out, and then litigated. The courts have seen Creationism for what it is: not an alternate scientific model, but a restatement of a religious ideology. Statutes passed by state legislatures requiring the teaching of Creationism in public schools have been deemed unconstitutional by the courts in several states, including Arkansas and Louisiana (Scott 1987). The Louisiana statute came before the Supreme Court of the United States in 1987 where seven out of the nine justices agreed that Creationism represented little more than a restatement of a particular religious ideology—that presented in the Old Testament of the Judeo-Christian Bible. Therefore, its teaching could not be mandated in public school science classrooms. The Supreme Court decision has not ended attempts to have Creationism taught in public schools. In June 1989, a Constitutional amendment was proposed to mandate prayer and Creationism in schools. As of August 1989 the so-called Dannemeyer amendment had thirty-four cosponsors in the House of Representatives.

There are several fine books on the nature of Creationism and the threat it poses to science education in America and elsewhere (Eldredge 1982; Futuyma 1983; Godfrey 1983; Montague 1982). There is also a pamphlet series available from the American Anthropological Association (1984) as well as a short publication from the National Academy of Sciences (1984). These are all excellent sources on the topic of Creationism. We needn't go into this issue in more depth here.

However, the claimed existence of physical evidence supporting biblical literalism is often used to support the *scientific* underpinnings of Creationism. Such physical evidence falls into the field of focus of this book. The two pieces of ostensible evidence we will assess here are (1) the existence of the "artifact" of Noah's Ark and (2) evidence of the recent creation of the earth in the form of proof of the contemporaneity of human beings and dinosaurs.

Noah's Ark

For there to have been a Noah's Ark, the biblical story of the Flood must have been a true and accurate account of an environmental catastrophe (Figure 11.1). Ignoring the religious aspects of the tale, does the Flood story itself make sense; and is there any evidence to support the claim made by most Creationists that a universal deluge, wiping out all human and animal life on the planet except those saved on board the Ark, actually happened within the last 6,000 years? Using a deductive approach as applied elsewhere in this book to nonreligious claims about the past, we can ask the following questions: (1) Could the Ark as described in the Bible have actually been built? (2) Could the people involved have saved representatives of each animal species? (3) Is there any geological evidence of a universal Flood? (4) Is there archaeological evidence of the Flood? and finally, (5) Does the Ark remain as the single most convincing artifact of the story of Noah? We can answer these questions in sequence.

1. *Could the Ark have been built?*

Robert A. Moore (1983) has written a point-by-point examination of the Flood story. He determined that building the Ark would have been impossible. The technology necessary to construct a seaworthy ship the size of the Ark as delineated in the Bible did not exist until the nineteenth century A.D. and would have taken hundreds of people to build, not the four men and four women who made up Noah's family.

2. *Could the people involved have saved representatives of each and every animal species on earth?*

Noah and his family (his wife, three sons, and their wives) could not have gathered and accommodated all the animals allegedly saved on the Ark—some from as much as 12,000 miles away, from continents not even known to Noah. This would have included 25,000 species of birds, 15,000 species of mammals, 6,000 of reptiles, 2,500 of amphibians, and more than 1,000,000 species of insects, all multiplied by the two of each kind (or seven of each kind; the biblical story is contradictory on the number of each species) brought on board (Schneour 1986:312). Moreover, the small number of people could not have fed, watered, and tended the vast number of animals on board the boat.

Beyond this, even considering the enormous size of the Ark, there would have been less than one cubic meter (a stall a little more than three feet by three feet by three feet) for each

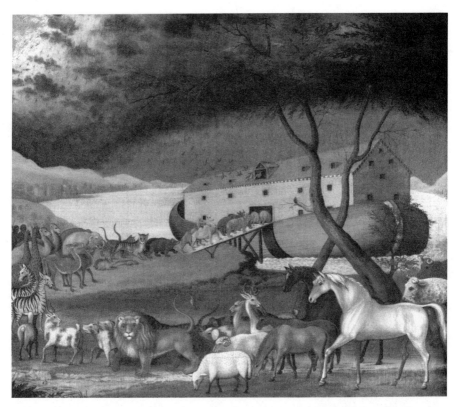

Figure 11.1 An artist's rendition of the gathering of animals boarding Noah's Ark. Geological, biological, paleontological, and archaeological evidence indicates that Noah's Flood was not a historical event. (*Noah's Ark*, 1846, by Edward Hicks. Philadelphia Museum of Art. Bequest of Lisa Norris Elkins)

vertebrate and its food supply (Schneour 1986:313). And remember, as we will see in the next section, many Creationists believe that dinosaurs lived during Noah's time and were among the animals saved on the Ark (Taylor 1985a). Needless to say, a 30-ton, 40-foot-tall, 100-foot-long *Supersaurus* would have been more than a little cramped in its quarters.

On a less sarcastic note, even in the twentieth century, zoos have trouble keeping some species alive in captivity; their dietary and other living requirements are so finely adjusted in nature that they cannot be duplicated. How did Noah accomplish this?

Finally, though extinction technically occurs when the last member of a species dies, species extinction effectively occurs when numbers fall below a certain threshold. For example, the

population of about one thousand pandas left in their natural habitat may be too small a number to prevent eventual disappearance of the species in the wild (Dolnick 1989). Yet, if the Flood story were true, we would have to believe that the panda and all of the other species we see today were able to successfully survive after their numbers had dwindled to either two or seven of each. Genetic variability is so small with such a limited population size that most species would have disappeared.

3. *Is there geological evidence for the Flood itself?*

Certainly such a catastrophic event occurring so recently in the historic past would have left clear evidence. In fact, worldwide geological evidence does not support the claim of a great Flood. The vast majority of the features of the earth's surface are the result of gradually acting, uniform processes of erosion repeated over vast stretches of time, not short-lived, great catastrophes (though occasional catastrophic events like asteroid impacts do occur and may have had significant effects—one large asteroid strike may have been the cause for dinosaur extinction about sixty-five million years ago).

For example, paleontologists have long recognized the *biostratigraphic* layering present in the earth. Biostratigraphy refers not just to the layering of geological strata, but also to the occurrence of plant and animal fossils in these strata. These biological traces are not present in a hodgepodge; they are not randomly associated in the layers, but tend to be neatly ordered. That ordering—older species are found in deeper layers, more recent species are found in higher strata—is a reflection of lengthy chronology, not a recent catastrophe.

If a recent, universal Flood simultaneously destroyed virtually all plants and animals, their remains would have been deposited together in the sediments laid down in that Flood. Dinosaurs and people, trilobites and opossums, giant ground sloths and house cats, *Australopithecus* and the Neandertals— all would have been living at the same time before the Flood and should have been killed together during the Flood. We should be able to find their fossils together in the same geological layers.

Of course, we find no such thing. Plant remains are found in layers older than those containing animals. Single-celled organisms are found in layers below those containing mul-

ticelled organisms. Reptiles are found in older strata than are mammals. For example, layers containing dinosaurs never show evidence of human activity and are always far older than layers containing human fossils. (See "Footprints in Time" later in this chapter.)

Creationists recognize this powerful contradiction to their view. They lamely conjecture that biostratigraphy, instead of representing an ancient chronological sequence, instead represents differences in animal buoyancy during the Flood. In other words, reptiles are found in lower strata than are mammals because they don't float as well. This would be laughable if the threat to science and science education were not so real.

4. *Is there archaeological evidence for the Flood?*

If a universal Flood occurred between five and six thousand years ago, killing all humans except the eight on board the Ark, it would be abundantly clear in the archaeological record. Human history would be marked by an absolute break. We would see the devastation wrought by the catastrophe in terms of the destroyed physical remains of pre-Flood human settlements. Above all else, we would see sharp discontinuity in human cultural progression. All advances in technology, art, architecture, and science made up until the point of the catastrophe would have been destroyed. Human cultural evolution, as reflected in the archaeological record, would have necessarily started all over again after the Flood.

Imagine the results of a nuclear war that left just a handful of people alive. Consider the devastation such a war would visit upon human culture. Think about what the remains of the pre- and post-war societies would look like from an archaeological perspective. This is comparable to what the differences would have been between pre- and post-Flood societies and their archaeology.

Unfortunately for the Flood enthusiasts, the destruction of all but eight of the world's people left no mark on the archaeology of human cultural evolution. The cultural records of the ancient Egyptians, Mesopotamians, Chinese, and American Indian civilizations show no gaps in development. Cultural trajectories in these world areas either were affected not at all by the destruction of their total populations, or there simply was no universal Flood. Applying Occam's Razor, we have to

conclude that, based on the archaeological record, there could have been no universal Flood like that described in the Bible.

5. *Do remains of Noah's Ark still exist?*

Are there archaeological remains of a great ship located on the slopes of a mountain in Turkey? Are these, in fact, the actual physical remains of Noah's Ark? For years, various groups associated with numerous fundamentalist organizations have searched for remains of the Ark on Mount Ararat in Turkey (LeHaye and Morris 1976). One of these groups has included former astronaut James Irwin. They have, as yet, all been unsuccessful.

Local Kurdish tribesmen who claim to have visited the largely intact Ark on the 17,000-foot peak have been interviewed. Stories have been collected of the Russian discovery of the Ark in 1916. That legend maintains that when the communists took control in the Soviet Union, all photographs of the Ark were destroyed and eyewitnesses of the Ark were executed. Some have circulated stories of an American discovery of the Ark in the 1960s. Here, a joint, secret expedition of the Smithsonian Institution and the National Geographic Society supposedly discovered the Ark but suppressed the information "in order to preserve the dominance of Darwinian theory" (Sallee 1983:2). An obvious question that might have been asked is, naturally enough, Then why did they go looking for the Ark in the first place?

Eyewitnesses have invariably been unable to relocate the Ark and bring people to it. Other alleged evidence for the Ark has consisted of photographs and movies. These have always either mysteriously disappeared or turned out to be of images of misidentified rock formations.

In 1959, a French explorer, Fernand Navarra, claimed to have visited the Ark and even brought back wood samples. Unfortunately for the "arkeologists," radiocarbon dating applied to the wood indicated that it dated not to 5,000 years ago as it should have according to biblical chronology, but to between the sixth and ninth centuries A.D. (Taylor and Berger 1980).

One might suppose that with the stunning lack of any corroborative evidence, interest in the Ark would have waned after the years of fruitless searching. It hasn't, but this is because the search for the Ark has little to do

with objective, scientific testing of a hypothesis and everything to do with supporting a religious ideology. As one searcher stated: "My motive is just to show to the world that the Bible is God's word, and that the stories in the Bible are truth, not fiction" (Sallee 1983:1).

Footprints in Time

Recently, I had the wondrous experience of taking my three-year-old son, Joshua, to the American Museum of Natural History in New York City. As a child, I spent quite a bit of time there myself, prowling the halls of that wonderful place. My favorite displays back then were the same as Josh's now: the enormous fossils of the dinosaurs.

When I was a little older than Josh is now, I began to read about the dinosaurs. I could tell you how they walked, what they ate, and what their skin looked like. I could even tell you when they, sadly from the perspective of a five-year-old, became extinct. It is a little more than sixty-five million years since these great beasts thundered across the landscape. Stratigraphy shows this. Dating techniques show this. Paleontology shows this.

Yet, some fundamentalist Christians deny the dating of the extinction of the dinosaurs. In fact, it is their view that the universe, including our world and ourselves, is only about 6,000 years old. In 1650, Irish archbishop James Ussher determined that God had created the universe in 4004 B.C. Some fundamentalists still accept the validity of that date and so claim that human beings and dinosaurs walked the earth during the same period, that is, before Noah's Flood.

Creationist Paul S. Taylor (1985a), in a book intended for children, maintains that dinosaurs were taken on board Noah's Ark since the Bible states that representatives of *all* animal kinds were taken. Dinosaurs, according to Taylor, became extinct only after the Flood.

In the same book, Taylor asks, "Was it dangerous to live with dinosaurs?" He answers, "Dinosaurs would have been no danger to man in the original creation, however, in later years they may have developed into somewhat of a problem" (1985a:6). Yes, I imagine that a fifty-foot-long, carnivorous *Tyrannosaurus* with a six-foot jaw filled with razor-sharp six-inch teeth would have been "somewhat of a problem."

Needless to say, such a remarkable scenario, while in agreement with some awful Hollywood movies and *The Flintstones* cartoon, stands in contradiction to the accumulated wisdom of the fields of biology, zoology, paleontology, geology, and anthropology. Basing conclusions on the seemingly indisputable evidence of stratigraphy, fossils, artifacts, and radiometric dating, these fields show quite clearly that the last of the dinosaurs died off about sixty million years before the appearance of the first upright walking hominids.

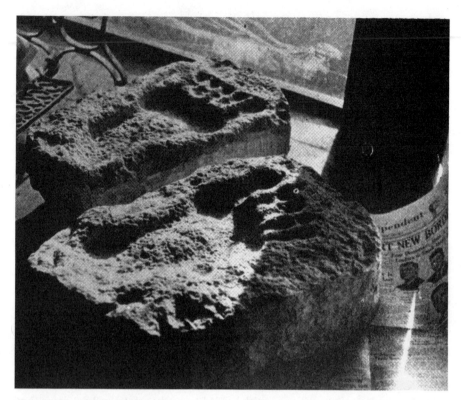

Figure 11.2 These obviously carved human footprints were found by scientist R. T. Bird in a store in Arizona. He traced them back to Glen Rose, Texas, where he subsequently located a rich deposit of genuine, fossilized dinosaur footprints in the Paluxy River bed. (Neg. No. 2A17485. Photo by K. Perkins and T. Beckett. Courtesy Department of Library Services, American Museum of Natural History)

Many Creationists reject all these data in favor of one bit of presumed evidence they claim shows the contemporaneity of dinosaurs and human beings—footprints from the Paluxy River bed in Glen Rose, Texas (Morris 1980).

Fossilized dinosaur footprints along the Paluxy River were first brought to the attention of scientists and the general public in 1939 when scientist Roland Bird (1939) mentioned their existence. In the same article, Bird noted that giant, *fake* human footprints were being made and sold by people who lived in the area of the genuine dinosaur prints (Figure 11.2).

Thereafter, claims were published in a Seventh Day Adventist church periodical that there were *genuine* "mantracks" side by side with, in the same stratum with, and sometimes overlapping dinosaur prints in the Paluxy River bed (Burdick 1950). Similar claims were made in a major Creationist publication purporting to prove the validity of the biblical Flood story (Whitcomb and Morris 1961). Throughout the 1960s, 70s, and 80s,

Figure 11.3 Creationists have claimed there are fossilized footprints of giant human beings in the same layer with and side by side with, the dinosaur prints in the Paluxy River bed. These turn out to be misinterpreted portions of genuine dinosaur footprints. Impressions left by three claws can be discerned at the front (left) of this print. (Courtesy © 1985 Glen J. Kuban)

Creationists of various denominations and perspectives have conducted "research" in the area, looking for trackways and other evidence that dinosaurs and humans lived during the same recent period of the past—in Texas, at least.

A film, *Footprints in Stone*, was produced in 1973. Until its withdrawal in 1985 this film was available to the public and likely was seen by thousands of people. One individual who has been involved in the area since 1982, the Reverend Carl Baugh, has gone so far as to purchase land in the vicinity of the footprint finds and has built a small museum there. Baugh intends to raise some $3.5 million to build a larger museum the size and configuration of Noah's Ark, with a water flume ride that will replicate the hydraulic forces present during Noah's flood (Hastings 1985).

Certainly, the association of dinosaur and human footprints in the same geological stratum in Glen Rose would contradict the biostratigraphic record of the rest of the world and would seem to indicate that human beings and dinosaurs, indeed, were contemporaries.

The footprint data have been most thoroughly summarized from a Creationist perspective by John Morris (1980) in his book *Tracking Those Incredible Dinosaurs and the People Who Knew Them*. It is clear from his descriptions that there are at least three distinct categories of features in the Paluxy River bed: (1) indisputable dinosaur footprints, (2) indisputably fraudulent, carved giant human footprints, and (3) long (some more than 50 cm), narrow, ambiguous fossilized imprints.

Little needs to be said of the first two categories. Physical anthropologist Laurie Godfrey (1985) has shown quite clearly that the fraudulent "mantracks" were known to have been carved and sold by at least one local resident during the Depression. Extant examples of these frauds (see Figure 11.2) bear no relationship to the anatomy of the human foot or the way human footprints are produced (their *ichnology*).

It is the third category that has caused the greatest amount of confu-

sion. Those impressions available for study are invariably amorphous imprints that, while exhibiting only in a very general sense the outline of huge human feet, bear no actual humanlike features (Godfrey 1985; Cole, Godfrey, and Schafersman 1985; Edwords 1983; Kuban 1989a). Interestingly, many of the Creationists who discovered the prints admit the fact that, as a result of erosion, the prints are now unimpressive, while maintaining they were clearly human when first discovered (Taylor 1985b).

Godfrey shows quite clearly that the elongate fossil impressions are a mixed lot of erosional features and weathered, bipedal dinosaur footprints (Figure 11.3). Most of the prints are vague—even Creationists cannot agree on the length, width, or even the left/right designation of the same prints. None of the so-called mantracks exhibit anatomical features of the human foot, nor do they exhibit evidence of the biomechanics of human locomotion. As Godfrey points out, humans have a unique way of walking that gets translated into the unique characteristics of our footprints. When we walk, each foot contacts the ground in a rolling motion—the heel strikes the surface first, then the outer margin of the foot, next the ball of the foot, and finally the big toe or *hallux*. Godfrey's analysis shows that the Paluxy mantracks do not exhibit these aspects of human locomotion.

Recently, most Creationists changed their minds concerning at least the tracks discovered before 1986 (Taylor 1985b; Morris 1986). The film *Footprints in Stone* was withdrawn from circulation. Kuban (1989b) discovered that the exposed tracks had weathered, revealing the claw impressions of the three-toed dinosaurs who made the prints Creationists had claimed were made by humans. Though hopeful that earlier, now-destroyed discoveries might have been genuine human footprints or that future discoveries might be made of real mantracks, most Creationists for a time accepted what evolutionists had been saying all along; there is no evidence for the contemporaneity of human beings and dinosaurs in the Paluxy River bed.

Perhaps not surprisingly, as researcher and writer Glen Kuban (1989a) points out, some Creationists are backtracking on the tracks again. New tracks have been found, and claims have been made that some are the fossilized footprints of human beings who were contemporaries of the dinosaurs. Kuban has examined the new tracks and has concluded that they are certainly not human. As he states, "Evidently little if anything was learned from past mistakes" (Kuban 1989a:15).

The Shroud of Turin

In discussing scientific epistemology in Chapter 2, I pointed out that science does not proceed through a simple process of elimination. We do not simply suggest a number of hypotheses, eliminate those we can, and then accept whichever one is left. Yet just such an approach is at the heart of much of the pseudoscience surrounding the so-called *Shroud of Turin*.

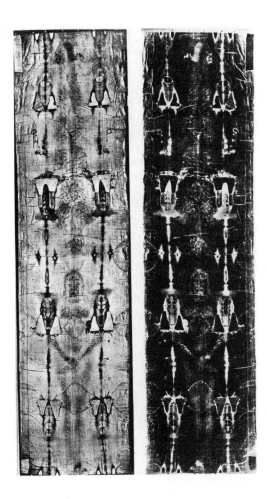

Figure 11.4 Positive [left] and negative [right] images of the Shroud of Turin. Some have claimed that the Shroud was the actual burial garment of Jesus Christ and that the image on the shroud was miraculously wrought at the moment of resurrection. However, historical evidence, microscopic analysis, and a recently derived radiocarbon date show that it was the work of a fourteenth-century artist. (Photo by G. Enrie. Courtesy of the Holy Shroud Guild)

This fourteen-foot by three-and-a-half-foot piece of cloth is presumed by some to have been the burial garment of Jesus Christ. It is further asserted by some that the image on the cloth of the front and back of a man, apparently killed by crucifixion (Figure 11.4), was rendered not by any ordinary human agency, but by miraculous intervention at the moment of Christ's resurrection (Stevenson and Habermas 1981a & b; Wilson 1979). Such a conclusion was reached by some of the scientists who participated in the Shroud of Turin Research Project (STURP) in 1978 (Weaver 1980).

At least in terms of the technology applied, STURP used a scientific approach in analysis of the shroud. Over five days in 1978, using seventy-two crates of high-tech equipment, they conducted an intensive examination of the shroud. The quality of a scientific investigation, however, cannot be assessed by the tonnage of the equipment brought to bear. The STURP research ultimately was a scientific failure. Even before they began, several

of those involved had already made up their minds that the shroud housed in the cathedral in Turin, Italy, was the result of a supernatural occurrence (Mueller 1982).

Beyond this, their approach was not consistent with scientific methodology. In essence, they considered a limited number of prosaic explanations for the image on the shroud (oil painting, watercolors, stains from oils used to anoint the dead body). They applied their high-tech equipment in testing these hypotheses and found none of the explanations to their satisfaction. They ended up suggesting that the image was actually a scorch mark created by an inexplicable burst of radiation (Holy Shroud Guild 1977). Though, officially, STURP did not conclude that the image had been miraculously wrought, Mueller (1982) points out that STURP's "burst of radiation" from a dead body would most certainly have been miraculous.

Some STURP members (in particular, Stevenson and Habermas 1981a) were more forthcoming in explicitly concluding that the image must have been the result of a miracle. They further maintained that the image is that of a person bearing precisely the wounds of Christ as mentioned in the New Testament (scourge marks, crown of thorns, crucifixion nail holes, stab wound). They finally conclude that the image on the shroud is, in fact, a miraculously wrought picture of Jesus Christ.

Not all were convinced by STURP's official argument or the more religious claims of Stevenson and Habermas. One member of the original STURP team (he subsequently resigned) was Walter McCrone, the world-renowned microscopist who discovered that the Yale Vinland map was a forgery (see Chapters 3 and 6). McCrone examined sticky-tape samples taken of the shroud and discovered that the image bore traces of iron oxides and mercury, the constituents of red ochre and vermillion pigments (McCrone 1982). In other words, the image, including the so-called blood stains, was made with paint. McCrone found no evidence of blood on the shroud.

Beyond this, Joseph Nickell (1983b) suggested a plausible artistic method for the production of the shroud. This involved daubing powdered pigment on cloth molded over a bas-relief of a human being. His method seemed to explain the curious fact that the image on the shroud appears more realistic in negative reproductions; that simply is a product of the technique of image manufacture (as in a grave rubbing). Though his method has been used by European artists for 700 years, and his replica of the face on the shroud bears a striking resemblance to the original, not surprisingly his suggestion was rejected outright by those who felt the shroud represented an authentic miracle (Figure 11.5).

Similarly, the supposedly mysterious three-dimensional information contained in the shroud has been explained as a product of the technique Nickell says was used to produce the image (Mueller 1982), and the anatomical precision of the wounds depicted has been seriously questioned (Rhein 1980).

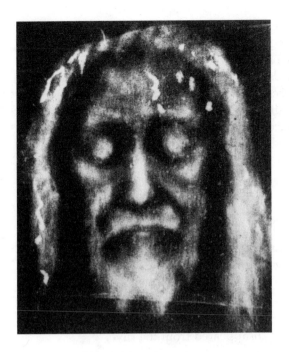

Figure 11.5 Shroud enthusiasts claimed that there was no natural explanation for the image on the shroud. However, shroud investigator Joseph Nickell was able to duplicate the image of the face on the shroud by using an artistic technique long known to artists. (Courtesy Joseph Nickell)

With these skeptical reports in mind, it must be admitted that if the image on the shroud is miraculous, it is, of course, beyond the capability of science to explain it. Nonetheless, we can apply scientific reasoning concerning the historical context of the shroud. In other words, if the shroud is the burial cloth of Jesus, and if the image appeared on the shroud through some inexplicable burst of divine energy at the moment of resurrection, then we might expect to find that:

1. The shroud was a regular part of Jewish burial tradition.
2. The shroud image was described by early Christians and, as proof of Christ's divinity, used in proselytizing.
3. The Shroud of Turin can be historically traced to the burial garment of Christ mentioned in the New Testament.
4. The Shroud of Turin can be dated to the period of Jesus Christ.

We can test these implications of the hypothesis of the shroud's authenticity.

1. *Jewish burial shrouds.*

The story begins with the crucifixion of Jesus Christ. Whatever one's perspective concerning the divinity of Jesus, a few things are clear. Christ was a Jew and one among a

handful of alleged messiahs in the general period of about 2,000 years ago. As such, from the perspective of the Roman occupiers of Israel, Christ was one in a series of religious and political troublemakers. The Romans dealt harshly with those who directly or indirectly threatened their authority. Crucifixion—execution by nailing or tying the offender to a wooden cross in a public place—was a way of both eliminating the individual and reminding the populace of the cost of defying Roman rule.

As a Jew, Christ's death almost certainly would have resulted in a Jewish burial ceremony. At the time, this would have involved taking the body, anointing it with oils, and wrapping it with a burial shroud of linen. According to *halacha* (Jewish law), burial ordinarily should occur within twenty-four hours of death or soon thereafter.

According to the New Testament, Christ was removed from the cross and placed in a cave whose entrance was sealed with a large rock. Christ is then supposed to have risen from the dead, and his body disappeared from the cave.

Taking an anthropological perspective, analysis of Jewish burial custom suggests that a burial sheet or shroud is to be expected in the case of the death and burial of Christ. But what should that shroud look like? Old Testament descriptions of shrouds seem to imply that the body was not wrapped in a single sheet (like the "winding sheets" used in burials in medieval Europe), but in linen strips, with a separate strip or veil placed over the face. And, in fact, in the Gospel of John, there is a description of the wrapping of Jesus's body in linen clothes and a separate face veil. So there are significant inconsistencies between what the burial garments of Jesus should look like, what the Gospel of John says it looked like, and the actual appearance of the Shroud of Turin.

2. *Was the shroud image mentioned in the Gospels?*

The Gospel of John is clear concerning the discovery of the burial linens of Jesus. Certainly, the Gospels were not averse to advertising the miracles allegedly performed by Christ. These were used in an attempt to convince disbelievers of the divinity of Christ. A miraculous image on the burial linens of Jesus would certainly have been noticed, recorded, and, in fact, shouted from the rooftops. The cloth would likely have been paraded in the streets of Jerusalem. Stories of walking on

water, curing the sick, and such may have been enticing to many, but actual physical evidence of a miracle associated with the death of Christ would have riveted everyone's attention.

And there is the rub. Very simply, there is absolutely no mention of a miraculous image on the shroud anywhere in the New Testament. This is almost certainly simply because there was no image on the shroud.

3. *Tracing the current shroud.*

With the preceding argument in mind, can we nevertheless trace the burial linens of Jesus mentioned in the New Testament to the shroud housed in the cathedral in Turin? The answer very simply is, no.

The very earliest mention of the current shroud is A.D. 1353. Between the death of Jesus and A.D. 1353, there is no historical mention of the shroud and no evidence that it existed. It makes little or no sense, if indeed a shroud existed with a miraculous image of Christ on it, for it to have gone unmentioned for more than 1,300 years. Applying Occam's Razor, a more reasonable explanation might be that the shroud with the image of Christ did not exist until the fourteenth century.

The history of the shroud after 1353 is quite a bit clearer. It has been described in an excellent book, *Inquest on the Shroud*, by science writer Joseph Nickell (1983b). Apparently, a church named Our Lady of Lirey was established in 1353 to be a repository for the shroud, and it was first put on view there a few years later. It was advertised as "the true burial sheet of Christ" and admission was charged to the pilgrims who came to view it (Nickell 1983b:11). Medallions were struck (and sold) to commemorate the first display of the shroud; existing medallions show an image of the shroud.

The Church in Rome took a remarkably skeptical approach to the shroud. As a result of the lack of reference to such a shroud in the Gospels, Bishop Henri de Poitiers initiated an investigation of the shroud and a lengthy report was submitted to the Pope in 1359. The report pulls no punches; it concludes that the shroud was a fake produced to make money for the church at Lirey. It was even discovered that individuals had been paid to feign sickness or infirmity and to fake "miraculous" cures in the presence of the shroud. The report goes even further, mentioning the confession of the forger:

"the truth being attested by the artist who had painted it, to wit, that it was a work of human skill and not miraculously wrought or bestowed" (as quoted in Nickell 1983b:13).

As a result of the Church-sponsored report, Pope Clement VII declared that the shroud was a painted cloth and could be exhibited only if: (1) no candles or incense were burned in its presence, (2) no honor guard accompanied it, and (3) the following disclaimer were announced during its exhibition: "It is not the True Shroud of Our Lord, but a painting or picture made in the semblance or representation of the Shroud" (as quoted in Nickell 1983b:17).

Even with the disclaimer, the shroud attracted pilgrims and believers. The shroud became an article of commerce, being bartered for a palace in 1453. In 1578 it ended up in Turin, Italy, where it was exhibited in the sixteenth through twentieth centuries.

4. *What is the age of the shroud?*

We have not been able to validate any of our predictions regarding the Shroud of Turin if, indeed, it were the actual shroud of Christ. Even if we could validate the final concomitant of shroud authenticity—its being the correct age—the evidence discussed would seem to negate any hypotheses concerning its authenticity.

Note here that even if the Shroud of Turin turned out to be a two-thousand-year-old piece of cloth, the shroud-as-miracle would not be established. It still could be a fraud rendered two thousand years ago—or more recently on old cloth. However, a final blow would be struck to any hypotheses of authenticity if the cloth could be shown to be substantially younger than the time of Jesus. Recent analyses have shown just this.

The Church agreed to have three radiocarbon dating labs date the shroud. Small pieces of the linen were removed for analysis. The dates indicated that the shroud is no more than about seven hundred years old; the linen cloth was woven from flax harvested sometime between A.D. 1260 and 1390 (Vaughan 1988:229; Nickell 1989). These dates correspond not with the time of Jesus, but with the first historical mention of the existence of the shroud. That the shroud of Turin was a medieval artifact was fairly certain before the dating. After the dating the issue is settled.

New Age Prehistory

On August 16/17, in 1987, people all over the world congregated in various special locations to mark the beginning of a new age. The geographical foci chosen were supposed "sacred sites." Not surprisingly, some of the places that were chosen should now be familiar to the readers of this book: Mystery Hill, Serpent Mound, and Cahokia (Peterson 1988). The moment was one apparently resonant with earth-shaking possibilities, for it heralded the beginning of a change in the trajectory of human evolution and history.

It was not simply that August 16, 1987, was the tenth anniversary of the death of Elvis Presley, though that irony (or perhaps it was a joke after all) seems to have been lost on the true believers. No, those days had been singled out in a very popular book, *The Mayan Factor: Path Beyond Technology*, by José Argüelles. He called that two-day period (conveniently on a weekend so the celebrants wouldn't have to take a day off from work) the *Harmonic Convergence* (1987:170).

In blunt terms *The Mayan Factor* masquerades as profundity for the ignorant and the credulous. In a parade of seemingly meaningless statements, using Mayan mythology, a sort of Mayan numerology, and—as Argüelles admits—"leaps of faith and imagination" (p. 86), he does little more than resurrect von Däniken's nonsense concerning ancient astronauts. Though his prose is quite obscure, the essence of his argument seems to be that the Mayan Indians were intergalactic beings who visited the earth. They were not the crude, high-tech types of von Däniken's fantasy, cruising the universe in spaceships. Instead the Maya were beings who could "transmit themselves as DNA code information from one star system to another" (p. 59). (See Chapter 12 of this book for a discussion of Mayan archaeology.)

Their purpose on earth is rather obscure (to me, at least):

> The totality of the interaction between the Earth's larger life and the individual and group responses to this greater life define "planet art." In this large process, I dimly perceive the Maya as being the navigators or charters of the waters of galactic synchronization (Argüelles 1987:37).

If that doesn't quite clear it up for you, Argüelles adds that the Maya are here on earth "to make sure that the galactic harmonic pattern, not perceivable as yet to our evolutionary position in the galaxy, had been presented and recorded" (p. 73).

Apparently, the Maya, who are actually from the star Arcturus in the Pleiades cluster, materialized in Mesoamerica a number of times as "galactic agents." They introduced writing and other aspects of civilization to the Olmec, a pre-Mayan group, as part of a quite vague plan to incorporate humanity into some sort of cosmic club.

Argüelles maintains that a Mayan cycle of time that began in 3113 B.C.

will end December 21, 2012 A.D. He states that the Maya are already on their way back to earth via "galactic synchronization beams," traveling by way of "chromo-molecular transport" (p. 169). The date of the Harmonic Convergence was significant, though for rather obscure reasons, relative to the "re-impregnation of the planetary field with the archetypal harmonic experiences of the planetary whole" (p. 170).

In any event, by harmonically converging on that two-day period, we were sending a signal to the oncoming Maya that we humans were ready (for what, I am not sure). Soon, according to Argüelles, there will be no more cancer or AIDS (in reality caused by "radial blockages in our collective bio-electromagnetic field") (p. 182) and no more threat of war (read the newspaper to check out this claim). Then, on December 21, 2012, the Maya will arrive and reality will be transformed.

Of course, there is no reference to archaeological evidence or any sort of scientific testing for the speculations made by Argüelles. The claims may seem laughable, but at this time in genuine human history, the joke isn't funny. The specter of thousands of people waiting hopefully for some "planetary synchronization" or "harmonic convergence" to cure all of the ills that afflict us and our planet is ultimately, desperately sad.

𝕾𝕾𝕾𝕾𝕾𝕾 CURRENT PERSPECTIVES 𝕾𝕾𝕾𝕾𝕾𝕾
Religions Old and New

Around 1885, a Paiute Indian named Wovoka had a vision in which Jesus Christ came to him and told of a new order that was to come. Jesus, who in the vision was an Indian, instructed Wovoka to teach his people a new dance. If enough Indians from different tribes would only join in, this dance would lead to miracles. All sick or injured Indians would regain their health. All dead Indians from all the ages would come back to life and join in the dance. These countless Indians dancing together would float into the air and a great flood would decimate the country, destroying in its wake all the white settlers. When the flood waters subsided, the Indians would gently return to the ground to begin a paradisiacal life of plenty, with lots of food, no sickness—and no white settlers (Mooney 1892–93; Kehoe 1989).

The *Ghost Dance*, as it came to be called, was what anthropologists label a *revitalistic movement*. Movements such as the Ghost Dance occur when a people sees its way of life threatened by a terrible, impending calamity. The old ways, including the old gods, seem to have no effect. A new, revolutionary belief system or sometimes simply a return to a previous, "purer" way is seized upon as offering a solution.

In the case of the Ghost Dance, Indians faced with cultural extinction at the hands of the European colonists looked for some way out of their terrible predicament. There could be no military solution, and there appeared to be no spiritual recourse. There seemed to be no way out.

Wovoka's vision of salvation gave them a way out. Thousands of Indians in hundreds of groups across the United States believed in Wovoka's vision and joined in the dance.

One cannot help but be struck with the common thread running through this revitalistic movement of a century ago and spiritual and religious upheavals in the modern world. Fundamentalist Christians and Moslems see all of the modern world's ills as spiritually based; if we could all just return to the one true belief, all would be cured. At the same time, New Age beliefs seem to provide spiritual relief for those who perceive the precariousness of modern existence but who do not see the solution in old time religion.

A century ago Wovoka and the Indian people were faced with the destruction of their way of life and even their own extinction. The terrors of our own century are just as great and include the quick death of nuclear extinction and the slow decay wrought by pollution, terrorism, poverty, drugs, and disease. Science seems to offer little in the way of solution and, in fact, is seen by many as being at the core of the problem.

How comforting to believe that we can change all this simply by returning to a more fundamental belief in the Bible or that the solution to our problems is only twenty-five years away in the guise of godlike extraterrestrial aliens who have been here before and who will save us, ultimately, from ourselves.

It is all the better, then, if the archaeological record can be interpreted as supporting such beliefs. In this perspective, both fundamentalism (of all sorts) and the New Age philosophy can be viewed as twentieth century revitalistic movements, offering hope to people desperate to believe there is a spiritual solution to our otherwise seemingly insoluble dilemmas.

There is, of course, a catch; the Ghost Dance movement ended because, in the final analysis, it couldn't deliver. Indians dancing, no matter what the numbers, could not prevent their slaughter at the hands of white soldiers with Gatling guns. The massacre at Wounded Knee, at which more than 300 Indian men, women, and children were killed despite their supposed protection by the dance, effectively destroyed the Ghost Dance movement (Brown 1970).

Harmonic convergers and fundamentalists alike might do well to heed that message. Revitalistic movements, whether based on a literal interpretation of the Bible or remarkable interpretations of the archaeological record, can do little to address the real problems facing the world.

Real Mysteries
of a Veritable Past

The past never ceases to surprise, fascinate, intrigue, and amaze people. Many are drawn to it and revel in reconstructions of what happened in the past and what it was like to live in the times that preceded our own.

Perhaps ironically, it is this built-in interest that makes so many so susceptible to frauds, myths, and supposed mysteries like those detailed in this book. Note that I have here repeated our title, but inserted the word "supposed" since the mysteries of the Moundbuilders, Atlantis, ancient astronauts, and the rest have been shown to be not mysteries at all, but simply confusion resulting from misinterpretation or misrepresentation of human antiquity.

Eliminating the false "mysteries," however, certainly does not leave us with a dull or mundane human past. There still are plenty of "mysteries" in the sense of enormously interesting, open questions about what has gone before. Three such examples of genuine mysteries of the past relate to the Paleolithic cave paintings of Europe, the European Megalithic site of Stonehenge, and the development of—and the fall of—the Mayan Indian civilization.

The Cave Painters of Europe

Beginning more than 30,000 years ago, the inhabitants of Europe produced some of the first art attributable to our species (Conkey 1983). Using cave walls as prehistoric canvases for their paintings and employing stone, bone, antler, ivory, and clay as the media for their sculptures and engravings, our

Figure 12.1 The Paleolithic cave paintings of Europe often are remarkably realistic depictions of the animal life of the ancient world. Here, a bison, apparently impaled by spears, stands frozen in time in the cave at Niaux. (Museum of Man, Paris, Mandement)

Paleolithic forebears produced a remarkable and varied body of art work. The cave paintings immediately capture our attention. A veritable bestiary of ancient animals stands frozen in time on the walls of Lascaux, Altamira, Niaux, and about 130 other European caves. Rendered in pigments of orange, yellow, red, and brown derived from iron oxides, along with black produced from manganese, many of these paintings are astonishingly lifelike, displaying a realism unexpected among a people so ancient and supposedly so primitive (Ruspoli 1986).

There are horse and elk, woolly mammoth and wild cattle, rhinoceros and bison (Figure 12.1), all captured in exquisite detail by the ancient artists' skill and talent. Often, the animals are not shown in simple, static poses, but in fluid motion. A red horse flees from spears on the cave wall at Lascaux. Two woolly mammoths confront each other, face to face, on a wall in the cave of Rouffignac. Two spears hang from a dying bison at Lascaux.

Figure 12.2 Called "The Sorcerer," this beast, painted on the wall of the cave of Trois-Frères, appears to be an amalgam of a human being and, perhaps, a deer. Its meaning is unknown. (Neg #329853. Courtesy Department of Library Services, American Museum of Natural History.)

The ancient artists did not depict only those animals that the archaeological record indicates were hunted for food. Bears, lions, and other carnivores also are rendered. These were often placed on walls far from the central parts of the caves, down long, sinuous, rock-strewn passageways.

And there is more. Animals were not the only objects commanding the attention of Paleolithic artists. Abstract designs, geometric patterns, human handprints, and mythical beasts also adorn the cave walls (Figure 12.2). Rarely, we even find depictions of the humans themselves. Intriguingly, such "self-portraits" are often vague and indistinct—quite unlike the realistic depictions of the animals with whom our ancestors shared their ancient world.

In the cave paintings, as well as in the rest of what is called "Paleolithic art," rests a mystery. What prompted our ancient ancestors to produce these works on the cave walls? Was it simply "art" done for the sake of beauty (Halverson 1987)? We certainly can recognize the beauty in the work and today can appreciate it as art, but was that the intention of those who produced it (Conkey 1987)?

Was there some more complex reason for painting the images on the cave walls beyond simply a "delight in appearance" (Halverson 1987:68)? Were the cave paintings sympathetic magic—an attempt to capture the

spirit of animals and thereby assure their capture in the hunt (Breuil 1952)? Were the paintings the equivalent of our modern trophy heads—in effect, historically recording the successes of actual hunts (Eaton 1978)? Were the paintings part of a symbolic system that revolved around male and female imagery (Leroi-Gourhan 1968)? Or were the paintings part of a system of marking territory by different human groups during periods of environmental stress (Conkey 1980; Jochim 1983)?

Several prehistorians are focusing on the meaning of the cave art (Conkey 1987 provides a useful summary). There are as yet no definitive answers; there may never be. In that sense, the art of the Paleolithic—though certainly recognizable as the work of ancient human beings and not attributable to refugees from Atlantis or extraterrestrial visitors—is a fascinating legacy of our past and can, indeed, be labeled an unsolved mystery of human antiquity.

Stonehenge

Some five thousand years ago, the inhabitants of the Salisbury Plain in the southern part of England began a construction project that was to last for nearly two thousand years. From 5,000 to 3,000 years ago, possessors of a seemingly simple farming culture built the impressive but enigmatic monument today known as *Stonehenge*.

Begun simply, with a circular ditch some 100 m (300 feet) across, the project culminated in an enormous structure composed of more than 160 stones. There were thirty uprights or *sarsens*, each over 3 meters tall (10 feet) and weighing approximately 24,000 kilograms (26 tons), arranged in a circle 30 meters (100 feet) across (see Figure 9.7). Thirty *lintels*, each weighing about 5,500 kilograms (6 tons), were perched in a continuous ring atop the sarsens. Five sets of three stones known as the *trilithons* were erected. These consisted of two uprights, 8 meters (nearly 24 feet) high and weighing 45,000 kilograms (50 tons) apiece, supporting a lintel some 9,000 kilograms (10 tons) each (for the facts and figures behind Stonehenge see Wernick et al. 1973, and Chippindale 1983).

Other concentric rings of smaller stones were at one time contained within the sarsen circle. Other uprights were placed outside the sarsens, including the so-called *heel stone*—a 73,000-kilogram (80-ton) stone located about 80 meters (240 feet) northeast of the center of the sarsen circle.

The work necessary to produce Stonehenge was astonishing. The sarsens, trilithons, and their lintels are composed of sandstone blocks harder than granite. They had to be quarried and shaped using stone tools and then transported from their likely source in Marlborough Downs some thirty-five km (more than twenty miles) from the building site without the benefit of draft animals. Enormously heavy stones had to be erected, and huge

lintels had to be raised as much as eight meters where they were placed atop the uprights. These lintels were not simply rested on the sarsens and trilithon uprights, but were attached using a mortise and tenon configuration with bumps carved into the top of the uprights and matching depressions carved into the bottoms of the lintels.

Stonehenge has justifiably generated a prodigious amount of interest. How did an ancient and presumably simple farming people construct the monument? How did they quarry the stones? How did they move them? How could they have planned and designed the monument? How did they erect the huge stones? And finally, perhaps the greatest mystery, why did they do it?

Some of the mystery of Stonehenge is a result of our own temporal chauvinism. We find it hard to conceive of ancient people as being inventive, ingenious, or clever. Certainly, it took ingenuity and not just a little hard work to produce Stonehenge and the thousands of other large stone or *Megalithic* monuments that are found in Europe. If we can leave our temporal biases behind, we can clearly see that the archaeological record of the human past shows that people, including those from five thousand years ago, are capable of ingenuity and hard work. Certainly, we need not fall back on lost continents or ancient astronauts to explain the accomplishments of the megalith builders or any other ancient human group.

But how was Stonehenge built? The stone likely was quarried by taking advantage of natural breaks in the bedrock and using fire, cold water, and persistent hammering to split the stones into the desired shapes. The stones could have been moved on wooden sledges pulled by rope, perhaps using log rollers to quicken the pace. The upright stones were likely erected using levers and the lintels raised by a combination of levering and the construction of wooden staging around the uprights. The accomplishment was—and is—truly remarkable, but certainly within the capabilities of a large number of dedicated people working diligently toward a desired goal (for example, see Figure 9.5 for an ancient artist's rendition of Egyptian methods for moving large objects).

That leaves unanswered the question of why the enormous task of Stonehenge's construction was undertaken. There certainly have been a large number of suggestions (Chippindale 1983). Perhaps the most interesting has been that of the astronomer Gerald Hawkins (1965) who proposed that Stonehenge was, in effect, an astronomical computer designed to keep track of the sun's position on the horizon at sunrise and sunset, as well as the moon's position on the horizon at "moonrise" and "moonset." He went on to suggest that Stonehenge was even used as an eclipse predictor.

In essence, Hawkins sees Stonehenge as an enormous sighting device. From the center, one's view of the surrounding horizon is limited; one is not afforded a 360-degree vista since much of the horizon is blocked by sarsens

or trilithons. Hawkins hypothesizes (and tests his hypothesis, using a computer to check all of the possible horizon sighting points) that those points on the horizon that one can see from the center of Stonehenge and that appear to be marked by additional stones outside of the sarsen circle are all significant astronomically. Most obvious is the sighting from the center of Stonehenge to the northeast. Hawkins relates this orientation to the rising of the sun.

The sun does not "rise in the east and set in the west" as many think. In fact, the sun's position on the horizon at sunrise and sunset moves slightly from day to day during the course of a year. In the Northern Hemisphere, the sun's position at sunrise moves a little bit north along the horizon each day in the spring until it reaches its northernmost point on the first day of summer—the specific *azimuth* or angle differs depending upon one's latitude.

After its northernmost rising, the sun appears to rise a little farther south each day. On the first day of fall, the *autumnal equinox*, it rises due east. It then continues to rise farther south until it rises at its southernmost position on the first day of winter—the *winter solstice*. The sun then appears to change direction and rise a little farther north each day, rising due east again on the first day of spring, the *vernal equinox*. Continuing its apparent motion north, it again reaches its northernmost rising point exactly one year since it previously rose in that spot.

The sun rises at its farthest northern point on the horizon on the longest day of the year—the *summer solstice*. On this clearly demarcated day of the year, from a vantage point in the center of the sarsen circle at Stonehenge, one can see the sun rise directly over the heel stone.

Is this coincidental? As long ago as the early eighteenth century, Stonehenge investigator William Stukeley recognized the orientation of Stonehenge toward the summer sunrise. Hawkins maintains that this orientation of Stonehenge is no coincidence and that too many of the possible solar and lunar sighting points at Stonehenge relate to significant points like the sunrise at the solstice.

Hawkins proposed that Stonehenge began as a simple, though large-scale, calendar for keeping track of the seasons—a valuable thing for people dependent upon farming for their subsistence—and evolved over some two thousand years into the very impressive monument we see today. Others, however, have questioned Hawkins, particularly in his more extreme and certainly speculative claims concerning eclipse prediction (Atkinson 1966).

That Stonehenge was a remarkable accomplishment is unquestioned. That it marked at least the position of sunrise at the summer solstice is likely. Beyond this, the precise intent of the builders of Stonehenge, and the reason so much effort was dedicated to its construction, is still a mystery.

The Civilization of the Maya

Chichén Itzá, Uxmal, Tikal, Copan, Sayil, Palenque; the names resound with mystery. These were all cities of the ancient Mayan civilization that flourished more than ten centuries ago in the lowlands of Guatemala, Honduras, El Salvador, Belize, and the Yucatán Peninsula of Mexico. Archaeological research in the past few decades has brought to light some of the remarkable accomplishments of this indigenous American Indian civilization (Sabloff 1989).

The architectural achievements of the Maya match those of any of the world's ancient cultures. The imposing, elliptical Pyramid of the Magician at Uxmal is a stunning piece of architecture and engineering (see Figure 8.6, bottom). The eighty-eight room "Governor's Palace" at Sayil, with its columned facade and imposing stone staircase, is similarly impressive. The Temple of Inscriptions at Palenque, El Castillo at Chichén Itzá, and the Temple of the Jaguar at Tikal all provide mute testimony to the splendid architecture of the Mayan world (Figure 12.3).

Beyond their ability at construction, the Maya also developed their own hieroglyphic writing system and left a fascinating legacy of written work in the form of relief carvings, paintings, and books called *codices*. Recent advances in translating the Mayan written language have enabled researchers to begin studying Mayan history from a Mayan perspective, much in the way we can study European history.

The Maya were precise mathematicians and developed the concept of zero. They also were great astronomers and even built an observatory at Chichén Itzá (Figure 12.4). With their mathematical and astronomical genius, the Maya developed a system of two calendars that together enabled them to chart time more accurately than we do with our standard calendar. In all ways the Maya were a remarkable people.

Hypotheses of von Dänikenesque extraterrestrials or harmonically converging intergalactic agents are silly and superfluous for explaining the Maya. The Maya were, quite simply, human beings who accomplished much in the relatively short tenure of their civilization. Their great fluorescence occurred between A.D. 300 and A.D. 900. After that, Mayan civilization waned. Both in the development of their civilization, as well as in its fall, lie ancient mysteries.

Kantunil, Xocchel, Chapab, Tahmek: these are not the names of ancient Mayan cities, but instead the names of modern Mayan towns in the vicinity of some of the most spectacular of the ancient sites. The descendants of the inhabitants of the great cities still live in the tropical lowlands of Mesoamerica, but the contrast between their lives and those of their ancestors is extreme. Living in poverty, they no longer build pyramids or chart the movement of planets. The mystery of the Maya concerns how and why a great civilization developed in tropical lowlands that today seem unable to

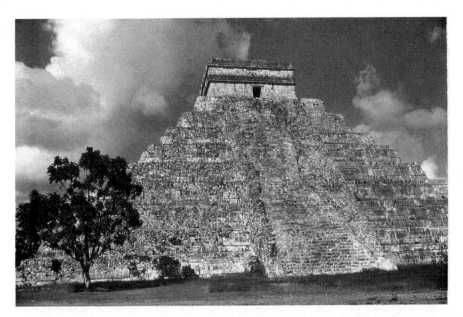

Figure 12.3 El Castillo—The Temple of Kukulcan—at the Mayan site of Chichén Itzá. It stands some thirty meters high and was constructed in nine levels; each of its four sides possesses a staircase with ninety-one steps—for a total of 364 steps plus the landing at the top of the pyramid for 365, the number of days in a year.

support a great civilization, and how and why the ancient civilization that did develop there fell.

Interestingly, there are probably fewer hypotheses for explaining the rise of the Maya than there are for the disintegration of their civilization. The patchy nature of resources like obsidian and salt may have encouraged the formation of an elite class to conduct or regulate trade (Rathje 1972). This trade, and the concentration of power and wealth in the hands of those controlling it, may have fostered further social stratification along with the development of trading centers that eventually became cities with populations of up to 100,000 people (Tikal, for example).

The key to the rise of the Maya may rest in their method of subsistence. It had been thought that the Maya relied on slash and burn agriculture, a common farming method in tropical areas today. Here, forest is cleared by burning, a crop is planted, and the patch is soon depleted of nutrients. Another patch is cleared by burning, and the previously farmed section is allowed to rejuvenate—a process that may take many years. This method is extensive rather than intensive and requires quite a bit of land for each family unit.

Recent research, however, suggests that the Maya developed a far more complex method of farming that involved the creation of raised fields in swampy areas. Here, fill is brought in to raise patches of wetlands. Crops

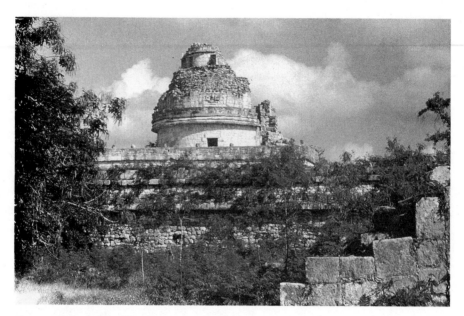

Figure 12.4 El Caracol, or the Observatory at Chichén Itzá. Along with being an impressive piece of architecture, the tower has a number of openings through which, it is thought, Mayan astronomer priests observed the night sky.

including corn, chili peppers, and yucca are grown on this raised ground.

Canals separate the patches of raised ground. In the canals, water plants are encouraged and periodically removed and placed on the raised ground where they serve as compost. In the canals, the water plants are fed on by fish that are periodically harvested, supplying additional protein to the Mayan diet.

In this scenario, Mayan civilization developed, at least in part, as a result of the necessity for a more complex social organization to control the community work necessary to produce the raised fields. While small families could have burned forest and planted their own food, the raised field system needed the cooperation of many people, and such cooperation would be greatly facilitated by a formal system of organization. Beyond this, the raised field system, being far more intensive than slash and burn agriculture, can produce a large food surplus. Such a surplus allows for the maintenance of an elite of priests, traders, artisans, soldiers, and workers (like pyramid builders).

The raised field system, however, eliminates a previously popular hypothesis for the fall of the Maya. Slash and burn agriculture requires an enormous amount of land (perhaps twenty acres for each family) and quickly depletes the soil of its nutrients. As Mayan population grew, the argument went, they eventually would have depleted the soil on their farms, eliminating the subsistence base of their society. Under this hypothe-

sis, the Maya fell because their food base was destroyed. The raised field scenario renders this hypothesis untenable.

The fall of the Maya and the descent of their once great civilization into its current state of poverty and powerlessness remains unexplained. Was it the result of internal political squabbles? Was it because of turmoil induced by outsiders like the Toltecs of central Mexico? Did population growth, indeed, outstrip their food base, despite the raised field system? The answers to the questions, "How and why did the Mayan civilization develop and why did it collapse?" remain unknown.

Conclusion: A Past We Deserve

The past, rather obviously, no longer exists. It is gone, whether we are contemplating human evolution, the earliest settlement of the Americas, the origins of civilization, the veracity of biblical stories, or any of the past times and events discussed in this book. In this sense, scientists and nonscientists alike are forced always to invent or construct an image of the past in the present. As scientists, of course, we do so in the hope that our constructs reflect the way things really were.

We believe we can construct a past that is veritable, that is accurate in terms of actual past events, since the past has left its mark in the present. But the data of antiquity are often vague, ambiguous, and difficult to interpret. There are, therefore, many different possible pasts that can be constructed. All scientists, in whatever the field, who consider the past history of the universe, the planet, life, or humanity recognize this. The message of this book has been that, while there are many different possibilities, not all of these constructed pasts—not all of the possibilities—are equally plausible.

Ultimately, then, we get the past we deserve. As shown in this book, in every generation, thinkers, writers, scholars, charlatans, and kooks (these are not necessarily mutually exclusive categories) attempt to cast the past in an image either they or the public desire or find comforting. Biblical giants—some, apparently, walking their pet dinosaurs—large-brained, ape-jawed ancestors, lost tribes, lost continents, mysterious races, ancient astronauts, and intergalactic Maya have all been a part of their concocted fantasies.

But I believe, and have tried to show in this book, that we deserve better—and we can do better. We deserve a veritable past, a real past constructed from the sturdy fabric of geology, paleontology, archaeology, and history, woven on the loom of science. We deserve better and can do better than weave a past from the whole cloth of fantasy and fiction. I hope that I have shown in this book that the veritable past is every bit as interesting as those pasts constructed by the fantasy weavers of frauds, myths, and mysteries.

References

Adams, R. E., W. E. Brown, and T. P. Culbert. 1981. Radar mapping, archaeology, and ancient Mayan land use. *Science* 213:1457–63.

Adovasio, J. M., J. Donahue, K. Cushman, R. C. Carlisle, R. Stuckenrath, J. D. Gunn, W. C. Johnson. 1983. Evidence from Meadowcroft Rockshelter. In *Early Man in the New World*, ed. R. Schutler, pp. 163–89. Newbury Park, Calif.: Sage.

Aitken, M. J. 1959. Test for correlation between dowsing response and magnetic disturbance. *Archaeometry* 2:58–59.

———. 1970. Magnetic location. In *Science in Archaeology*, ed. D. Brothwell and E. Higgs, pp. 681–94. New York: Praeger.

Alcock, J. 1989. Channeling: Brief history and contemporary context. *The Skeptical Inquirer* 13(4):380–84.

American Anthropological Association. 1984. Pamphlet Series. Washington, D.C.: American Anthropological Association.

Argüelles, J. 1987. *The Mayan Factor: Path Beyond Technology*. Santa Fe: Bear and Co.

Ashe, G. 1971. Analysis of the legends. In *Quest for America*, ed. G. Ash, pp. 15–52. New York: Praeger.

Atkinson, R. J. C. 1966. Moonshine on Stonehenge. *Antiquity* 40:262–74.

Atwater, C. [1820] 1973. *Description of the Antiquities Discovered in the State of Ohio and Other Western States*. Transactions and Collections of the American Antiquarian Society. New York: AMS Press (reprinted for the Peabody Museum of Ethnology and Archaeology, Harvard University).

Austen, G. 1985. Diviner tunes in to park's ghost town. *The Sun*, July 24. Melbourne, Australia.

Bailey, R. 1983. Divining edge: Dowsing for Medieval churches. *Popular Archaeology*, February, p. 5.

Bainbridge, W. S. 1978. Chariots of the gullible. *The Skeptical Inquirer* 3(2):33–48.

Bakeless, J. 1964. *The Journals of Lewis and Clark*. New York: Mentor Books.

Ballinger, B. 1978. *Lost City of Stone: The Story of Nan Madol, the "Atlantis" of the Pacific*. New York: Simon and Schuster.

Barton, B. S. 1787. *Observations on Some Parts of Natural History*. London.

Bartram, W. [1791] 1928. *The Travels of William Bartram*. New York: Dover.

Bastedo, R. 1981. An empirical test of popular astrology. In *Paranormal Borderlands of Science*, ed. K. Frazier, pp. 241–62. Buffalo: Prometheus Books.

Berlitz, C. 1972. *Mysteries from Forgotten Worlds*. New York: Dell.

———. 1984. *Atlantis: The Eighth Continent*. New York: Fawcett Crest.

Bird, R. T. 1939. Thunder in his footsteps. *Natural History* 43(5):254–61, 302.

Blavatsky, H. P. 1888–1938. *The Secret Doctrine*. Wheaton, Ill.: Theosophical Publishing House (6 volumes).

Blinderman, C. 1986. *The Piltdown Inquest*. Buffalo: Prometheus Books.

Breuil, H. 1952. *Four Hundred Years of Cave Art*. Montignac, France: Centre d'Études et de Documentation Prehistorique.

Brown, D. 1970. *Bury My Heart at Wounded Knee*. New York: Bantam.

Brumbaugh, R. S. 1954. *Plato's Mathematical Imagination*. Bloomington: Indiana University Press.

Burdick, C. 1950. When GIANTS roamed the earth: Their fossil footprints still visible. *Signs of the Times*, July 25, p. 6, 9.

Butzer, K. 1976. *Early Hydraulic Civilization of Egypt: A Study in Cultural Ecology*. Chicago: University of Chicago Press.

Byrne, M. St. Clere (ed.) 1979. *The Elizabethan Zoo: A Book of Beasts Fabulous and Authentic* (selected from Philemon Holland's 1601 translation of Pliny and Edward Topsell's 1607 *Historie of Foure-Footed Beastes* and his 1608 *Historie of Serpents*). Boston: Nonpareil Books.

Cardiff Giant. 1898. *Ithaca Daily Journal*. January 4. Ithaca, N. Y.

Case of the Ancient Astronauts (television program). 1978. *Nova*. Boston: WGBH.

Cayce, E. 1968. *Edgar Cayce on Atlantis*. New York: Hawthorn Books.

Chambers, H. 1969. *Dowsing, Divining Rods, and Water Witches for the Millions*. Los Angeles: Sherbourne Press.

Chatelain, M. 1980. *Our Ancestors Came from Outer Space*. London: Arthur Baker.

Chippindale, C. 1983. *Stonehenge Complete*. Ithaca: Cornell University Press.

Clark, A. 1970. Resistivity surveying. In *Science in Archaeology*, ed. D. Brothwell and E. Higgs, pp. 695–707. New York: Praeger.

Clarke, D. 1978. *Analytical Archaeology*. New York: Columbia University Press.

Cohen, D. 1969. *Mysterious Places*. New York: Dodd, Mead.

Cole, J. R. 1979. Inscriptionmania, hyperdiffusionism, and the public: Fallout from a 1977 meeting. *Man in the Northeast* 17:27–53.

———. 1982. Western Massachusetts "Monk's caves": 1979 University of Massachusetts field research. *Man in the Northeast* 24:37–70.

Cole, J. R., L. Godfrey, and S. Schafersman. 1985. Mantracks: The fossils say no! *Creation/Evolution* 5(1):37–45.

Conkey, M. 1980. The identification of prehistoric hunter-gatherer aggregation sites: The case of Altamira. *Current Anthropology* 21(5):609–39.

———. 1983. On the origins of Paleolithic art: A review and some critical thoughts. In *The Mousterian Legacy*, ed. E. Trinkaus, pp. 201–27. Oxford: British Archaeological Reports, International Series, 164.

———. 1987. New approaches in the search for meaning? A review of research in "Paleolithic art." *Journal of Field Archaeology* 14:413–30.

Connah, G. 1987. *African Civilizations*. Cambridge: Cambridge University Press.

Dall, W. H. 1877. On succession of shell heaps of the Aleutian Islands. In *Contributions to American Ethnology* Volume 1, 41–91. Washington, D.C.: U.S. Department of the Interior.

Daniel, Glyn. 1977. Review of *America B.C.* by Barry Fell. *New York Times Book Review*. March 13, 8ff.

Darwin, C. [1859] 1898. *On the Origin of Species by Means of Natural Selection*. New York: Appleton and Co.

———. [1871] 1930. *The Descent of Man*. London: C. C. Watts.

Darwin Theory Is Proved True. 1912. *New York Times*, December 22.

Dawson, C., and A. S. Woodward. 1913. On the discovery of a Paleolithic human skull and mandible in a flint bearing gravel overlying the Wealden (Hastings Beds) of Piltdown, Fletching (Sussex). *Quarterly Journal of the Geological Society*, 69:117–51.

Deacon, R. 1966. *Madoc and the Discovery of America.* New York: George Braziller.

de Camp, L. S. 1970. *Lost Continents: The Atlantis Theme in History, Science, and Literature.* New York: Dover Books.

Dincauze, D. 1982. Monk's Caves and short memories. *Quarterly Review of Archaeology* 3(4):1, 10–11.

Dolnick, E. 1989. Panda paradox. *Discover*, Sept., 71–76.

Donnelly, I. [1882] 1971. *Atlantis: The Antediluvian World.* New York: Harper.

Doyle, A. C. [1891–1902] 1981. *The Celebrated Cases of Sherlock Holmes.* London: Octopus Books.

Drake, W. R. 1968. *Gods and Spacemen in the Ancient East.* New York: Signet.

Du Pratz, L. P. 1774. *History of Louisiana.*

Eaton, R. 1978. The evolution of trophy hunting. *Carnivore* 1(1):110–121.

Edwords, F. 1983. Creation/evolution update: Footprints in the mind. *The Humanist* 43(2):31.

Eldredge, N. 1982. *The Monkey Business: A Scientist Looks at Creationism.* New York: Washington Square Press.

Elvas, Gentleman of. [1611] 1907. *The Discovery and Conquest of Terra Florida by Don Ferdinando de Soto and Six Hundred Spaniards, His Followers.* The Hakluyt Society. New York: Burt Franklin.

Fagan, B. 1977. Who were the Mound Builders? In *Mysteries of the Past*, ed. J. J. Thorndike, Jr., pp. 118–35. New York: American Heritage Press.

Faulkner, C. 1971. *The Old Stone Fort.* Knoxville: University of Tennessee Press.

Feder, K. L. 1980a. Foolsgold of the gods. *The Humanist*, Jan/Feb., 20–23.

———. 1980b. Psychic archaeology: The anatomy of irrationalist prehistoric studies. *The Skeptical Inquirer* 4(4):32–43.

———. 1983. American disingenuous: Goodman's *American Genesis*—A new chapter in cult archaeology. *The Skeptical Inquirer* 7(4):36–48.

———. 1984. Irrationality and archaeology. *American Antiquity* 49(3):525–41.

———. 1985/6. The challenges of pseudoscience. *Journal of College Science Teaching.* Dec/Jan., 180–86.

———. 1986. *The Beaver Meadow Complex Prehistoric Archaeological District.* National Register of Historic Places Inventory Nomination Form. Manuscript on file. Hartford: Connecticut Historical Commission.

———. 1987. Cult archaeology and creationism: A coordinated research project. In *Cult Archaeology and Creationism: Understanding Pseudoscien-*

tific Beliefs About the Past, ed. F. Harrold and R. Eve, pp. 34–48. Iowa City: University of Iowa Press.

Feder, K. L., and M. A. Park. 1989. *Human Antiquity.* Mountain View, Calif.: Mayfield.

Feldman, M. 1977. *The Mystery Hill Story.* North Salem, N.H.: Mystery Hill.

Fell, B. 1976. *America B.C.: Ancient Settlers in the New World.* New York: Demeter Press.

———. 1980. *Saga America.* New York: Times Books.

———. 1982. *Bronze Age America.* New York: Times Books.

Fernandez-Armesto, F. 1974. *Columbus and the Conquest of the Impossible.* New York: Saturday Review Press.

Fitzhugh, W. 1972. Environmental archaeology and cultural systems in Hamilton Inlet, Labrador: A Survey of the central Labrador coast from 3000 B.C. to the present. *Smithsonian Contributions to Anthropology,* No. 16.

Foster, J. W. 1873. *Prehistoric Races of the United States of America.* Chicago: S. C. Griggs.

Fowler, M. 1974. *Cahokia: Ancient Capital of the Midwest.* Addison-Wesley Module No. 48. Menlo Park, Calif.: Cummings.

———. 1975. A Precolumbian urban center on the Mississippi. *Scientific American* 233(2):92–101.

Franco, B. 1969. *The Cardiff Giant: A Hundred Year Old Hoax.* Cooperstown, N. Y.: The New York State Historical Association.

Friedlander, P. 1969. *Plato: The Dialogues.* Volume 3. Princeton: Princeton University Press.

Frost, F. 1982. The Palos Verdes Chinese anchor mystery. *Archaeology,* Jan/Feb., 23–27.

Fuson, R. 1987. *The Log of Christopher Columbus.* Canada, Maine: International Marine Pub.

Futuyma, D. J. 1983. *Science on Trial: The Case for Evolution.* New York: Pantheon.

Galanopoulos, A. G., and E. Bacon. 1969. *Atlantis: The Truth Behind the Legend.* Indianapolis: Bobbs-Merrill.

Gallatin, A. 1836. A synopsis of the Indian tribes within the United States east of the Rocky Mountains, in the British and Russian possessions in North America. *Archaeologica Americana,* Volume 2, 1–422, Cambridge, Mass.

Galvaño, A. [1555] 1962. *The Discoveries of the New World from Their First Original unto the Year of Our Lord 1555.* The Hakluyt Society. New York: Burt Franklin.

Gish, D. 1972. *Evolution? The Fossils Say No.* San Diego: Creation Life Publishers.

Gladwin, H. 1947. *Men Out of Asia.* New York: McGraw-Hill.

Goddard, I., and W. Fitzhugh. 1979. A statement concerning *America B.C. Man in the Northeast* 17:166–72.

Godfrey, L. (ed). 1983. *Scientists Confront Creationism.* New York: Norton Press.

———. 1985. Footnotes of an anatomist. *Creation/Evolution* 5(1):16–36.

Godfrey, W. 1951. The archaeology of the Old Stone Mill in Newport, Rhode Island. *American Antiquity* 17:120–29.

Goodman, J. 1977. *Psychic Archaeology: Time Machine to the Past.* New York: Berkley.

———. 1981. *American Genesis.* New York: Berkley.

Goodwin, W. 1946. *The Ruins of Great Ireland in New England.* Boston: Meador.

Gordon, C. H. 1974. *Riddles in History.* New York: Crown.

Gould, S. J. 1980. The Piltdown conspiracy. *Natural History,* August, 8ff.

———. 1981. A visit to Dayton. *Natural History,* Nov., 8ff.

———. 1982. Moon, Mann, and Otto. *Natural History,* Jan., 4–10.

Gradie, R. F. 1981. Irish immigration to 18th century New England and the stone chamber controversy. *Bulletin of the Archaeological Society of Connecticut* 44:30–39.

Gramly, M. 1982. *The Vail Site.: A Paleo-Indian Encampment in Maine.* Bulletin of the Buffalo Society of Natural Sciences, Volume 30.

Greene, J. 1959. *The Death of Adam: Evolution and Its Impact on Western Thought.* Ames, Iowa: Iowa State University Press.

Griffin, J. B., B. Meltzer, and B. Smith. 1988. A mammoth fraud in science. *American Antiquity* 53(3):578–81.

Guidon, N. 1987. Cliff notes. *Natural History,* August, 6ff.

Haas, J. 1982. *The Evolution of the Prehistoric State.* New York: New York University Press.

Hakluyt Society. 1904. *The Letters of Amerigo Vespucci and Other Documents Illustrative of His Career.* New York: Burt Franklin.

Halverson, J. 1987. Art for art's sake in the Paleolithic. *Current Anthropology* 28:63–71.

Hanke, L. 1937. Pope Paul III and the American Indians. *Harvard Theological Review* 30:65–102.

Hansel, C. E. M. 1980. *ESP and Parapsychology: A Critical Re-evaluation.* Buffalo: Prometheus Books.

Harris, M. 1968. *The Rise of Anthropological Theory.* New York: Thomas Y. Crowell.

Harrison, W. 1971. Atlantis undiscovered—Bimini, Bahamas. *Nature* 230:287–89.

Harrold, F., and R. Eve (eds). 1987. *Cult Archaeology and Creationism: Understanding Pseudoscientific Beliefs About the Past.* Iowa City: University of Iowa Press.

Hartmann, N. 1987. Atlantis lost and found. *Expedition* 29(2):19–26.

Hastings, R. 1985. Tracking those incredible creationists. *Creation/Evolution* 5(1):5–15.

Hawkins, G. 1965. *Stonehenge Decoded.* New York: Dell.

Haynes, C. V. 1988. Geofacts and fancy. *Natural History,* Feb., 4–12.

Hempel, C. G. 1966. *Philosophy of Natural Science.* Englewood Cliffs, N.J.: Prentice-Hall.

Henningsmoen, K. 1977. Pollen-analytical investigations in the L'Anse aux Meadows area, Newfoundland. In *The Discovery of a Norse Settlement in America,* by A. S. Ingstad, pp. 289–340. Oslo, Norway: Universitetsforlaget.

Heyerdahl, T. 1958. *Aku-Aku.* New York: Rand McNally.

Hoffman, M. 1979. *Egypt Before the Pharoahs.* New York: Knopf.

———. 1983. Where nations began. *Science 83* 4(8):42–51.

Hole, F. 1981. *Saga America*: Book Review. *Bulletin of the Archaeological Society of Connecticut* 44:81–83.

Hole, F., K. Flannery, and J. A. Neely. 1969. *Prehistory and Human Ecology of the Deh Luran Plain: An Early Village Sequence from Khuzistan, Iran.* Ann Arbor: University of Michigan Press.

Holy Shroud Guild. 1977. *Proceedings of the 1977 United States Conference on the Shroud of Turin.* New York: Holy Shroud Guild.

Holzer, H. 1969. *Window to the Past.* Garden City, N.Y.: Doubleday.

Hopkins, D., J. Mathews, C. Schweger, and S. Young (eds). 1982. *The Paleoecology of Beringia.* New York: Academic Press.

Howard, R. W. 1975. *The Dawn Seekers.* New York: Harcourt, Brace, Jovanovich.

Huddleston, L. 1967. *Origins of the American Indians: European Concepts, 1492–1729.* Austin: University of Texas Press.

Hudson, L. 1987. East is east and west is west? A regional comparison of cult belief patterns. In *Cult Archaeology and Creationism: Understanding Pseudoscientific Beliefs About the Past*, ed. F. Harrold and R. Eve, pp. 49–67. Iowa City: University of Iowa Press.

Hume, I. N. 1974. *Historical Archaeology*. New York: Knopf.

Hunt, K. A. 1984. *Point Cook Homestead Electro-Magnetic Photo-Field Survey for Melbourne and Metropolitan Board of Works, Melbourne, Victoria, Australia*. Unpublished ms.

Hutchins, R. M. (ed). 1952. *The Dialogues of Plato*, trans. B. Jowett. Chicago: William Benton/Encyclopedia Britannica.

Ingstad, A. S. 1977. *The Discovery of a Norse Settlement in America*. Oslo, Norway: Universitetsforlaget.

———. 1982. The Norse settlement of L'Anse aux Meadows, Newfoundland. In *Vikings in the West*, ed. E. Guralnick, pp. 31–37. Chicago: Archaeological Institute of America.

Ingstad, H. 1964. Viking ruins prove Vikings found the New World. *National Geographic* 126(5):708–34.

———. 1971. Norse site at L'Anse aux Meadows. In *The Quest for America*, ed. G. Ashe, pp. 175–98. New York: Praeger.

———. 1982. The discovery of a Norse settlement in America. In *Vikings in the West*, ed. E. Guralnick, pp. 24–30. Chicago: Archaeological Institute of America.

Irving, W. 1987. New dates for old bones. *Natural History* Feb., 8–13.

Ives, R. 1956. An early speculation concerning the Asiatic origin of the American Indians. *American Antiquity* 21:420–21.

Jackson, N. F., G. Jackson, and W. Linke, Jr. 1981. The "trench ruin" of Gungywamp, Groton, Connecticut. *Bulletin of the Archaeological Society of Connecticut* 44:20–29.

Jacobsen, T. W. 1976. 17,000 years of Greek prehistory. *Scientific American* 234(6):76–87.

Jennings, J. 1989. *Prehistory of North America*. Mountain View, Calif.: Mayfield.

Jochim, M. 1983. Paleolithic cave art in ecological perspective. In *Hunter-Gatherer Economy in Prehistory: A European Perspective*, ed. G. Bailey, pp. 211–19. Cambridge: Cambridge University Press.

Jones, D. 1979. *Visions of Time: Experiments in Psychic Archaeology*. Wheaton, Ill.: Theosophical Publishing House.

Jones, G. 1982. Historical evidence for Viking voyages to the New World. In *Vikings in the West*, ed. E. Guralnick, pp. 1–12. Chicago: Archaeological Institute of America.

————. 1986. *The Norse Atlantic Saga*. New York: Oxford University Press.

Josselyn, J. [1674] 1865. *An Account of Two Voyages to New England Made During the Years 1638, 1663*. Boston: W. Veazie.

Kehoe, A. B. 1989. *The Ghost Dance: Ethnohistory and Revitalization*. New York: Holt, Rinehart, and Winston.

Keith, A. 1913. The Piltdown skull and brain cast. *Nature* 92:197–99.

Kennedy, K. A. R. 1975. *Neanderthal Man*. Minneapolis: Burgess Press.

Klass, P. 1986. *The Public Deceived*. Buffalo: Prometheus Books.

————. 1989. UFO-Abductions: A Dangerous Game. Buffalo: Prometheus Books.

Kolosimo, P. 1975. *Spaceships in Prehistory*. Secaucus, N. J.: University Books.

Kosok, P., and M. Reiche. 1949. Ancient drawings on the desert of Peru. *Archaeology* 2(4):206–15.

Kuban, G. 1989a. Retracking those incredible man tracks. *National Center for Science Education Reports* 9(4):13–16.

————. 1989b. Elongate dinosaur tracks. In *Dinosaur Tracks and Traces*, ed. D. D. Gillette and M. G. Lockley, pp. 57–72. New York: Cambridge University Press.

Kuhn, T. 1970. *The Structure of Scientific Revolutions*. Chicago: University of Chicago Press.

Lafayette Wonder. 1869. *Syracuse Daily Journal*. October 20. Syracuse, N. Y.

Lamberg-Karlovsky, C. C., and J. Sabloff. 1979. *Ancient Civilizations: The Near East and Mesoamerica*. Prospect Heights, Ill.: Waveland Press.

LeHaye, T., and J. Morris. 1976. *The Ark on Ararat*. San Diego: Creation Life Publishers.

Leroi-Gourhan, A. 1968. The evolution of Paleolithic art. *Scientific American* 209(2):58–74.

MacCurdy, G. 1913. Ancestor hunting: The significance of the Piltdown skull. *American Anthropologist* 15:248–56.

————. 1914. The man of Piltdown. *Science* 40:158–160.

MacLaine, S. 1983. *Out on a Limb*. New York: Bantam.

MacNeish, R. S. 1967. An interdisciplinary approach to an archaeological problem. In *The Prehistory of the Tehuacan Valley: Volume 1—Environment and Subsistence*, ed. D. Byers, pp. 14–23. Austin: University of Texas Press.

Magnusson, M., and H. Paulsson (trans.) 1965. *The Vinland Sagas*. New York: Penguin.

Major, R. H. (ed). 1961. *Christopher Columbus: Four Voyages to the New World—Letters and Selected Documents.* New York: Corinth Books.

Marden, L. 1986. The first land fall of Columbus. *National Geographic* 170(5):572–77.

Marks, D., and R. Kammann. 1980. *The Psychology of the Psychic.* Buffalo: Prometheus Books.

Marshack, A. 1972. *The Roots of Civilization.* New York: McGraw-Hill.

Martin, M. 1983/4. A new controlled dowsing experiment. *The Skeptical Inquirer* 8(2):138–42.

McCrone, W. 1976. Authenticity of medieval document tested by small particle analysis. *Analytical Chemistry* 48(8):676A–79A.

———. 1982. Shroud image is the work of an artist. *The Skeptical Inquirer* 6(3):35–36.

McGhee, R. 1984. Contact between native North Americans and the medieval Norse: A review of the evidence. *American Antiquity* 49:4–26.

McGovern, T. 1980–81. The Vinland adventure: A North Atlantic perspective. *North American Archaeologist* 2(4):285–308.

———. 1982. The lost Norse colony of Greenland. *Vikings in the West*, ed. E. Guralnick, pp. 13–23. Chicago: Archaeological Institute of America.

McIntyre, I. 1975. Mystery of the ancient Nazca lines. *National Geographic* 147(5):716–28.

McKusick, M. 1970. *The Davenport Conspiracy.* Report #1, Iowa City: Office of the State Archaeologist, University of Iowa.

———. 1976. Contemporary American folklore about antiquity. *Bulletin of the Philadelphia Anthropological Society* 28:1–23.

———. 1979. Some historical implications of the Norse penny from Maine. *Norwegian Numismatic Journal* 3:20–23.

———. 1982. Psychic archaeology: Theory, method, and mythology. *Journal of Field Archaeology* 9:99–118.

———. 1984. Psychic archaeology from Atlantis to Oz. *Archaeology* Sept/Oct., 48–52.

———. In Press. *The Davenport Conspiracy Revisited.* Ames: Iowa State University Press.

McKusick, M., and E. Shinn. 1981. Bahamian Atlantis reconsidered. *Nature* 287:11–12.

Meltzer, D. J. 1989. Why don't we know when the first people came to North America? *American Antiquity* 54(3):471–90.

Mendelssohn, K. 1974. *Riddle of the Pyramids.* New York: Praeger.

Millar, R. 1972. *The Piltdown Men.* New York: Ballantine Books.

Miller, G. 1915. The jaw of Piltdown man. *Smithsonian Miscellaneous Collections* 65:1–31.

Money, L. 1985. Down on the farm—in spirit, at least. *The Herald,* July 26. Melbourne, Australia.

Montague, A. 1960. Artificial thickening of bone and the Piltdown skull. *Nature* 187:174.

———— (ed). 1982. *Evolution and Creationism.* New York: Oxford University Press.

Mooney, J. [1892–93] 1965. *The Ghost-Dance Religion and the Sioux Outbreak of 1890.* Chicago: University of Chicago Press.

Moore, R. A. 1983. The impossible voyage of Noah's ark. *Creation/Evolution* 11:1–43.

Morison, S. E. 1940. *Portuguese Voyagers to America in the Fifteenth Century.* Cambridge: Harvard University Press.

Morris, H. 1974. *The Troubled Waters of Evolution.* San Diego: Creation Life Publishers.

————. 1977. *The Scientific Case for Creation.* San Diego: Creation Life Publishers.

Morris, J. 1980. *Tracking Those Incredible Dinosaurs and the People Who Knew Them.* San Diego: Creation Life Publishers.

————. 1986. The Paluxy River mystery. *Impact* No. 151. El Cajon, Calif.: Creation Research Institute.

Mosimann, J., and P. Martin. 1975. Simulating overkill by Paleo-Indians. *American Scientist* 63:304–13.

Mueller, M. 1982. The Shroud of Turin: A critical approach. *The Skeptical Inquirer* 6(3):15–34.

National Academy of Sciences. 1984. *Science and Creation: A View from the National Academy of Sciences.* Washington, D.C.: National Academy Press.

Neudorfer, G. 1980. *Vermont Stone Chambers: An Inquiry into Their Past.* Montpelier: Vermont Historical Society.

News. 1912. *Nature* 92:390.

Nickell, J. 1983a. The Nazca drawings revisited. *The Skeptical Inquirer* 7(3):36–44.

————. 1983b. *Inquest on the Shroud.* Buffalo: Prometheus Books.

————. 1989. Unshrouding a mystery: Science, pseudoscience and the cloth of Turin. *The Skeptical Inquirer* 13(3):296–99.

Noorbergen, R. 1982. *Treasures of the Lost Races*. New York: Bobbs-Merrill.

Oakley, K. P., 1976. The Piltdown problem reconsidered. *Antiquity* 50 (March):9–13.

Oakley K. P., and J. S. Weiner. 1955. Piltdown Man. *American Scientist* 43:573–83.

Omunhundro, J. T. 1976. Von Däniken's chariots: A primer in the art of cooked science. *The Zetetic* Vol. 1(1):58–67.

Osborn, H. F. 1921. The Dawn Man of Piltdown, Sussex. *Natural History* 21:577–90.

Paleolithic Man. 1912. *Nature* 92:438.

Paleolithic Skull Is Missing Link. 1912. *New York Times*, Dec. 19.

Patterson, T. 1973. *America's Past: A New World Archaeology*. Glenview, Ill.: Scott, Foresman, and Co.

Pauwels, L., and J. Bergier. [1960] 1964. *The Morning of the Magicians*. New York: Stein and Day.

Peterson, N. 1988. *Sacred Sites: A Traveler's Guide to North America's Most Powerful and Mysterious Landmarks*. New York: Contemporary Books.

Putnam, C. E. 1886. The Davenport tablets. *Science* 7, No. 157:119–20.

Randi, J. 1979. A controlled test of dowsing abilities. *The Skeptical Inquirer* 4(1):16–20.

———. 1981. Atlantean road: The Bimini beach-rock. *The Skeptical Inquirer* 5(3):42–43.

———. 1984. The great $110,000 dowsing challenge. *The Skeptical Inquirer* 8(4):329–33.

Rathje, W. 1972. Praise the gods and pass the metates: A hypothesis of the development of lowland forest civilization in Mesoamerica. In *Contemporary Archaeology*, ed. M. Leone, pp. 365–92. Carbondale: University of Illinois Press.

Reiche, M. 1978. *Mystery on the Desert*. Stuttgart: Heinrich Fink.

Rhein, R. W. 1980. *Medical World News*, Dec. 22, 40–50.

Robertson, M. G. 1974. *Primera Mesa Redonda de Palenque*. Pebble Beach, Calif.: Robert Louis Stevenson School.

Ross, A., and P. Reynolds. 1978. 'Ancient Vermont.' *Antiquity* 52:100–107.

Rowe, J. H. 1966. Diffusionism and archaeology. *American Antiquity* 31:334–37.

Ruspoli, M. 1986. *The Cave at Lascaux: The Final Photographs*. New York: Abrams.

Sabloff, J. 1989. *The Cities of Ancient Mexico: Reconstructing a Lost World.* New York: Thames and Hudson.

Sabo, D., and G. Sabo. 1978. A possible Thule carving of a Viking from Baffin Island, NWT, Canada. *Journal of Archaeology* 2:33–42.

Sallee, R. 1983. The search for Noah's Ark continues. *Houston Chronicle*, Aug. 20, Section 6, 1–2. Houston, Texas.

Schledermann, P. 1981. Eskimo and Viking finds in the High Arctic. *National Geographic* 159(5):575–601.

Schneour, E. 1986. Occam's Razor. *The Skeptical Inquirer* 10(4):310–13.

Schoolcraft, H. R. 1854. *Historical and Statistical Information Regarding the History, Condition, and Prospects of the Indian Tribes of the United States.* Part IV. Philadelphia.

Schwartz, S. 1978. *The Secret Vaults of Time: Psychic Archaeology and the Quest for Man's Beginnings.* New York: Grosset and Dunlap.

———. 1983. *The Alexandria Project.* New York: Delacorte Press.

Scott, E. C. 1987. Antievolutionism, scientific creationism, and physical anthropology. *Yearbook of Physical Anthropology* 30:21–39.

Severin, T. 1977. The voyages of "Brendan." *National Geographic* 152(12):770–97.

Shapiro, H. 1974. *Peking Man: The Discovery, Disappearance, and Mystery of a Priceless Scientific Treasure.* New York: Simon and Schuster.

Sharer, R., and W. Ashmore. 1987. *Archaeology: Discovering Our Past.* Mountain View, Calif.: Mayfield.

Shorey, P. 1933. *What Plato Said.* Chicago: University of Chicago Press.

Shutler, R., and M. Shutler. 1975. *Oceanic Prehistory.* Menlo Park, Calif.: Cummings.

Silverberg, R. 1970. *The Moundbuilders.* New York: Ballantine.

Simpson, R. D. 1978. The Calico Mountains archaeological site. In *Early Man in America from a Circum-Pacific Perspective*, ed. A. Bryan, pp. 218–20. Occasional Paper No. 1 of the Department of Anthropology, University of Alberta. Edmonton, Alberta, Canada: Archaeological Researches International.

Smith, G. E. 1927. *Essays on the Evolution of Man.* London: Oxford University Press.

Snow, D. 1981. Martians and Vikings, Madoc and runes. *American Heritage* 32(6):102–8.

So Big: The All Time Mass Market Best Sellers. 1989. *Publisher's Weekly*, May 26, p.531.

Solheim, W. 1972. An earlier agricultural revolution. *Scientific American* 226(4):34–41.

Spence, L. [1926] 1968. *The History of Atlantis.* New York: Bell Publishing.

Spencer, F. 1984. The Neandertals and their evolutionary significance: A brief history and historical survey. In *The Origins of Modern Humans: A World Survey of the Fossil Evidence,* ed. F. Smith and F. Spencer, pp. 1–50. New York: Alan R. Liss.

Squier, E. G., and E. H. Davis. [1848] 1973. *Ancient Monuments of the Mississippi Valley: Comprising the Results of Extensive Original Surveys and Explorations.* Smithsonian Contributions to Knowledge, Volume 1. New York: AMS Press (Reprinted for the Peabody Museum of Archaeology and Ethnology, Harvard University).

Stevenson, K. E., and G. R. Habermas. 1981a. *Verdict on the Shroud.* Ann Arbor, Mich.: Servant Publications.

———. 1981b. We tested the Shroud. *The Catholic Digest,* Nov., 74–78.

Steward, T. D. 1973. *The People of America.* New York: Charles Scribner's Sons.

Stiebing, W. 1984. *Ancient Astronauts, Cosmic Collisions, and Other Popular Theories About Man's Past.* Buffalo: Prometheus Books.

Stone Giant. 1869. *Syracuse Standard.* Nov. 1. Syracuse, N.Y.

Story, R. 1976. *The Space-Gods Revealed: A Close Look at the Theories of Erich von Däniken.* New York: Harper and Row.

Sullivan, G. 1980. *Discover Archaeology: An Introduction to the Tools and Techniques of Archaeological Fieldwork.* New York: Penguin.

Swauger, J. L. 1981. Petroglyphs, tar burner rocks, and lye leaching stones. *Pennsylvania Archaeologist* 51(1–2):1–7.

Taylor, A. E. 1962. *A Commentary on Plato's Timaeus.* Oxford: Clarendon Press.

Taylor, P. 1985a. *Young People's Guide to the Bible and the Great Dinosaur Mystery.* Mesa, Ariz.: Films for Christ Association.

———. 1985b. *Notice Regarding the Motion Picture "Footprints in Stone."* Mesa, Ariz.: Films for Christ Association.

Taylor, R. E., and R. Berger. 1980. The date of Noah's Ark. *Antiquity* 54:34–36.

Thomas, C. [1894] 1985. *Report on the Mound Explorations of the Bureau of Ethnology.* Washington D.C.: BAE (reprinted by Smithsonian Institution Press).

Thomas, D. H. 1989. *Archaeology.* New York: Holt, Rinehart, and Winston.

Tomas, A. 1971. *We Are Not the First.* New York: Bantam.

Trento, S. 1978. *The Search for Lost America. Mysteries of the Stone Ruins in the United States.* New York: Penguin.

Turner, C. G. 1987. Telltale teeth. *Natural History,* Jan., 6–10.

Twain, M. 1957. A ghost story. In *The Complete Short Stories of Mark Twain,* ed. C. Neider, pp. 245–49. New York: Bantam.

van Kampen, H. 1979. The case of the lost panda. *The Skeptical Inquirer* 4(1):48–50.

Van Sertima, I. 1976. *They Came Before Columbus.* New York: Random House.

Van Tilburg, J. 1987. Symbolic archaeology on Easter Island. *Archaeology* 40(2):26–33.

Vaughan, C. 1988. Shroud of Turin is a fake, official confirms. *Science News* 134(15):229.

Vescelius, G. 1956. Excavations at Pattee's Caves. *Bulletin of the Eastern States Archaeological Federation* 15:13–14.

Vogt, E., and R. Hyman. 1980. *Water Witching U.S.A.* Chicago: University of Chicago Press.

von Däniken, E. 1970. *Chariots of the Gods.* New York: Bantam.

———. 1971. *Gods from Outer Space.* New York: Bantam.

———. 1973. *Gold of the Gods.* New York: Bantam.

———. 1975. *Miracles of the Gods.* New York: Bantam.

———. 1982. *Pathways to the Gods.* New York: Putnam.

———. 1989. *In Search of the Gods.* New York: Avenel.

Wallace, B. 1982. Viking hoaxes. In *Vikings in the West,* ed. E. Guralnick, pp. 51–76. Chicago: Archaeological Institute of America.

Warner, F. 1981. Stone structures at Gungywamp. *Bulletin of the Archaeological Society of Connecticut* 44:4–19.

Waterston, D. 1913. The Piltdown mandible. *Nature* 92:319.

Weaver, K. 1980. Science seeks to solve the mystery of the Shroud. *National Geographic* 157(6):730–753.

Weidenreich, F. 1943. Piltdown man. *Paleontologica Sinica* 129:273.

Weiner, J. S. 1955. *The Piltdown Forgery.* London: Oxford University Press.

Wendorf, F., R. Schild, and A. Close. 1982. An ancient harvest on the Nile. *Science 82* Vol. 3(9):68–73.

Wernick, R., and the editors of Time-Life Books. 1973. *The Monument Builders.* New York: Time-Life Books.

West, F. H. 1981. *The Archaeology of Beringia.* New York: Columbia University Press.

Whitcomb, J. C., and H. Morris. 1961. *The Genesis Flood.* Nutley, N.J.: Presbyterian and Reformed Publishing Co.

Whittle, A. 1985. *Neolithic Europe: A Survey.* Cambridge: Cambridge University Press.

Willey, G., and J. Sabloff. 1980. *A History of American Archaeology.* San Francisco: Freeman.

Wilmsen, E. 1965. An outline of early man studies in the United States of America. *American Antiquity* 31:172–92.

———. 1974. *Lindenmeier: A Pleistocene Hunting Society.* New York: Harper and Row.

Wilson, D. 1988. Desert ground drawings in the lower Santa Valley, north coast of Peru. *American Antiquity* 53(4):794–803.

Wilson, I. 1979. *The Shroud of Turin: The Burial Cloth of Jesus Christ?* New York: Image Books.

Index

219